SEP 19 2018

D. R. Toi
223 Southlake Pl.
Newport News, VA 23602-8323

SACRED GEOMETRY
FOR **ARTISTS, DREAMERS,**
AND **PHILOSOPHERS**

"From a drop of water to the expanse of the solar system and beyond, this book reveals an unseen harmony pervading the natural world."

MARK VIDLER AND CATHERINE YOUNG,
AUTHORS OF *SACRED GEOMETRY OF THE EARTH*

"John Oscar Lieben has developed a simple framework with which to view the whole world of geometric formation and proportion. His visual language maintains wholeness while giving detailed examples in architecture, musical proportion, the human form, cosmic time, and the elements. This art and craft can form sacred images which, like traditional mandalas and yantras, find a balanced order in the world."

RICHARD HEATH, AUTHOR OF
THE HARMONIC ORIGINS OF THE WORLD,
SACRED NUMBER AND THE ORIGINS OF CIVILIZATION,
AND *MATRIX OF CREATION*

SACRED GEOMETRY
FOR ARTISTS, DREAMERS, AND PHILOSOPHERS
Secrets of Harmonic Creation

JOHN OSCAR LIEBEN

Inner Traditions

Rochester, Vermont

For Mother
May I hold you in memory

———✸———

Inner Traditions
One Park Street
Rochester, Vermont 05767
www.InnerTraditions.com

Library of Congress Cataloging-in-Publication Data
Names: Lieben, John Oscar, author.
Title: Sacred geometry for artists, dreamers, and philosophers : secrets of harmonic creation / John Oscar Lieben.
Description: Rochester, Vermont : Inner Traditions, 2018. | Includes bibliographical references and index.
Identifiers: LCCN 2017044078 (print) | LCCN 2018015692 (e-book) | ISBN 9781620557013 (hardcover) | ISBN 9781620557020 (e-book)
Subjects: LCSH: Cosmology. | Geometry—Miscellanea. | Geometry—Religious aspects. | Music—Miscellanea.
Classification: LCC BF1999 .L3429 2018 (print) | LCC BF1999 (e-book) | DDC 133.3/3—dc23
LC record available at https://lccn.loc.gov/2017044078

Printed and bound in India by Replika Press Pvt. Ltd.

10 9 8 7 6 5 4 3 2 1

Text design by Priscilla Baker and Debbie Glogover and layout by Virginia Scott Bowman
This book was typeset in Garamond Premier Pro with Trajan Pro and Gill Sans used as display typefaces

To send correspondence to the author of this book, mail a first-class letter to the author c/o Inner Traditions • Bear & Company, One Park Street, Rochester, VT 05767, and we will forward the communication.

CONTENTS

INTRODUCTION

⸺ ⚬⚬⚬ ⸺

A Harmony That Structures the Universe

WE ARE IN THE MIDST OF A REVIVAL of an ancient way of looking at the world as an interlocking system of harmonious numbers. The revelations that result from this perception awaken feelings of wonder in those who care about such things. Why should it surprise us that this is the way things are? Marie-Louise von Franz writes in *Number and Time:*

> We have long known that numbers did not always possess the dry-as-dust abstract quality that characterizes them today. Formerly they were not only something "godlike" but possessed—curiously enough—an all-embracing significance. They did not divide but united two worlds.[1]

When we begin to see in this way it becomes clear that the concept of a meaningless universe in which evolution proceeds blindly from random event to random event is a delusion. This new way of seeing is really very old. It has been called *harmonics,* which includes the disciplines of number, geometry, music, and cosmology—the quadrivium of the ancient mystery schools. Of great importance to the ancients was the discovery of the numerical ratios that were the basis of musical intervals. While musicians had intuitively employed these ratios since the beginnings of their art, the practitioners of the harmonic arts realized that such intervals could also be obtained through the integral divisions of the musical string. This discovery of a numerical basis for sensory experience was the beginning of exact science. This science

1

of sound as embodied in the musical scales became the foundation of a musical-numerical conception of nature, which included ideas as diverse as astronomical cycles and the nature of the human soul. The art of geometry was part of this exploration since it could visually portray numbers, just as music could portray them through sound. In the process of their geometric work it became apparent to the harmonicists that the generated forms had symbolic qualities—that is, they could somehow awaken perceptions about higher realities. For example, the circle seemed to have an affinity with universal cycles and with the infinite, and the square with the earthly and the finite. Thus the circle-in-the-square could represent the human being who was seen as an earthly vessel containing a divine essence. This symbolic character of geometry provides a simple way of contemplating complex ideas and processes, and as such it became an indispensable foundation in the training of both artists and philosophers in the ancient world.

Today, as in the past, when architects and designers of spaces who are working with sacred intention wish to place a firm foundation under their work they must turn to the laws of creation, which include the laws that determine cosmic time cycles and the shapes that arise from natural forces. While these laws can be complex, there are simple ways of making use of them, and this is what harmonics offers. The study of harmonics is an entry into a world of cosmic meaning. This ancient art is now rising from the dark sea of the unconscious like a lost continent where once a great, golden civilization flourished. As we unearth the artifacts, we wonder why they should appear now. Is there a reason? Isn't everything random and meaningless as so many of us have been taught? The harmonicist knows that this is untrue, and the reason the mountains are rising from the dark sea is that—it is time. The wheel has turned, the flower is opening, and the Law must be fulfilled.

*

This book demonstrates specific ways of creating harmonious forms using geometry and numbers derived from the musical scale. In this approach we are working with tools that are as ancient as time yet perfectly suited to be impeccable instruments for the creation of new forms. The reader will find that the discipline of harmonics naturally weaves together symbolic form (geometric, numerical, and musical) and the practical. The practical applications, the human creations, will be seen to arise naturally from the energy contained

within primordial number and geometry. This process resonates with nature's way of creation in which complex forms arise from the simple geometric shapes of atomic structures.

I have found that there is a creative matrix in which these energies can interact. I have called this the vesica construction. Its central figure is the vesica, the leaf-shaped product of the intersection of two circles. Most geometers are familiar with the vesica piscis, the vesica that is formed when the two circles intersect each other's centers. The vesica piscis has been an important form generator in sacred geometry. An example of its power is demonstrated in chapter 11 in which it generates the foundational polygons. I have explored some other vesicas, which can take infinite forms ranging from a thin sliver, when its intersecting circles are barely penetrating one another, to wider and wider figures resembling fish and eyes and then to broad figures shaped like fruit until it becomes a single circle as the intersecting circles join and become congruent. While this figure may seem simplistic, it actually has profound symbolic and generative properties. The process of intersection of the vesica-forming circles exactly corresponds to the intersections of waves, which are perhaps the most universal of dynamic processes in nature. The infinite variety of vesica shapes corresponds to the innumerable height-to-width ratios of created beings. And the vesica ratios that we will use are of great interest in their intimate association with tonal ratios. This will be discussed further in chapter 1.

The establishment of the vesica-construction matrix is also described in the first chapter. We should note that almost all the constructions in the book can be made using classical geometry, which is geometry created using only compass and straightedge—that is, without the need for measurement. While this simplifies the drawing process, there are deeper reasons for this restriction. It requires one to proceed one step at a time, building each new part on a previous part. This is the way of nature: from seed to sprout to leaf to flower. The sequence must be followed. One cannot hurry through, and in this process there is room for quiet contemplation that invites the unknown, the new, to enter.

Also in the first chapter we introduce the seed form of our vesica constructions, the circle-in-the-square, a simple form with great generative potential. This is the field, the matrix within which our vesica geometry will be generated. We briefly mention an invaluable technique of generating tonal ratios

from the intersection of the many kinds of diagonals that the square generates. This method is described in appendix 2, drawing A2.2. This technique makes it possible to create a direct correspondence between the vesica and the ratios found on the musical string. Simply put, we have created a harmonic workshop in which we will work for the remainder of the book.

In chapter 2 we journey further into the realm of tone-geometry and how it can be used to reveal connections between the Mayan calendar, an ancient Greek temple of Apollo (whose ground-plan ratio will occur in different contexts throughout the book), and the lunation cycle. Two other themes that will recur throughout the book are introduced: the golden proportion and the tritone interval, the mysterious center of the musical scale. In this chapter we begin to get a sense of the nonrandom nature of cosmic space-time—that there seems to be a musical-geometric harmony that structures the cosmos.

Chapter 3 explores, among other things, the harmony of the Earth-Moon system. The significance of the 366 rotations of the Earth on its yearly voyage around the Sun is noted as well as its relation to the elusive *huang chung* note of the ancient Chinese. This number 366 will play an important role in future chapters. Next, a simple explanation of the formation of a diatonic musical scale is joined with an imaginary dialogue among three ancient masters who are selecting the tonally charged ratios that form the basis of our foot-and-mile measuring system. We will realize that this system reflects the musical structure of cosmic space-time and takes an honored place alongside the ubiquitous decimal metric systems, which have their own virtues but seem somewhat dry when used to describe an enchanted cosmos. Next we use our vesica-tone construction to accurately generate a model of the inner Earth.

Chapter 4 explores the substance of water. Surprisingly, the water-to-land ratio of the Earth generates the same vesica construction as that of the Apollo temple previously mentioned. The shape of the waterdrop is considered and geometrically constructed and compared to certain Neolithic flattened standing-stone circles in Britain. The intersecting vesical pattern formed by raindrops on the surface of a pond is related to the Flower of Life, a symbol of universal creation. An accurate model of the molecule of water is generated from the vesica construction at the interval of the major third. This model becomes the center of a design for a water temple garden.

Chapter 5 demonstrates how the vesica-tone construction can be used to generate the sizes of the inner planets and the Moon in relation to Earth. We take this further and generate pottery shapes from these planetary circles whose sizes are then compared, resulting in several interesting ratios. We briefly look at three leaf forms—perhaps the most ubiquitous vesical shape in nature—and discover their tones. The numerical harmonies between Earth and Sun are noted, and this leads to the drawing of a needle-like vesica, which describes their size relation.

Chapter 6 explores more of the numerical relations in the Earth-Moon-Sun system. We gain a new appreciation for the numbers of the Pythagorean intervals that seem to most accurately generate the synchronicities of the system. Then we look at how the vesica generates octave constructions with which we can draw more harmonious forms. And we demonstrate how tonal spirals can also be generated from the vesica construction, one of which is the ancient spiral of fifths, which includes all the tones of the Pythagorean scale. And a nautilus spiral will be analyzed using a vesica construction.

Chapter 7 describes the harmonic series and covers some essential information such as the arithmetic, geometric, and harmonic mean positions on the musical string that correspond to important ratios within the vesica construction. We briefly consider some tonally based room dimensions used by architects of both Renaissance buildings and nineteenth- and twentieth-century concert halls. The layout of a ground plan of a building is generated from a vesica-harmonic construction at the minor-third interval. We show how this interval symmetrically divides the scale and how it is intimately involved with phi (ϕ), the golden ratio.

Chapter 8 considers the resonance principle and how it can be included in the vesica construction. The two-from-one and the one-from-two creation principles are compared. A geometric-mythic creation story about the Birth of the Moon is constructed from thirteen drawings. We examine the principle of the intersection of energies using a crossed-vesica construction overlaid on a Greek sculpture and a medieval cathedral. A ground plan of a building is constructed using a similar method. We analyze a crossed-polygon drawing by the sixteenth-century master Giordano Bruno. A harmonious pottery figure is then constructed using the crossed-polygon principle.

Chapter 9 explains how the principle of correspondence when validated by harmonious number becomes a welcome simplification of complex knowledge. Examples of this principle are discovered in the Sun-Earth-Moon system. We note a biblical validation for the association of the interval of the third and water, whose molecule we have already generated from the third vesica construction. This information will be of use in chapter 10. We assign a cosmic number to the Great Central Sun of esoteric lore and proceed to generate harmonies that relate the ring shape of the inner Earth to the orbit of the solar system around the galactic core. The ground plan for a Galactic Temple is created using an asymmetrical crossed-vesica construction.

Chapter 10 is a study of cosmic time drawn from Carl Calleman's elucidation of the Mayan calendar. The numbers of the Earth-Moon system when correlated to the 16.4-billion-year Mayan cosmic history are found to agree with the findings of modern science. A pre-big-bang period also results from this analysis; its existence is hypothesized by modern cosmology and is part of aboriginal myth. Some of the numbers that describe this cosmic history are the same as we have seen in our Earth-Moon studies as well as in our analysis of the Apollo temple in Greece. We construct several drawings showing the musical and lunar aspects of the calendar. Another drawing shows a Tree of Time with its roots in the pre-big-bang, or Dreamtime, period of cosmic history. Using the particular vesica shape, which embodies the progression of the calendar, we design the ground plan of a Ship of Time Temple. We find correspondences between the calendar as a whole, the 5,125-year Long Count section of the calendar, and the *tzolkin* ritual year of 260 days.

Chapter 11 takes us on a journey into sacred cosmology, into regions where the only guides are number, geometry, tone, and imagination. We realize that the tools of the ancient harmonicists are still fresh and new. We see how—by means of our symbolic polygonal imagery—spirit, consciousness, life, and time emerge from the universal field. We further explore the Dreamtime, mentioned in chapter 10. We introduce the idea of ceremony, which is simply another means of exploration of the regions of experience closed to reductionist science.

Appendix 1 follows the example of the ancients who were naturally led by their study of harmonics to create sacred spaces, the temples in which ceremonies of invocation and thanksgiving were conducted. Five examples of ceremonies are

the subjects of this appendix. Our simplified approach is to generate, using circles and lines, symbols of Earth, Moon, water, Sun, and cosmic time. These are large drawings made on the ground or in a large room. The dimensions of the drawings accurately correspond to the realities they symbolize. Within these five drawings, whose construction we demonstrate step-by-step, ceremonies can take place. We include instructions for creating sacred space and suggestions for guided journeys, and so forth. These are ceremonies of honoring, of thanksgiving, and of purification, and while the geometry itself is fixed, the conduct of each ceremony is open to the interpretation of facilitators and participants.

Appendix 2 covers a variety of architectural techniques and historical practices, a technique for laying out a book page and designing typefaces, a discussion of the tonal content of the Fibonacci series, the construction of ellipses from vesicas, harmonic analyses of ancient sculpture and temples, tonal qualities of the moon's phases, and other material related to harmonic form and the vesica.

1

THE FIELD OF HARMONY

Our inquiry begins with the construction of a primal form: the circle-in-the-square. This simple shape is a source of innumerable forms, and its two elements can represent the polar opposites of mind and spirit or the finite and the infinite. The circle, symbolizing spirit, with its unknowable (because irrational) π circumference, is the first of the two forms to appear. We can imagine that it radiates from its center point of zero dimension, recalling the modern creation myth of the origin of the Universe from an infinitesimal singularity.

From the circle, symbol of primal unity, the enclosing square is generated. With its rational and thus measurable sides, each of which equals the circle diameter, the square is symbolic of reason and understanding. In enclosing the circle within the square we are symbolically attempting to understand, to bring within the realm of reason, that which can never be fully known. This attempt is amplified when we try to "square the circle"—that is, to construct, using only compass and straightedge, a circle and a square with equal perimeters or equal areas. The ancient practitioners who attempted circle squaring knew the resonant power of symbols, the true language of the unconscious. They believed that the symbol of the squared circle, which represents a congruence of mind and spirit, might, when perceived by the unconscious, help to manifest the symbolized unity in ordinary reality. The geometers were able to come very close to squaring the circle. But an exact circle squaring has, in modern times,

been shown to be impossible—a meaningful discovery, which demonstrates our limits in our quest for unity with the divine: there will always be realms that are unreachable.

The present approach to geometric construction can begin with a straight line that is bisected using compass, straightedge, and scriber (drawing 1.1 [1] and [2]). The process also generates, as a kind of side effect, the vesica piscis mentioned in the introduction. Our purpose, however, is to construct the circle-in-the-square using these same classical tools of compass and straightedge and scriber. Those persons who would rather use a computer drawing program can maintain the purity of the classical method by proceeding one step at a time with circles and straight lines and letting each step be guided by the previous step—that is, by not simply measuring out figures but letting the inherent properties of one stage lead to the next stage such as we demonstrate in drawings 1 and 2.

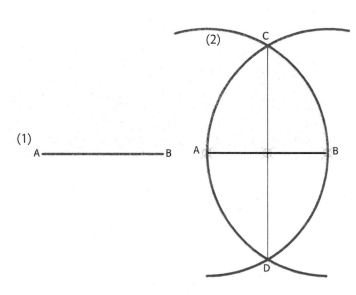

Drawing 1.1. *(1) The first steps in generating the primal form of the circle-in-the-square. Draw a line that will be the diameter of the circle. (2) Bisect the line with a vesica piscis, establishing a circle center and also the length of the radius.*

Drawing 1.2. *(1) After drawing the initial circle, draw (2) four circles with the same diameter as the circle in (1) with centers at the ends of the crossing diameters. The intersecting points of these four circles give us the corners of the enclosing square. Draw lines from these points to make the surrounding square.*

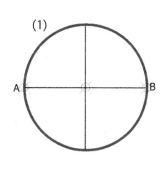

THE RING FORM

The circle within a circle—the primal wave pattern symbolizing rhythmic temporal expansion or, in space, a vessel holding an essence—is the *ring* form, which exists throughout material and nonmaterial nature. It is the cell with its nucleus, the outer layers and core of celestial bodies, the orbits of planets around the Sun, the flesh and stone of a fruit. The ring symbol connects diverse phenomena—of all shapes. The classic temple, though generally a rectangle, is also a ring with its outer corridors protecting the inner sanctum in a manner similar to the way the outer bodies of animals protect their vital inner organs.

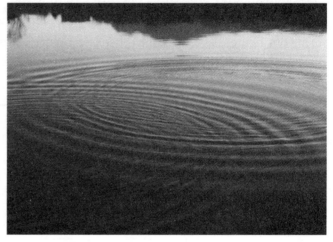

Figure 1A. *"The voice is moved in an infinite number of undulating circles similar to those generated in standing water if a stone is cast into it, when we see innumerable rings spreading forth from the center and traveling out as far as they possibly can. . . ." wrote Vitruvius.*[1] *Here two stones cast into a pond generate with their ripples the form of the vesica, a two-dimensional symbol of the intersection of radiant energies in the three-dimensional world.*

In nature it is common for the ring shape to be expanded to include several rings—a nesting of circles or other shapes. Thus, the inner Earth and the atmosphere consist of regions arranged in concentric layers. The human body consists of skin, muscle, fascia, and so forth, which protect and nourish the organs. Furthermore, it is believed that there are energetic rings surrounding the physical body—such as the subtle etheric and mental bodies—which correspond to the layers of atmosphere and magnetism surrounding the Earth. Figure 1B shows a few examples of the ring form in nature and art that, again, are a reminder of the universal occurrence of this form whose simplest expression are the rings spreading out from a raindrop falling into water. The geometer works with this idea of rings but in a context of harmony unaffected by the environmental factors of the physical world that tend to distort the purity of primal form. As we will see below, there are ring structures that we may generate with the vesica construction in which the relations among the rings are highly harmonious.

THE VESICA-TONE CONSTRUCTION

As an introduction to the vesica form, I present an example that shows how this form reveals the way we see the world. When a person stands on the edge of the sea, the horizon is about three miles away. Imagine a second person standing in a rowboat that is floating on the first person's horizon. We can affirm that the circle of perception of both persons combined is about six miles in diameter. Furthermore their circles of perception intersect one another, forming a common vesica-shaped space (see drawing 1.3 on p. 12). The name for this particular vesica is the *vesica piscis,* formed when two circles intersect one another at their centers. Now let us imagine that the person in the rowboat begins rowing toward the person on the shore. The size of their circles of perception remain the same, but they begin to overlap one another more and more deeply. The vesica grows wider and wider as its shape traverses innumerable height-to-width ratios until the boat reaches the shore and the persons come together. Their two circles of perception have joined with the vesica, which has expanded into a circle; the three elements have become a single circle.

So, generally speaking, when we look at another person we are joined to them within a perceptual vesica whose size and shape depends on the distance we are from them. (This applies also to objects that we can imagine being sentient and having circles of perception.) But what is interesting for the present study is the tonal aspect of this phenomenon. If we imagine a straight line between our shore person and the rowboat person, this line can represent a stretched musical string. Now, as the rowboat person rows toward the shore person, tones are being sounded along the musical string. This is the basic idea behind the vesica constructions shown in drawings 1.4 and 1.5 on pages 13 and 14, respectively.

We begin with our circle-in-the-square. The horizontal diameter of the circle becomes our musical string. We now need to locate the points on the string that correspond to musical intervals. We note here the requirement for a number to be usable as a musical tone: it must be a fraction composed of whole numbers. An irrational number cannot be used as a tonal number for the simple reason that it cannot be exactly located on the musical string. To find a tone on the string we decide on a ratio, say 2/3, and measure out a one-third segment leaving a two-thirds segment. Then we place a stop (such as a finger) at the 2/3 point and pluck the 2/3 length. In this case we have sounded the interval of the musical

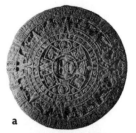

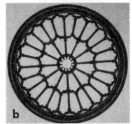

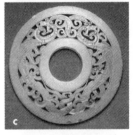

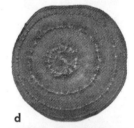

Figure 1B. *Five rings both man-made and natural: (a) Aztec calendar stone; (b) rose window of Notre Dame de Paris; (c) Chinese pi disc; (d) cross section of a beet; (e) water ripples in a tide pool.*

11

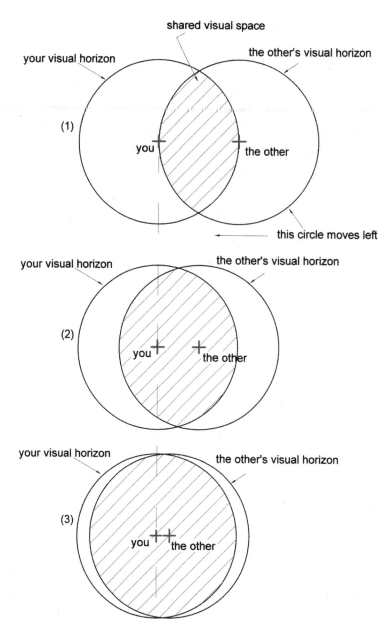

Drawing 1.3. *As described in the text the vesical shape encloses the shared visually perceived space between a person standing on the shore and another person standing in a rowboat on the horizon (1). In (2) and (3) the other can be imagined to be rowing a boat toward the shore and in so doing altering the shape of the shared vesica. Thus we see a geometric connection between the psychic-numeric tools that determine the way we perceive and the vesica. In other words we live and move in circular space bordered by the horizon. Other beings move in and out of our circle, and our spatial relationship to them can be expressed in ideal terms—that is, as vesical geometry that reveals that the visual space we have in common has a vesica shape that widens or narrows as we approach or recede from one another.*

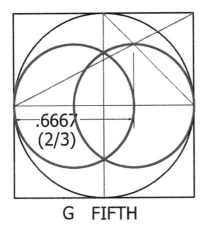

.6667
(2/3)

G FIFTH

Drawing 1.4. *The interval of
the fifth on the string/diameter
is generated from crossed
diagonals.*

fifth in relation to the open string, considered to be the fundamental (if we had plucked the 1/3 length, an *octave* fifth would have sounded). See drawing A2.2 on page 200 for a description of the technique of diagonal crossings.

Yet we would prefer, at least in our geometrical drawings, to locate tonal nodes without resorting to measurements or as few as possible. One important use of measurements that is employed in this book is to identify the ratio of the points on the string/diameter that are generated from the crossed diagonals. These points create rational divisions of the string/diameter, which, interestingly, are generated from irrational diagonals that are themselves generated from rational divisions of the sides of the square. We might say that the rational in the form of simple numbers applied to the sides of the square is transmuted in the cauldron of the irrational, in the form of crossed diagonals, into a new kind of rational number—namely, the numbers of the musical intervals. With the present method we can use the numerous crossings of the great variety of diagonals within the square as tools to locate our tonal nodes on the string/diameter of the circle in the square. The crossing of two diagonals locates a point, which, when a perpendicular from it is dropped to the string, locates a tonal node (see drawing 1.4). The diagrams in drawing 1.5 (p. 14) locate some of the tones of a common just-tuned scale using this method.

Let us now consider how the vesica itself is generated. It is instructive to consider this geometric construction as a symbolic enactment of cosmic process. This imaginative way of seeing is actually one of the principal virtues of sacred geometry. Thus, the original circle can be seen as the field of creation waiting for the initiating impulse. At the center of the circle is the primordial point from which

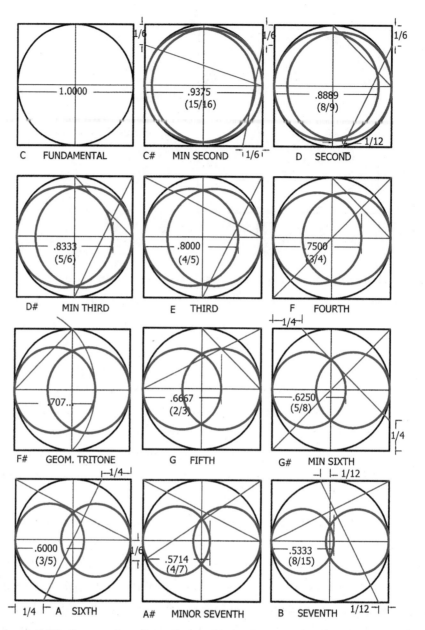

*Figure 1C. Cells
doubling during
mitosis. The implied
vesica between the
daughter cells is
symbolically moving
through all the tones
from the fundamental
at the single cell
position to the final
separation when
the octave will be
sounded.*

Drawing 1.5. *The intersection of two diagonal lines that originate from integral division points of the containing square result in crossing nodes that, when a perpendicular is dropped to the main diameter or musical string, divide the string into rational or musical segments. When this diameter point is mirrored on the opposite side of the vertical axis and circles are drawn through these two points, a vesica is formed that can then be associated with the tone generated from the original intersection of diagonals. In this drawing twelve vesica-tone constructions created from various diagonals within the square result in a twelve-tone scale. The geometric tritone, the center of the scale, is an exception: being an irrational quantity, it is generated by a circle arc. This crossing of diagonals within the square is the beginning gesture that we will use to generate the vesica constructions throughout the book. (For the vesica ratios and other properties see drawing A2.1, p. 199.)*

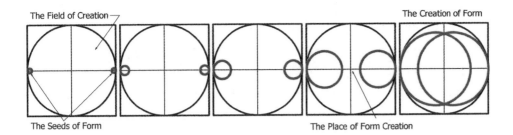

The Field of Creation

The Creation of Form

The Seeds of Form

The Place of Form Creation

Drawing 1.6. *The creation of form as symbolized by the intersection of waves and the resulting vesica, the symbol of form. This drawing might be considered as a preview of the separating cells in figure 1C: the male and female pronuclei join to form the first cell, then, as in 1C, they begin separating into two.*

the circular field was generated. Being at the halfway point of the string/diameter, it is tonally at the octave position of the whole string—that is, at the first octave. On either side, from center to diameter end, are innumerable tonal positions whose pitches become higher as they approach the ends.

Now let us imagine a very high vibration beginning at each end that causes circular waves to begin rippling through the medium of the circular field. When the waves impinge on the string/diameter they cause a tone to issue from the string. So, as the wave front grows and moves along the string, a descending glissando of tones is sounded (or really a *unison* of the glissando, because there are *two* wave fronts, each moving from its pole toward the center). The waves have a destination represented by the central vertical diameter. This is the portal into the 2/1 ratio, the first octave, the place where the intersection of the two waves takes place and the series of vesicas begin. During this process we can accurately state that all tones are being produced. But now we decide that we only need a few of these tones for the scale we are building. Let us stop the process at, for example, 2/3 of the whole string length. We have noted above how geometrically we can find the 2/3 node on the string—with diagonals that connect integer nodes on the perimeter of the square. We now have an example of the symbolic purpose of the square that we have constructed around the circle. It is a workshop, a laboratory within which the transcendent circle may be studied and transmuted into a source of harmonious form. The tools that are employed are the diagonals and their generated points and numbers.

*

As we have noted, the crossings of these various diagonals of the square generate tonal nodes, places where the wave fronts, expanding from the equator ends,

Figure 1D. *The ancient harmonicists used a device called a monochord that consisted of one or more strings stretched across a sounding board on which measurements could be made. On the monochord they could locate numerical ratios and hear them by stopping the string at the measured point and plucking it to sound the tone. Above, a three-string monochord.*

can be stopped and where the musical string can then be plucked to produce our geometrically derived tones. The node, in this case the 2/3 or musical interval of the fifth, is now sounded, and the vibrational wave of sound expands through the circular field until it is stopped at the limit of the field. This process takes place simultaneously on both sides of the vertical axis and generates a central vesica, a new form composed of circle arcs arising within an environment formerly dominated by circles and straight lines. Each vesica is unique with its own height-to-width ratio, its own ring structure, and its own tone, its song. A vesica can assume an innumerable variety of shapes, from the slenderest of grasslike forms to forms of near-circular fullness. The shape of the vesica depends on its tone, which corresponds to the point on the string/diameter where we have stopped the string.

*

The first octave, the place where the vesica takes form, could be called the realm of physical reality, of three-dimensional space, two dimensions of which, height and width, contain the geometry of the vesica. The third, depth, is suggested to the imagination but has no place in this symbolic geometry, because to include it would defeat this geometry's purpose: the simplification of the overwhelming complexity of the world.

We recall that outside the central octave are higher octaves—that is, tonal positions on each side of the central octave. The circles of these higher octaves, in our present conception, have not yet "taken form" by entering the realm of the vesica by joining with their mirrors—that is, intersecting with their corresponding circles on the other side of the vertical axis representing the main octave. They exist as pure moving energy until they cross the threshold into form. They are represented by the growing circles that emanate from the diameter ends of the containing circle.

There is another interesting feature of the vesica construction. We note that there is an implied inner circle within the vesica and an implied circle that encloses the vesica (see drawing 1.7). The inner circle we will call C_4, the outer circle C_3, and the enclosing circle that is circumscribed by the containing square we will call C_1. The two vesica-forming circles we will call C_2. A striking property of vesica constructions is the geometric proportion that exists among the diameters of the nested circles:

$$C_1 : C_3 :: C_3 : C_4.$$

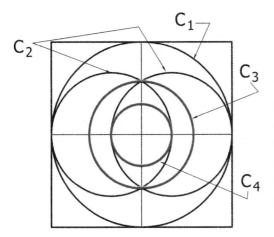

Drawing 1.7. *The circles of the vesica construction: C_1, the enclosing circle; C_2, the two vesica-forming circles; C_3, the circle that encloses the vesica; C_4, the circle that is enclosed by the vesica.*

In demonstration of this fact let us look more closely at the details of our vesica construction of the musical fifth (drawing 1.4). Given our circle in the square, whose construction is shown in drawings 1.1 and 1.2, we use the crossing of quarter-square and double-square diagonals to locate a tonal node on the circle diameter. We bisect the distance between this node and the farther diameter end to give us a center for our vesica-forming circle (C_2). This circle is mirrored on the opposite side resulting in a vesica, in this case a vesica piscis, generated from two circles, each of which intersects the other's center. With this vesica piscis generated by the vesica construction at the interval of the fifth the diameter proportion of the implied vesica rings is

$C_1 : C_3 :: C_3 : C_4$ = the irrational value of $\sqrt{3}$, or 1.732 . . . , which is the ratio of the inner diagonal between opposite corners of a cube to its side and also the distance between parallel sides of the hexagon.

It becomes apparent that the limitless variety of vesica constructions make available to us a wealth of proportional ring structures that are expressions of geometric and tonal realities. These ideal structures do not exist in a vacuum but instead correspond to the ubiquitous ring structures of organic and cosmic forms that underlie the natural world.

TONE

Tonal quantities are expressed as ratios composed of whole-number fractions of the string length, such as 2/3 for the fifth interval or 4/5 for the third. The inverse of these fractions—that is, 3/2 and 5/4—are the *frequency* ratios, the

rate of vibrations of the string in relation to the vibration rate of the fundamental or open string, which is designated as 1/1. The octave, with frequency 2/1 at the center of the string, is the beginning point from which the series of vesicas unfold. The octave represents the principle of doubling that we encounter in most if not all life processes. The series 1, 2, 4, 8, 16, 32, 64, 128, 256, 512, and so forth, is an octave or doubling progression embedded in natural growth processes. The single egg or cell when activated divides into two; then the two become four, and so on. So the octave, the doubling of the fundamental tone, corresponds to this universal doubling gesture.

While it has been noted that the octave, fifth, and third have been present in musical scales throughout time and across cultures, there is an even firmer foundation for these and for the other intervals to be present in the harmonicists' toolbox. This foundation is contained in the harmonic series in which all the intervals of the scale are present. Following is a simplified description.

> An object when struck will vibrate in many different frequencies. The musical string is the model for this phenomenon because of its simplicity and minimum of distorting factors such as shape, size, and material composition. An open musical string will vibrate as a single whole but also simultaneously in two parts, three parts, four parts, five parts, and so on, in theory, to infinity. While this complex vibration is going on all the harmonics are being sounded with decreasing volume in higher and higher octaves. To draw on the tones within the harmonic series when constructing a scale or generating a vesica construction is thus a "lawful" way to proceed, since we are drawing on ratios which are embedded in the vibratory nature of existence.

In the following table we choose the first harmonic to be in the key of C—that is, the fundamental is the C tone that, because it is the tone sounded by our open musical string, has a ratio of 1/1. The second harmonic, with ratio 1/2, divides the string in two, sounding an octave of the fundamental. The third harmonic divides the string into thirds, sounding a fifth (1/3 is the octave of the 2/3 fifth interval and is multiplied by 2 to bring it into the main octave), and so on. The first nineteen harmonics generate the tones (less one) of the standard scale. Some are exact just-intonation tones, while others are close approximations. We have to jump to the twenty-seventh harmonic to find the final tone of the chromatic scale, the major sixth interval. This

happens to be the Pythagorean sixth with ratio 16/27 (.5925), quite close to the just sixth of 3/5 (.60) ratio.

Tones	Harmonics	Same Octave
1—fundamental (c)	1/1	1
2—first octave (c')	1/2	1/2 (.50)
3—fifth (g')	1/3	2/3 (.6667)
4—second octave (c'')	1/4	1/2 (.50)
5—major third (e'')	1/5	4/5 (.80)
6—fifth (g'')	1/6	2/3 (.6667)
7—minor seventh (a♯'')	1/7	4/7 (.5714)
8—third octave (c''')	1/8	1/2 (.50)
9—major second (d''')	1/9	8/9 (.8889)
10—major third (e''')	1/10	4/5 (.80)
11—tritone (f♯''''ˇ)	1/11	8/11 (.7272)
12—fifth (g''')	1/12	2/3 (.6667)
13—minor sixth (g♯'''ˆ)	1/13	8/13 (.6153)
14—minor seventh (a♯''''ˇ)	1/14	4/7 (.5714)
15—major seventh (b''')	1/15	8/15 (.5333)
16—fourth octave (c'''')	1/16	1/2 (.50)
17—minor second (c♯''''ˇ)	1/17	16/17 (.9412)
18—major second (d'''')	1/18	8/9 (.8889)
19—minor third (d♯''''ˇ)	1/19	16/19 (.8421)
. . .		
27—sixth (a''''ˆ)	1/27	16/27 (.5925)

For clarity we have, through successive multiplications by 2, reduced the increasingly higher harmonics into the main octave—that is, between ½ and 1. For example, $1/14 \times 2 = 1/7$; $1/7 \times 2 = 2/7$; $2/7 \times 2 = 4/7$, the minor seventh in the main octave. Because the harmonics do not always exactly correspond to the ideal ratios the little arrows next to some of the octave tics indicate such discrepancies: up arrow means the tone is sharp of exact tuning; down arrow means the tone is flat.

2

THE GEOMETRY OF TIME

IT IS DIFFICULT TO ESTABLISH AND MAINTAIN a standard for spatial measure in the material world. Even if a physical standard is established, sculpted into shape, and enshrined in a golden box there is always the chance (or inevitability) that it will be lost in the clash of civilizations or disintegrated by time. Yet time is measured with numbers that are more or less fixed and thus offers a nonarbitrary source of numbers and, as we shall see, highly meaningful ways to approach the measurement of space. For example, the lunar diameter of 2,160 miles may have been assigned its length by unknown astronomers because of the fact that the length of a precessional age is 2,160 years.

A supporting synchronicity is the fact that the lunation cycle of new moon to new moon is 29.53 days, and the lunar orbital period, which is the period of one orbit of the Moon in relation to the fixed stars, is 27.32 days. The quotient of these two cycles, 29.53 ÷ 27.32, is 1.08, which also refers to 2,160, the Moon diameter, since 2,160 ÷ 2 = 1,080, the radius of the Moon in miles. These few examples suggest that the dimensions and the time cycles of the Moon may be meaningful—that is, *they do not consist of random numbers* but instead are part of an interconnected numerical *system*.

*

Continuing with the lunar-time properties we note that there are 12.36 lunations within a year of 365 days. Here we encounter the golden number, phi, or

φ (1.618 . . .), since 2/φ = 1.236. Thus there are exactly 20/φ lunations of 29.53 days in a year of 365 days:

$$20/φ × \text{lunation of 29.53 days} = 365 \text{ days, since } 20 ÷ 1.618 = 12.36,$$
$$\text{and } 12.36 × 29.53 = 365 \text{ days.}$$

Furthermore, we note that the diameter relation in miles of Earth to Moon is 7,920/2,160, which equals 3.66 (11/3). (We here use the ancient canonical value of the Earth diameter as opposed to the modern measure of 7,926 miles.) So the Moon diameter is exactly 3/11 (1/3.666) that of Earth's diameter. And 366 is also an important time number, being the number of *revolutions* of Earth on its axis in one year. (Here we have a congruence of a space number and a time number, a synchronicity that should alert us to its importance. Later we will see this number in its roles as both a tonal frequency and a number embedded in cosmic evolution.)

*

Let us briefly look at these values in a tonal context. The ratio 3/11 (.2727) is the octave above the tone 6/11 (.5455), known as the *neutral seventh*. We rarely encounter 11-based or undecimal tones in the Western scale except in modern avant-garde work such as that of Harry Partch, although Arabic composers have traditionally used these ratios. In the harmonic series 11 is the number of the undecimal tritone of 8/11 (.7273), a ratio that is the third octave of the 1/11 (.0909) harmonic node. Eleven is a key number in ancient canons of proportion. For example, it divides an even 720 (an important highly composite number) times into 7,920, the value of Earth's diameter. Eleven is the number that relates the diameter sizes of Earth and Jupiter (see drawing 2.1 on p. 22). Along with the number 7, also rare in Western music, the number 11 and its multiples were important calculating tools for the ancient builders. The ratio 22/7, for example, is a good approximation of π. The ratio 11/14 approximates the area of a circle with diameter equal to 1. The ratio 21/11 (1.91) is the volume ratio of a cube to its inscribed sphere, whose diameter equals 1. The 7/11 (.6364, an *undecimal augmented fifth*) tone generates a vesica construction that accurately reveals the relative sizes of the moon (the C_4 circle), the Earth circle (C_1), and an approximation of the size of Mars (the C_3 circle) as shown in drawing 2.2 (p. 22). Another coincidence involving the number 11 is that the difference between the 365-day year and twelve lunations (354 days) equals eleven days—as if pointing us toward this key number in Earth-Moon relations.

Owing to the difference between solar and sidereal time, the Earth rotates upon its axis 366 times in a year of 365 days. Earth completes a revolution on its axis in 23 hours and 56 minutes. This is the sidereal day, the time that the stars appear to complete one revolution around the Earth. At the same time, the Earth advances about a degree eastward on its orbit around the Sun as it turns eastward around its axis. The same meridian that was found at noon on one day on the next day is 1/365 behind. Thus the Earth performs one complete rotation on its axis plus the 365th part of a rotation every day. Therefore in 365 days the Earth turns 366 times on its axis. And so there are 366 sidereal days in a year.

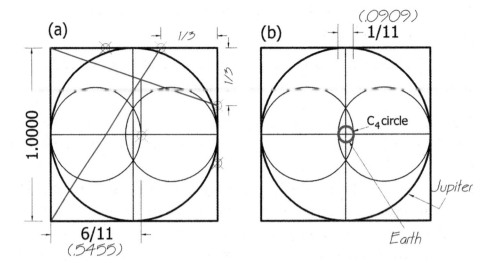

Drawing 2.1. *(a) Crossed diagonals from two corners to adjacent 1/3 points on the perimeter of the square generate the 6/11 tone. This is the octave of the Moon tone of 3/11, whose diameter in relation to the Earth diameter is 3:11. (b) This tone generates a C_4 circle whose diameter is 1/11 of that of the enclosing circle. The ratio 1/11 is the diameter ratio of Earth to Jupiter.*

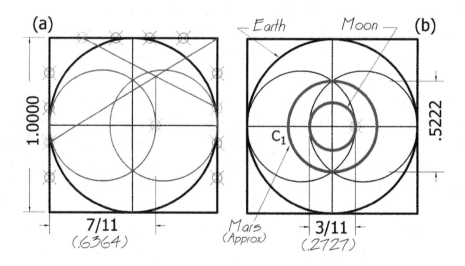

Drawing 2.2. *(a) The 7/11 tone is generated from diagonals originating from points that divide the perimeter lines of the square into five parts. (b) The area of the inner vesica circle in relation to the C_1 enclosing circle area is in the precise Moon-Earth ratio of 3/11. The circle that encloses the vesica is quite close to the relative size of Mars, whose diameter equals 4,221 miles. The circle in this drawing has a relative diameter of 4,136 miles. Thus 4136/4221 = .98—that is, the Mars circle is 98 percent accurate. The ratio of the vesica = 1.9149 = $\sqrt{3.666}$, with 3.666 = 11/3.*

THE CENTER OF TIME

Ancient calendar makers were faced with the obstacle of the incommensurability of the month and the year. But, as we have seen with the 20/ϕ relation of lunar to solar year, there is an underlying pattern or meaning in this discrepancy. It may be that the Maya discovered this pattern, and it was a factor in their development of their vigesimal system of numeration based on the number 20 as opposed to our base 10 decimal system.

One of the most important time periods for the Maya was the *uinal,* a period of 20 days. Thirteen uinals equaled a *tzolkin,* the Mayan ritual year of 260 days. For our present discussion, the tzolkin is of interest in that it marks the very center of the year-as-scale.

Like many ancient cultures the Maya were concerned with locating the center of the cosmos. It is believed that the northern peoples, from whom the Maya were descended, considered the North Star to be the cosmic center. Ancestors of the Maya continued this belief even as they migrated south. Yet in southern Mexico and Central America where they settled this belief was no longer relevant, because the polestar had long since moved from its place overhead to an insignificant place near the horizon. According to John Major Jenkins, the Maya somehow located the Galactic Center in the region of the Dark Rift of the Milky Way and realized, long before our culture made the same discovery, that they had found the true center of the cosmos.

The Mayan tzolkin of 260 days also designated a center—the *tonal* center of the year. We know that the center of the musical scale is not the *arithmetic* mean or average between fundamental and octave but rather is located at the *geometric* mean. The arithmetic mean of the string length would be the fundamental plus the octave divided by 2:

$$1 + \tfrac{1}{2} \div 2 = 3/4,$$

which is the interval of the fourth. The tone that resides at the tonal center is called the *tritone.* The formula for locating this tonal center at the geometric mean is to take the square root of the fundamental times the octave string lengths, or

$$\sqrt{(1 \times \tfrac{1}{2})} = .707 \ldots ,$$

which is an irrational quantity.

23

As we noted earlier, to have an actual tone that can be located on a string we must have a rational fraction. There are many tritones that have been used as approximations to .707 . . . ; 5/7 is one of these and has a decimal value of .7142, which, when multiplied by 365 days, equals 260⅝, quite close to the 260-day tzolkin. A nearly identical tritone value of 52/73 (.712) produces an exact tzolkin period:

$$52/73 \times 365 \text{ days} = 260 \text{ days},$$

and may have been used by the Maya because of the important time numbers of which it is composed.

The Mayan Calendar Round of 18,980 days is the period in which the seasonal year of 365 days (the *haab*) and the tzolkin are synchronized:

$$18,980 \text{ days} \div 52 = 365 \text{ days (haab)};$$
$$18,980 \text{ days} \div 73 = 260 \text{ days (tzolkin)}.$$

This 52/73 ratio also relates the diameters of the Moon and Mercury:

$$2,160 \text{ miles (Moon)} / 3,032 \text{ miles (Mercury)} = 52/73.$$

THE TRITONE

Strictly speaking, the tritone interval is composed of three whole tones. Thus a three-tone interval between any two tones is a tritone. For simplicity we will consider the tritone to be the interval that joins the fundamental and the tonal center of the scale—for example, C and F♯. The tritone is considered to be the most dissonant interval and has often been shunned by composers, most notably by certain medieval authorities who called it the *diabolus in musica,* the "devil in music." These circumstances somehow reflect the fact that a true tritone, the actual tonal center, is unreachable because of its irrational nature. And because of this, an even integral bisection of the scale and thus of the whole tone that straddles the center is impossible. This situation is said to have disturbed the ancient Greek harmonicists for whom the scale was an essential tool of their highly rational harmonic science. We can compare this to the equally perplexing situation of the irrational diagonal of the square. The Kabbalist Leonora Leet offers a perspective on this problem.

It was the incommensurability of the diagonal to the side that was the great secret the Pythagorean initiate was vowed to keep, not, as generally taught,

"The use in Indian music of the augmented fourth, or tritone, at the critical times of midnight and midday reminds us of the magical importance attached to those hours, and of the use of the tritone (diabolus in musica) by Western musicians for the representation of magic, which is nothing other than the possible intersection, at certain critical hours, of worlds that cannot normally communicate."

—ALAIN DANIÉLOU[1]

24

because this fact destroys the rationality of Pythagorean geometry, but precisely because it is a revelation of the vital necessity of the suprarational, infinite element in all finite structures that the square root contains a power whose nature is, in truth, unutterable in terms of finite measure and that points to the deepest of cosmic mysteries.[2]

The same idea can be applied to the incommensurable tritone that lies at the heart of the mystery embodied by the scale of tones that joins two worlds—the rational world of number (quantity) and the unconscious realm wherein sound gives birth to feeling (quality). The tritone seems to point us toward the sacred center where the gods reside. In this context we recall the previously discussed ring structure in which an outer ring holds an inner essence. The central tritone could be considered the unknowable core of the scale surrounded by concentric rings of tones.

The region of the tritone, situated between the harmonious intervals of the fourth and the fifth, has been the source of various rational approximations

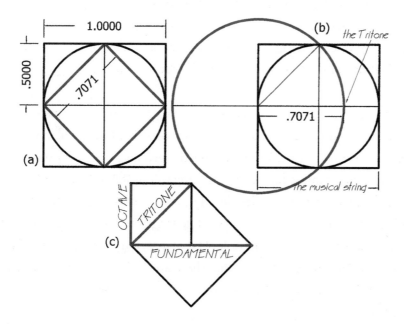

Drawing 2.3. *(a) We inscribe a square in a circle. The quarter square diagonal = .7071 . . . , which generates a circle (b) that intersects the musical string at the tritone. In (c) we see how the tritone and diagonal of the square are related: the tritone-diagonal is the catalyst of the octave-doubling process similar to space doubling: the large square area is twice that of the small square: as the fundamental is twice the string-length of the octave.*

throughout history since, as we have noted, the actual tonal center at string length .707 . . . (√2 ÷ 2) cannot, because of its irrational nature, be exactly located on the musical string but must be approximated by a rational fraction. Clustered around the irrational .707. . . are 8/11 (.7273), the tritone derived from the harmonic series; 5/7 (.7143), an ancient tritone (Ptolemy, Mersenne); 729/1,024 (.7119), Arabic; 32/45 (.7111) (Ptolemy), the most commonly used tritone in modern tuning; 45/64 (.7031), the inversion of 32/45; 17/24 (.7083), Arabic; 7/10 (.70), Euler's tritone ; 52/73 (.7123), the Mayan tritone, discussed above; and 512/729 (.7023), the Pythagorean tritone. Though seemingly unwieldy the Pythagorean tritone simply consists of three whole tones added together:

$$8/9 \times 8/9 \times 8/9 = 512/729 \text{ (.7023).}$$

(To add intervals multiply their ratios; to subtract one from another divide them.)

HARMONIOUS RECTANGLES

The Pythagorean tritone vesica construction may have been the initiating geometry of the ground plan of the temple of Apollo Epikourios at Bassai, Greece, thought to have been designed by Iktinos, the architect of the Parthenon. We have a dual purpose in choosing this temple as our subject.

Figure 2A. *The temple of Apollo Epikourios at Bassai, Greece, fifth century BCE*

The first purpose is to show a practical use of the tone-vesica construction; the second is to explain several of the harmonies contained in the plan of this temple that are revealed in the numbers and the geometric analysis of the ground plan. The Apollo temple has an overall dimension of 130.8 × 52.919 feet measured at the *euthynteria,* the first leveling course that slightly protrudes from beneath the bottom step of the temple. The length-to-width ratio is thus 2.472, which equals 4/φ, a ratio we have looked at previously in relation to its time properties, which include the fact that there are 12.36 lunations in a year (that is, 365 ÷ 29.53 = 12.36) and 2.472 ÷ 2 = 1.236.

The 4/φ ground plan of the Apollo temple thus embodies a double yearly lunation cycle along with the other interesting properties that this ratio generates.

After the Pythagorean tritone is located on the horizontal axis of the square by means of crossed diagonals (see drawing 2.4), we proceed with the vesica construction that results in the ground plan of the temple. In the detail (drawing 2.5, p. 28) we can better understand the advantage of the geometric method of building layout in creating a unity that would have been impossible if we had simply measured out a "harmonious rectangle." The construction lines themselves indicate the length and width of the temple as well as column placement and the cella borders.

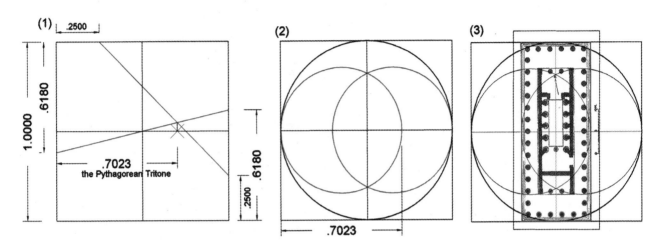

Drawing 2.4. *The ground-plan construction of the temple of Apollo Epikourios at Bassai, Greece. (1) Using diagonals we locate the Pythagorean tritone = 512/729 = .7023 on the string/diameter. (2) A vesica with ratio of 1.572 (√2.472) is constructed. (3) Tangents to the vesica are extended to the enclosing square producing an overall ground-plan rectangle of 2.472 (4/φ) ratio.*

Another tritone we will now consider is the irrational *sharpened tritone* (.691 . . .) that, though it may be approximated with 9/13 (.692) or 38/55 (.6909), we will continue to express as .691 because of certain important associations that this number has. To begin with, .691 is the reciprocal of 1.4472—that is, 1/.691 = 1.4472, and

$$1.4472 = 1 + (1 \div \sqrt{5}).$$

The square root of 5, or 2.236, is the ratio of the diagonal of the double square to its side and is intimately involved with φ:

$$(\sqrt{5} + 1) \div 2 = \phi.$$

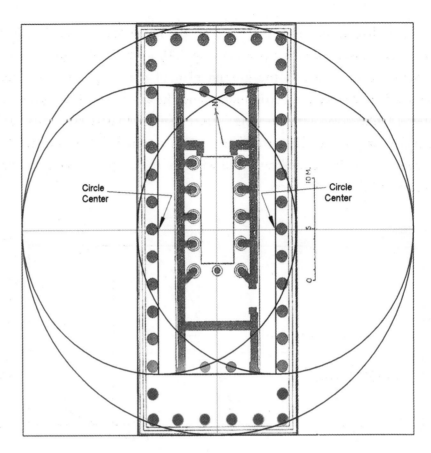

Drawing 2.5. *This detail of drawing 2.4 shows how the lines of the construction coincide with the temple structures.*

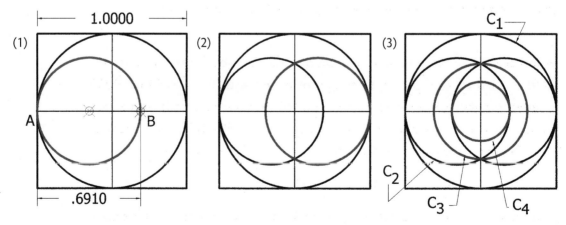

Drawing 2.6. *The ϕ tritone vesica construction. (1) The establishment of the .691 node at B is shown in drawing 2.8 (p. 30). The line AB is bisected and the circle is drawn and mirrored (2) forming a vesica with height-to-width ratio of 1.618, or ϕ. In (3) the interior (C_4) and exterior (C_3) vesica circles are drawn. Their diameters are $C_1 = 1$; $C_2 = .691$; $C_3 = .618$ $(1/\phi)$; and $C_4 = .382$ $(1/\phi^2)$; and their ratio is $C_1/C_3 = C_3/C_4 = 1.618$, or ϕ.*

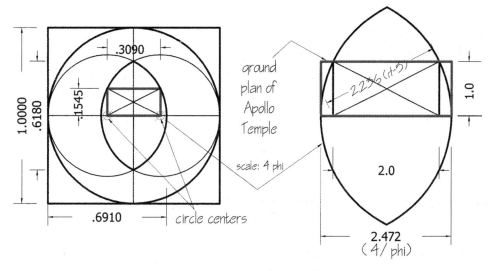

Drawing 2.7. *Another approach to drawing the Apollo temple rectangle. The φ tritone vesica construction (left) perfectly holds the double square that, when its base is extended to the circles (right), produces the 2.472 (4/φ) rectangle.*

There is another Greek temple whose ground plan is based on this sharpened tritone number .691, and that is the famous Parthenon, also designed by Iktinos along with the architect Callicrates. The euthynteria of the Parthenon has dimensions of 238×111.31 feet, resulting in a ratio of 2.138, and

$$2.138 = 1.4472 + .691.$$

The ground plan is thus based on the frequency (1.4472) plus the string length (.691) of our sharpened tritone. Jay Hambidge says of this 1.4472 ratio: "This is the key ratio for the Parthenon plan and appears many times in Greek design."[3] The .691 string-length ratio generates a vesica with a length-to-width ratio of 1.618, or φ, and for this reason we will now refer to .691 as the φ *tritone*. The circles of its vesica construction have the following diameters:

$$C_1 = 1; \ C_2 = .691; \ C_3 = .618 \ (1/φ); \ C_4 = .382 \ (1/φ^2).$$

The construction of the .691 tonal node is shown in drawing 2.8, and the φ vesica construction is shown in drawing 2.6 (2) and (3). We note that this construction also generates the relative sizes of Earth and Mercury, the C_1 circle representing Earth, and the C_4, Mercury.

It is interesting how the φ tritone vesica perfectly holds the double square, as shown in drawing 2.7. In fact, the whole φ tritone vesica construction could be generated from the double square, whose geometric potency was recognized

by the ancients. For example, the King's Chamber of the Great Pyramid has a double-square floor plan as does the hypostyle hall of Seti I at Karnak, Egypt. The Greek temple of Artemis at Ephesus has a floor-plan ratio of 2.09. Many other ancient temples are close to a double-square ground plan, which suggests that the builders may have begun with a double square and then modified it for various reasons.

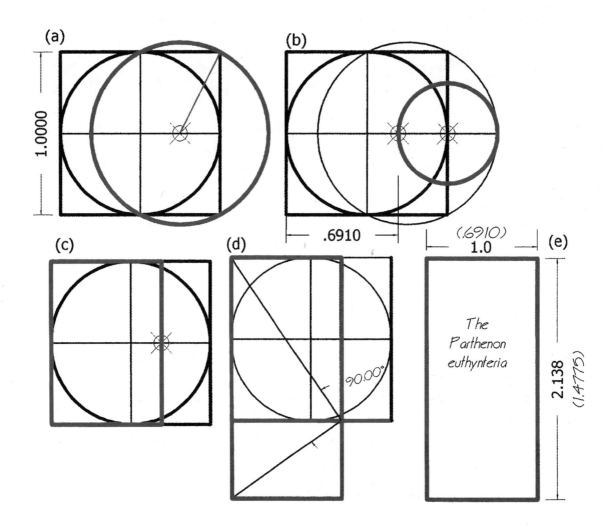

Drawing 2.8. *A construction of the Parthenon euthynteria, or first leveling course. In (a) and (b) we construct the .691 φ tritone that intersects the string/ diameter at a point from which a rectangle (c) is drawn. In (d) a perpendicular to the (c) rectangle generates a reciprocal rectangle. The two conjoined rectangles form rectangle (e), the completed Parthenon euthynteria. The important principle of ratio and reciprocal is thus demonstrated. This principle finds expression in musical tone, the string length being in reciprocal relation to the frequency: 1/string length = frequency.*

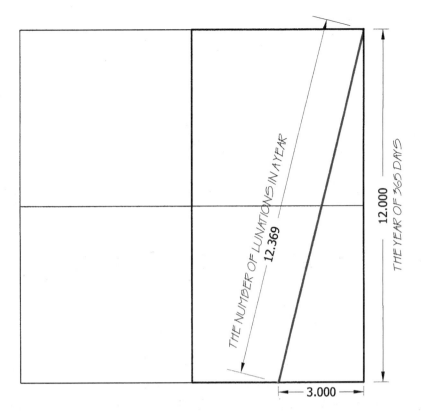

The labels within the drawing read: "THE NUMBER OF LUNATIONS IN A YEAR", "12.369", "THE YEAR OF 365 DAYS", "12.000", "3.000".

Drawing 2.9. *An internal time property of the double square becomes apparent when we scale its long side to equal 12. Then the half diagonal of the double square equals 12.3693 (10 × 2/φ), which is the number of lunations in a solar year. The solar year equals 365.2422 days, and the lunation cycle equals 29.53 days. So, 365.2422 ÷ 29.53 = 12.3683, accurate to within a thousandth of the half diagonal of the double square. (After Robin Heath's drawing)*

*

We have seen that the double square also generates the ground-plan ratio of the temple of Apollo Epikourios at Bassai (drawing 2.7). Perhaps Iktinos laid out a double square on the ground and simply used its diagonals as radii to sweep out two arcs that, in the process of generating the 4/φ rectangle, created a vesica of φ ratio. While this is the simplest approach, the Pythagorean tritone construction shown in drawings 2.4 and 2.5 more precisely reveals the inner structure of the temple. Perhaps Iktinos used both approaches—or neither.

3

~~~

# MOON AND EARTH

IN THIS CHAPTER WE WILL CONTINUE TO EXPLORE the dimensions and time periods of the Moon-Earth system in the context of the tonal and canonical numbers that reveal the deeper meanings of their relationship. There is an *intimate* relation between Earth and her life-forms and the Moon. Among some indigenous peoples the Moon is known as Grandmother Moon. She is the mature elder, the wisdomkeeper who teaches the mysteries of time and change, who draws us into the mystery with her mature beauty, who lights our way through the dark places or withholds her light so we may learn to walk in the dark. She is the one who initiates young women into the path of feminine wisdom through the monthly blood ritual. She is mistress of the waters moving the sea and the water within life-forms in daily and monthly rhythms through the great binding force of gravity. She clearly signals the changing intensities of her energy through the varying phases of her light so that all may prepare for and comfortably adjust to the changing monthly rhythms. Mircea Eliade writes of the Moon:

> It is through the moon's phases—that is, its birth, death, and resurrection— that men came to know at once their own mode of being in the cosmos and the chances for their survival or rebirth. It is through lunar symbolism that religious man was led to compare vast masses of apparently unrelated facts and finally to integrate them in a single system. It is even probable

that the religious valorization of the lunar rhythms made possible the first great anthropo-cosmic syntheses of the primitives. It was lunar symbolism that enabled man to relate and connect such heterogeneous things as: birth, becoming, death, and resurrection; the waters, plants, woman, fecundity, and immortality; the cosmic darkness, prenatal existence, and life after death, followed by a rebirth of lunar type ("light coming out of darkness"); weaving, the symbol of the "thread of life," fate, temporality, and death; and yet others. In general, most of the ideas of cycle, dualism, polarity, opposition, conflict, but also of reconciliation of contraries, of *coincidentia oppositorum,* were either discovered or clarified by virtue of lunar symbolism. We may even speak of a metaphysics of the moon, in the sense of a consistent system of "truths" relating to the mode of being peculiar to living creatures, to everything in the cosmos that shares in life, that is, in becoming, growth and waning, death and resurrection. For we must not forget that what the moon reveals to religious man is not only that death is indissolubly linked with life but also, and above all, that *death is not final, that it is always followed by a new birth.*[1]

And when she disappears at the dark of the Moon our common lineage is fully revealed: the stars of our galaxy, the Great Mother from which the Moon and all things in this corner of the Universe were born from exploding stars.

Yet Grandmother Moon is more than an inspirer of the mythic imagination. Her presence has shaped Earth in many ways. It is believed that she stabilized the orbit of the erratic early Earth and helped create the conditions for the rising of life. The Moon also reveals through her dimensions and cycles mathematical wisdom that helps us to understand our world. We have mentioned the 11/3 (3.66) diameter relation of Earth and Moon. We can look at this another way:

Earth diameter + Moon diameter = 1 + .272 (3/11) = 1.272 = 14/11.

The number 1.272 is a key number or numerical region in our study. It approximates the area ratio of a square to its inscribed circle (1.27323) and the $\sqrt{\phi}$ function (1.27202); and 14/11 (1.27273) gives us a rational value with which to do harmonic work in music and design. This number was enshrined in the Great Pyramid, whose cross section (drawing 3.1, p. 34), in referencing this important ratio, reveals significant relationships in the Earth-Moon structure.

**Figure 3A.** *Earth and Moon in their proper size relation*

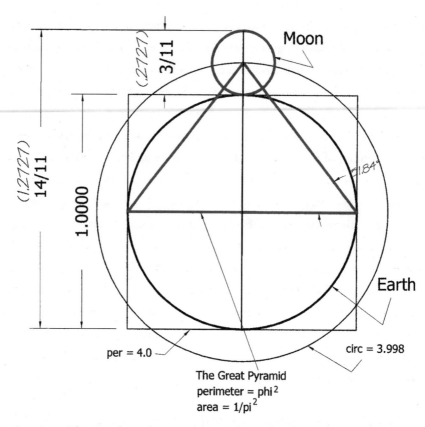

Drawing 3.1. *The Earth and Moon in proper size relation are embodied in the cross section of the Great Pyramid. A circle squaring is implied in this construction: the square surrounding Earth has the same perimeter (within .002) as the circle intersecting the center of the Moon. (After John Michell's drawing)*

The overall effect of this enchanted construction, based on John Michell's work, suggests the possibility of a harmoniously designed cosmos.

## MEASURES OF TIME AND SPACE

There is evidence that the musical scale was one of the principal tools that certain ancient civilizations used to investigate the workings of nature and the soul. We have heard that the Pythagoreans considered numbers and tonal ratios to be the foundation of the created world. The Chinese also recognized the cosmic significance of tone. In the *Shih Chi* it was written that the six *lu* (tones) are "the root stock of the myriad things."[2] Joseph Needham writes that the Chinese made practical application of this understanding in their use of pitch intervals as the basis of their measuring system. He states that originally grain scoops

were used as primitive percussive instruments or bells and that later the size and tone of these vessel/tone-makers were calibrated to correspond to an exact grain-holding capacity. Needham notes some further developments of this concept.

> The simple grain scoop having evolved into a bell, and the simple bell into a standardized measure or *chung* of fixed dimensions, capacity and weight, as well as musical pitch, it was natural, when pipes became the standard pitch-givers, that they should inherit the measuring functions which had one time belonged to bells. Consequently we read of the number of grains of millet which the Huang-chung [the fundamental tone] pipe ought properly to contain. . . . The standard measure, *chung,* had to emit the Huang-chung note.[3]

The huang-chung was a particular musical pitch that was believed to exist within nature. As time passed, elaborate divination rituals were conducted to find the huang-chung so that musical instruments could be tuned to it and the system of measure could be correlated to it. As the Chinese sought the huang-chung tone to construct their scale and to determine the other measurements that arose from the scale, so other ancient cultures sought a natural length that could serve as an incorruptible module for their measuring systems. It may be that they looked to the eternal heavens to find it. It was natural, when you think about it, that the Moon was chosen. Easy to see, full of visual cues in the form of maria and craters, it had long been used as a timekeeper by humans. And its regular advancing and retreating border between dark and light evokes a sense of precise spatial regularity, as if not just time but also space is being measured out.

# THE THREE MASTERS
## (PART 1)

As Aristarchus demonstrated, a good approximation of the relative sizes of Earth and Moon can be determined by observing the shape and size of Earth's shadow cast on the Moon during eclipses. The ancients seemed to have determined accurate values for both the Earth's and the Moon's diameters. John Michell writes that these early harmonicists, in selecting the Moon for their standard, had assigned the number $12^7$, or 35,831,808, as the number of units in the circumference of the Moon. This standard was then divided by an

ancient approximation of π, 864/275, to give 11,404,800 units for the Moon diameter. But there were other factors to be considered. The numerical description of the workings of an enchanted cosmos could not simply be dry decimal numbers but must have deeper meanings that would take the form of musical and temporal correspondences.

Let us now imagine an ancient scenario whose actors are three master harmonicists who are seeking an alternate system of measure to the decimal-based system with which to designate the diameters of the Earth and Moon. The Moon diameter is chosen as the one to be determined, and from this the known Moon/Earth ratio of 3/11 will determine the Earth's diameter. The harmonicists are Maestro, an elder from central Asia; Maestra, a wisewoman from a megalithic building clan of the British Isles; and the Traveler, a scholar of ancient architecture.

**Maestro:** It would be good to have a universal number for the Moon diameter so that it might be easily discovered by our descendants.

**Maestra:** A number with time resonance and with musical meaning.

**Traveler:** . . . a rich number befitting Grandmother Moon.

**Maestro:** I feel we need to enclose the Moon in a cube so that we have a rational structure with which to approach her. And then we must subdivide the cube into many smaller cubes. The number of small cubes across a face of the great cube will then be applied to the two-dimensional circle of the Moon. The question is: How many smaller cubes shall we fill the great cube with?

**Traveler:** Let us make use of our revered decimal system that can give us simple estimates. How about ten million little cubes?

**Maestra:** *(calculating)* . . . Then the large cube has a side whose length is 215.4 small cubes.

**Maestro:** We need something longer. Let's go with ten billion little cubes in the Moon cube.

**Maestra:** The Moon cube now has sides of 2,154 units.

**Traveler:** That's close to the 2,160-year precessional age number; just a little comma of difference.

**Maestra:** It's 1/360 to be exact, a little octave tritone. Another interesting time fact is that the lunation of 29.53 days divided by the Moon's orbital period of 27.32 days equals 1.08, or half of 2.16.

**Maestro:** And 2,160 seems resonant with time numbers.

**Traveler:** It has a musical pedigree also. Since 216 is a major sixth within our 128–256 octave.

**Maestra:** Right; $27/16 \times 128 = 216$. By the way here's another major sixth fact: $16/27 \times 365$ days in a year equals 216 days plus a few hours.

**Maestro:** So our Moon diameter has 2,160 units. And multiplying by the known Earth/Moon ratio of 11/3 the Earth diameter would be?

**Maestra:** Would be 7,920 units. This is also a good number. Dividing it by eleven gives us 720, one of our most divisible numbers: 7,920 is also divisible by 2, 3, 4, 5, 6, 8, 9, 10, 11, 12, 15, 16, and 18. This is a number with which we can work.

**Traveler:** And so the Earth's circumference is 7,920 times our π of 864/275, giving . . .

**Maestra:** An answer of 24,883.2 units . . . which we can call miles.

We pause the imaginary conversation here to give a brief introduction to the subject of musical scales and, in particular, a simple way to construct a basic Pythagorean scale and its relation to just intonation.

# CONSTRUCTING A SEVEN-TONE SCALE

We know that the intervals of the octave and the fifth have been present in the music of most cultures across Earth and through time. Musicians can locate them with intuitive accuracy on the musical string. From these two intervals a scale may be generated. We can approach our primordial scale from either of two directions. We can sound the fundamental first and then sound the fifth. Or we can sound the octave first and then sound a fifth down. (*Note:* on the musical string the octave divides the string in two, the fifth into 2/3 and 1/3 segments, and the fourth into 3/4 and 1/4 segments.) But now we have three intervals: the octave, the fifth, and the "fourth," since a fifth down from the octave lands us on the same tone as

a fourth up from the fundamental, the fourth being another harmonious-sounding interval.

Our scale is now

<div align="center">fundamental ——————— fourth–fifth ——————— octave.</div>

At this point we have a scale, but it is not of much use for creating rich-sounding music until we can fill in the blank places. How do we do that? One way is to take the interval between the fourth and the fifth, which we call a "whole tone" (WT) (8/9 of the string length), and add it to the fundamental within the lower part of the scale and to the fifth in the upper part of the scale. We can keep adding whole tones to the upper and lower parts of the scale giving us the following tonal intervals.

| (1 × 8/9) | (8/9 × 8/9) | semitone | (3/4 × 8/9) | (2/3 × 8/9) | (16/27 × 8/9) | | semitone |
|---|---|---|---|---|---|---|---|
| **1** | **8/9** | **64/81** | **3/4** | **2/3** | **16/27** | **128/243** | **1/2** |
| fund —— | 2nd —— | 3rd —— | 4th —— | 5th —— | 6th —— | 7th —— | octave |
| 8/9 | 8/9 | 243/256 | 8/9 | 8/9 | 8/9 | 243/256 | |

We notice two gaps: between the third and the fourth and between the seventh and the octave. The 8/9 whole tone is too large to fit between these intervals. To find an interval that does fit we subtract the third from the fourth through division: 3/4 ÷ 64/81 = 243/256. And we subtract the seventh from the octave in the same way: 1/2 ÷128/243 = 243/256. These are the Pythagorean semitones with string-length of .9364 (roughly 15/16) of the value of the whole tone, which was slightly too big to fit in the spaces between third and fourth and seventh and octave. We have just completed the construction of the Pythagorean seven-tone scale. The calculations above the scale show how the intervals were arrived at through multiplication, such as

$$3/4 × 8/9 = 2/3$$

It happens that all these tones are composed of the factors 2 and 3 or their multiples. If we introduce the number 5 and its multiples into this system we can simplify the more complex fractions—namely, 64/81, 16/27, 128/243—without varying their values by too much, as demonstrated by their decimal equivalents, listed in the following table.

| Pythagorean Tone | Adjusted |
|---|---|
| 64/81 (.7901) | 4/5 (.8000) |
| 16/27 (.5926) | 3/5 (.6000) |
| 128/243 (.5267) | 8/15 (.5333) |

These adjustments are simply made by adding the "syntonic comma," a small interval with frequency ratio 81/80, to the Pythagorean ratios. The result is a seven-tone just-intonation scale with the following intervals between the tones:

$$1 \longrightarrow 8/9 \longrightarrow 4/5 \longrightarrow 3/4 \longrightarrow 2/3 \longrightarrow 3/5 \longrightarrow 8/15 \longrightarrow 1/2$$
$$\quad\; 8/9 \qquad 9/10 \qquad 15/16 \qquad 8/9 \qquad 9/10 \qquad 8/9 \qquad 15/16$$

The intervals are now 8/9, whole tone; 9/10, minor whole tone; 15/16, semitone.

Further divisions can be made, and, of course, innumerable tones of widely varying ratios may be inserted into this basic structure. Now back to the conversation.

# THE THREE MASTERS
## (PART 2)

**Maestro:** We have our basic long unit—the mile—of which there are 2,160 in the Moon diameter and 7,920 in the Earth diameter—and now we need smaller units.

**Maestra:** Let us first establish an easily decipherable number of smaller units for the lunar circumference.

**Maestro:** A large number is needed. It must be of eternal vintage such as a musical number.

**Traveler:** Possibly twelve, the number of tones in the full scale raised to some power.

**Maestro:** Such as seven, the tones in the basic scale.

**Maestra:** So, $12^7$ smaller units in the Moon circumference: that would be 35,831,808 units.

**Traveler:** Divided by our $\pi$ number of 864/275, results in 11,404,800 units in the Moon diameter.

**Maestro:** So, 11,404,800 divided by the mile count of 2,160 equals . . . 5,280, the number of smaller units . . . feet . . . in our mile.

**Traveler:** Well, with 528 we're just barely into the 512–1024 octave.

**Maestra:** And 512/528 gives us an interval of 32/33. Sounds familiar.

**Traveler:** That's another beautiful comma.

**Maestro:** Its twelve lunations divided by the yearly day count.

**Maestra:** That is, 354/365 = 32/33.

**Maestro:** So we have our foot, 5,280 of which go into a mile. And 2,160 miles in the Moon's diameter and 7,920 in Earth's. Now, how do we divide the foot?

**Traveler:** The decimal metrologists always divide by ten. It would be better, I think, not to mix systems.

**Maestro:** Consistency is important. Let's look at our numbers and what divides evenly into them.

**Maestra:** Well, 2,160, 1,080, 7,920, 5,280 are all divisible by many numbers.

**Traveler:** I suggest we use the noblest number of them all.

**Maestro:** That, again, would be 12.

**Maestra:** So, 2,160 ÷ 12 = 180; 7,920 ÷ 12 = 660; 1,080 ÷ 12 = 90; 5,280 ÷ 12 = 440; and 12 itself, of course, is highly divisible—by 1, 2, 3, 4, and 6.

**Traveler:** And relates to our twelve zodiacal signs . . . and there are twelve tones in the scale. . . . I could go on.

**Maestro:** Are we all agreed?

**Traveler:** Twelve it is.

**Maestra:** Twelve . . . inches . . . to our new foot.

**Traveler:** What of the inch? It too needs division for finer measurements.

**Maestro:** The temptation is to use tenths. But, again, let us not mix systems.

**Maestra:** What is the simplest division of them all?

**Traveler:** Division into two.

**Maestro:** Of course. And its reciprocal, doubling. These are eternal.

**Traveler:** Two resonates with the octave, with the principle of duality, with the life generation principle of one from two. In geometry section into two is the most primal gesture of that art. It is good to include this in our system.

**Maestra:** The inch, then, would divide into halves, quarters, eighths, and so on.

**Maestro:** So be it.

# EARTH
# AND MOON

The central correspondence that emerges from our discussion is that the diameter ratio of Earth to Moon = 7,920/2,160 = 3.66, and Earth revolves about its axis 366 times in its yearly orbit around the Sun. As a tonal frequency, 366 is within the main octave of 256–512. Its frequency ratio is 366/256, and its string-length ratio is 256/366 = .699—close to the 7/10 tritone. As we have noted, the ancient Chinese searched for a tone embedded in cosmic structure that would serve as a beginning of their musical scale—the elusive huang chung. Levarie and Levy in their book *Tone* wrote:

> In traditional Chinese music, the pitch norm was a tone, called *huang chung* ("yellow bell") which sounds like our f-sharp and corresponds, as subsequent measurement revealed, to a frequency of 366. This tone and the pipe measures that defined it were derived from certain sacred cosmic proportions, which recur throughout Chinese philosophy and religion.[4]

Our .699 string length is multiplied by the yearly revolutions of the Earth of 366 days:

$$.699 \times 365 \text{ days} = 255.83 \text{ days}$$

within 99 percent of the 256 traditional frequency of middle C. The tritone of the year thus establishes the beginning of the scale.

There are other results that the 366-frequency number generates. Its establishment of the C-256 frequency as the beginning of the scale introduces lunar and solar numbers into the scale when the Pythagorean-sixth frequency of 27/16 (A-432) is substituted for the standard 5/3 (A-440) of the C-264 scale,

$$27/16 \times 256 = 432,$$

giving the mile-based measures of

$$4{,}320 \text{ miles} \div 2 = 2{,}160, \text{ the Moon diameter and}$$
$$432{,}000 = \text{Sun radius}.$$

Another instance of the 366 number occurs when we calculate the area of the Moon circle:

$$\text{Moon radius } 1{,}080^2 \text{ miles} \times \pi = 3{,}664{,}353 \text{ square miles}.$$

In chapter 10 we will discover how the number 366 plays an important role in cosmic history.

From the previous discussion a question arises: Are we meant to draw our musical scales from numbers embedded in the cosmos? We do know that both the Greeks and the Chinese proscribed the altering of the scales. Because music was considered to be of great importance to the harmonious functioning of society, to allow changes to its carefully crafted structure would invite inharmonious elements to enter into and corrupt the social order. This might indicate that their musical systems were drawn from imperishable and unchanging laws of nature that could no more be altered than could the time cycles of Sun and Moon.

Certainly the octave system of numbers, with its doubling and halving properties, is fundamental to universal law. This is most evident in the two-from-one process of mitosis and the one-from-two process of sexual reproduction.

The numbers 2, 4, 8, 16, 32, 64, 128, 256, 512, and so forth, are thus obvious choices for early musical theorists looking for raw materials for a scale. The Greeks used these powers of 2 and added the powers of 3 (3, 6, 9, 27, 54, 108, and so forth) to generate intervals for their scale. *Three* is another number that has universal correspondences, but with a different quality than 2: past, present, future; microcosm, mesocosm, macrocosm; birth, life, death; three dimensions of space; and so on. Later other numbers worthy of forming intervals were added to the musical and measurement canons—such as the powers of 5 series and φ-based numbers that had been discovered in time cycles such as, as noted above, in the Moon-Earth-Sun relation.

# THE
# INNER EARTH

Through the diligent work of earth scientists we now know a great deal about the sizes of the layers of the inner Earth. Much of this work has been done through the tracking of seismic waves as they ripple through the Earth reflecting and refracting as they encounter different materials and different densities. We now have fairly accurate measures of the depths and thicknesses of the main layers of crust, mantle, and core as well as their secondary layers. But as geometers we wonder if we can create a model of the ring structure of the Earth without resorting to measurement. We find that this is possible using the geometric methods we have already discussed.

The Moon, which we have learned how to construct from a circle representing Earth, seems to have a geometric presence *inside* Earth. As shown in drawing 8.3 (p. 105), the revolving barycenter, or center of mass of the Earth-Moon system, is located at a distance from the surface of the Earth of one Moon radius. The Moon revolves around this barycenter. The Earth does also, although its movement is more of a slight wobble. There is another way in which Earth contains the Moon that we will look at in the following drawings. Drawing 3.2 (p. 44) uses crossed diagonals to locate a node that produces the diameter of Venus relative to Earth. When mirrored, this node gives us the thickness of the combined upper mantle and crust of the Earth. In drawing 3.3 we construct a double-Moon circle whose diameter happens to be the size of the diameter of Earth's outer core. When placed within the Earth drawing it also defines the ring of the lower mantle. Finally, the major-sixth construction locates the inner core (drawing 3.4, p. 45).

Moon
and Earth

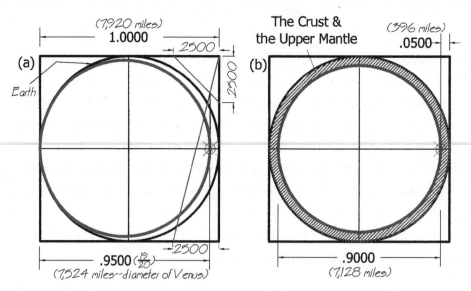

Drawing 3.2. (a) The first two of a series of drawings in which the layers of the inner Earth are constructed using tonal ratios that generate diagonal crossings. Here the intersection of the two diagonals drawn from quarter-square points on the enclosing square locates a point on the string/diameter to which an inner circle is constructed. This point is at 19/20 of the main diameter length that is considered the diameter of Earth (7,920 miles). The circle drawn to the point has a diameter of 7,524 miles, the diameter of Venus. (b) Next, the point is mirrored and a new circle drawn with a diameter of 9/10 (7,128 miles). (The Venus node of 19/20 is the ratio of an ancient semitone cited by Eratosthenes and Ptolemy. The ratio 9/10 is the minor whole tone.) The ring that is formed is proportionally about the size of the crust and upper mantle of the Earth.

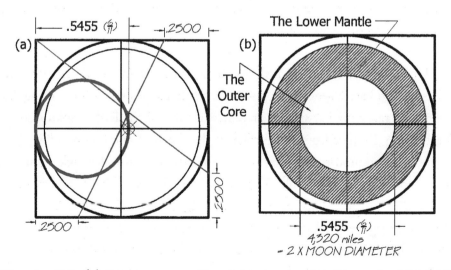

Drawing 3.3. (a) Quarter-square diagonals are crossed to locate the 6/11 (.5455) node on the string/diameter. (b) This generates a circle of proportionally 4,320 miles in diameter, which is double the Moon diameter of 2,160 miles. When centered on the construction this circle defines the perimeter of the Earth's outer core and the inner perimeter of the lower mantle.

44

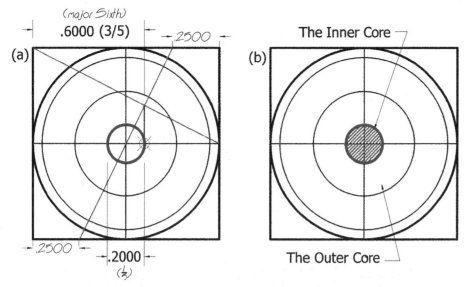

Drawing 3.4. *The inner-core circle (with diameter one-fifth that of Earth) is simply located with the diagonal construction for the major-sixth interval, again using quarter-square diagonals. The diameter ratio of outer core to inner core is 2.72 (4,320/1,584), which, in feet, is the length of the megalithic yard (MY) discovered by Alexander Thom, who believed that the MY was the basic unit used in the layout of the megalithic monuments of Britain. The number 2.72 also refers to the Moon/ Earth diameter ratio of 3/11 (.272).*

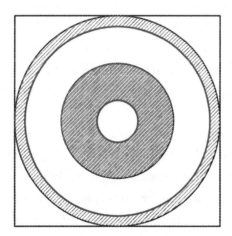

Drawing 3.5. *The rings of the inner Earth. The layers of the inner Earth described in the previous drawings combine to form a grand ring shape and an object of contemplation.*

# 4

~∞~

# THE TEMPLE OF WATER

IN THIS CHAPTER WE WILL CONSIDER THE SUBSTANCE OF WATER in a harmonic context. We know that water constitutes a majority of our physical bodies and of the surface of our world, but, of course, it is more than that. Its power and its character has, over the eons, integrated itself within our psychic structure, where it resides as a symbol for the unconscious itself—the great Deep with its hidden contents that, like unknown sea creatures, occasionally surface wearing beautiful or mysterious or monstrous forms.

Water takes on all the forms of human feeling: the perfect mirror of a still lake suggests the feeling that can arise in deep meditation; the wild thunderstorm reflects chaotic emotion; the monotonous rhythm of the continuous drip reminds us of the passing of time; the rushing mountain stream in late spring is an image of passion; the gentle sun-shower on a hot day can soothe us like the soft glissando of a harp. Water has, in older traditions, been associated with, or even identified with, the soul, and the reasons are evident. No life-forms can exist without water or without an animating soul. But, like the soul, water can become clouded, can become impure. Yet to cleanse it, often all that is required is stillness. The water becomes clean as the sediment sinks to the bottom of the pond; the soul in meditation returns to its source and becomes whole.

Yet, in the midst of such intuitive correspondences we allow ourselves to seek numerical relationships and geometrical symbols so we may better understand

this substance. Perhaps seeing water in a context that is filled with numerical synchronicities, as we are finding with the Moon and the Earth, will help us approach it in a sacred way. Numbers can often reveal a unitive energy behind the seemingly random forms and processes of the world.

## LAND AND WATER

The proportion of surface land and water areas on Earth as determined by modern surveying is, approximately:

Land: 148,300,000 km² = 29%
Water: 361,800,000 km² = 71%
Total: 510,100,000 km²

We can visually express this ratio of 71 percent water to 29 percent land area (which happens to be about the water-to-solid ratio within the adult human body) with a vesica construction (see drawing 1.7) in which the inner circle ($C_4$), enclosed by the vesica, represents the land area and the circle inscribing the vesica ($C_3$) represents the water area. It is interesting that the Pythagorean-tritone vesica construction, which we have used to lay out the ground plan of the Apollo temple (drawings 2.4 and 2.5), generates a nearly exact 71/29 area ratio between its outer ($C_3$) and inner ($C_4$) vesica circles (see drawings 4.1 and 4.2 on p. 48).

$C_3$ area (water): .3176 = 71.2%
$C_4$ area (land): .1285 = 28.8%
and
$71.2 \div 28.8 = 2.472 \ (4/\phi)$

The Apollo temple ground-plan ratio, along with its previously discussed time affinities, takes on a new meaning whether or not the builders were aware of it.

I pause here for a daydream. Because the water-area circle in this vesica construction is considered to be beneath the land-area circle, the image I see here is that of an island *floating* on the world ocean like the human-built floating reed islands of the Uros people out on Lake Titicaca. The daydream then remembers modern plate-tectonic theory in which the crust of the Earth is believed to be "floating" and gradually moving on the viscous mantle material reminding me of the primordial continent of Pangaea before it separated into our present

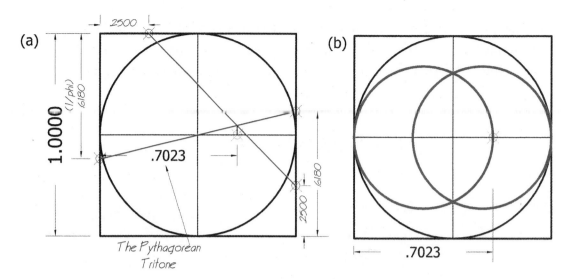

Drawing 4.1. *The water and land construction. We begin with the Pythagorean-tritone drawing that we used in chapter 2 to lay out the ground plan of the Apollo temple.*

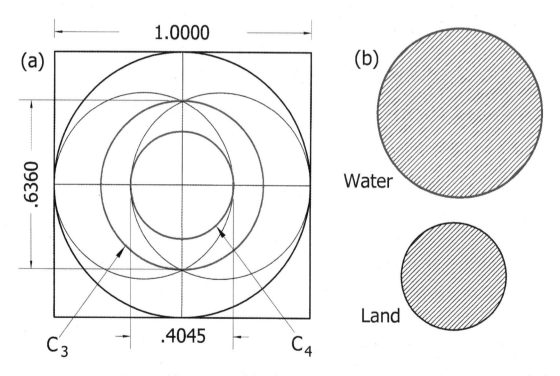

Drawing 4.2. *The water and land construction. The inner circle of the vesica ($C_4$) represents the land surface area of the Earth. The outer vesica circle ($C_3$) represents the water surface area of the Earth. The ratio is*

$$Water = 71.2\% \div Land = 28.8\% = 2.472 \ (4/\phi).$$

continents. I imagine the Apollo temple superimposed on this drawing, with which it aligns perfectly, its width being that of the land circle and its length extending to the containing circle. It thus symbolically holds the land and its inhabitants safely within itself as it navigates across the mysterious dark sea of existence.

## THE SHAPE OF RAINDROPS

A drop of water suspended in a cloud has a spherical shape. As it falls to earth it first assumes the shape of a sphere that is flattened along the top. During its long journey the flattened side oscillates between the top and bottom as the raindrop tries to maintain its structural integrity. The shape of a drop dripping from a faucet, shown in figure 4A, has the same top-flattened spherical shape as the raindrop in its initial falling stage, as shown in figure 4B. We can approximate this form by first drawing a circle in a square and doing some simple geometry (drawing 4.3, p. 50). A similar form can be made within a vesica construction (drawing 4.5, p. 52).

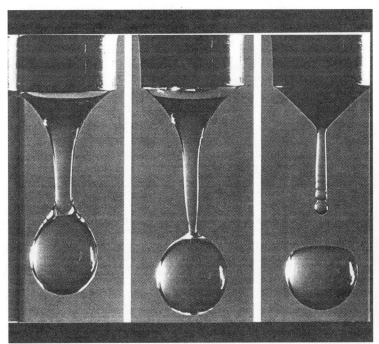

**Figure 4A.** *The waterdrop taking form*

**Figure 4B.** *The elegant shape of the falling waterdrop*

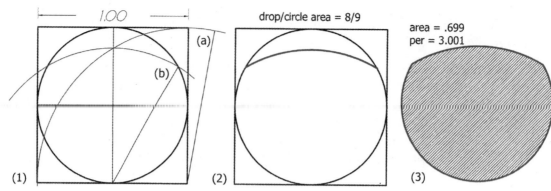

Drawing 4.3. *A construction of the waterdrop shape. In (1) draw a circle-in-the-square. Draw a circle (a) with center at the lower corner of the square and with radius equal to the side of the square to intersect the vertical diameter of the circle. Draw another circle (b) with center at the bottom of the vertical axis with radius extending to the intersection of circle (a) and the vertical axis. (2) Delete the construction lines except for the arc of circle (b) lying within the main circle. (3) Delete the remaining arc of the main circle and the square, leaving the drop form. Properties of the construction: diameter of circle = 1; area of drop = .699; perimeter of drop = 3.001. The diameter of the containing circle and the perimeter of the drop are in a near-integral relation of 1 to 3. There is a similar intent between this exercise and the circle-squaring process: to bring the unknowable into a rational framework.*

The .699 ratio of drop to square also recalls our discussion in chapter 2 of the huang chung frequency of 366 with its string-length ratio of .699, a tone that somehow inheres in this waterdrop figure.

Other harmonies include the crescent shape above the drop that has an area of .0864 (864 being the Sun number); the drop/crescent area ratio is .699 ÷ .0864 = 8.09 = 10 × $\phi$/2; and the area relation of drop to circle is .699 ÷ .7854 = .8899 = 8/9, a whole tone.

The waterdrop shape is similar to the standing-stone flattened-circle rings built by Neolithic peoples in Britain. Many of these were surveyed by Alexander Thom during the twentieth century, such as the one shown in drawing 4.4. Thom believed that the Neolithic builders consciously sought to establish a three-to-one ratio between circumference and diameter. He wrote that "megalithic man liked . . . to get as many as possible of the dimensions of his constructions to be multiples of his basic unit."[1] This fact enabled Thom to discover the unit used by the Neolithic builders of Britain, the megalithic yard, which equals 2.72 feet. Thom continues: "The reason for his obsession with

integers is not entirely clear, but undoubtedly the unit was universally used, perhaps universally sacred."[2]

Perhaps the flattened-circle space with its integral proportions was considered to have an energetic power that made it suitable for the cosmological and ceremonial functions that took place within the ring. We have seen that the musical intervals, to be in tune, must be composed of exact integral fractions of string length. Perhaps these flattened circles of the ancient Britons were an attempt at "tuning" their ritual spaces to a one-to-three harmony—one being the diameter and three being the perimeter of the rings. The creation of the flattened circles seems to be generated from the same quest that produced the circle-squaring efforts: to somehow transmute the π-generated and therefore unknowable circle into a rational figure, to bring the heavenly down to Earth.

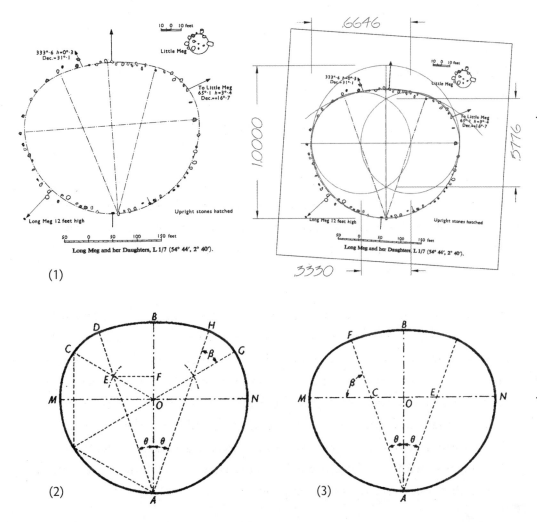

(1)

(2)

(3)

Drawing 4.4. *In (1) is Professor Alexander Thom's drawing of the standing-stone flattened circle known as Long Meg and Her Daughters. In (2) and (3) are Thom's drawings of two types of flattened circles that have near integral ratios between perimeter and diameter. In (2), the ratio is 3.059, and in (3) the ratio is 2.957. Further discussions of the geometry can be found in Thom's book* Megalithic Sites in Britain.

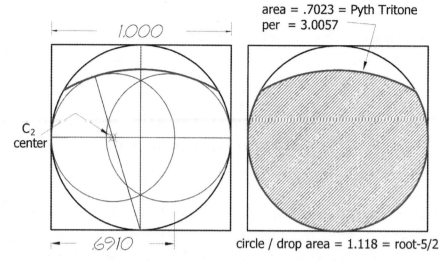

Drawing 4.5. *A waterdrop shape generated from the φ tritone vesica construction. The drop is in Pythagorean tritone relation to the surrounding square = 1. The area of the circle = .7854. The circle/drop ratio = 1.118, half of √5 (2.236). The area of the crescent above the drop is .0831. Therefore, the crescent-to-drop ratio is .118 = 1 ÷ 2φ³. There is a near φ relation between the circle circumference (π) and the crescent perimeter that = 1.936: π ÷ 1.936 = 1.622, which is within 99 percent.*

It may also be that Zalzal, the Arabic musician and maker of tones, played with this idea when he discovered his 3/8 tone with ratio 21/22 (.9545), which, when multiplied by π, is

$$21/22 \times \pi = 2.999.$$

So if we want a circle with a circumference of as close as possible to an even three feet we could begin with a diameter of 21/22 feet. Zalzal was undoubtedly aware of the ancient practical value of π of 22/7, which equals 3.1428, within 99 percent of π, which he simply tripled to get his frequency.

It is interesting that our waterdrop geometry has the same goal—the establishment of rationality. Perhaps the waterdrops themselves seek rational forms. As they descend from sky to earth they realize that to be rational is to be somehow real, just as tones must be composed of rational fractions in order to be located and sounded on a musical string. Each raindrop assumes a glissando of forms as it falls to earth. It strikes the solid earth and is absorbed becoming a life-nourishing resource. Or it strikes water where it generates a circular wave that interacts with other drop-generated circular waves to form a pattern of intersecting vesicas (see figure 4C on p. 54).

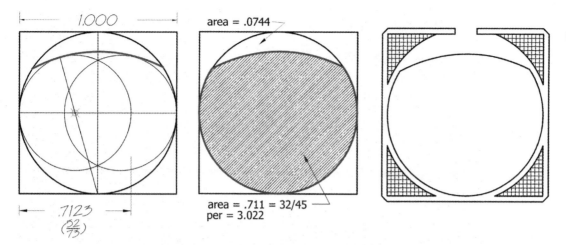

Drawing 4.6. *The "Mayan tritone" of 52/73 (.7123) string length (left) generates a waterdrop form with an area of 32/45 (.711) in relation to the area of the containing square. This ratio is the standard just-intonation tritone. The perimeter of the drop is 3.022 (center), maintaining the near-integral relation with the diameter. The .0744 (2/27) crescent area is in octave relation to the Pythagorean sixth (16/27). The drop-to-crescent area ratio of .711/.0744 = 9.556, which is the square of 3.09 = 6.18 ÷ 2. On the right is a conception of an enclosed pool of water or a ritual space with the form of this harmonic raindrop.*

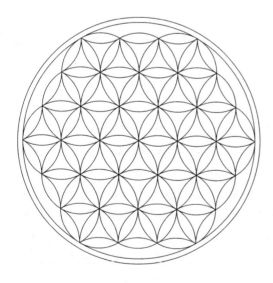

Drawing 4.7. *The Flower of Life is an ancient symbol that can represent the complex intersections of energies that constitute phenomena as diverse as molecular bonds, social networks, and the elements of the individual creative process. Being a complex wave interference pattern it could also represent what Laszlo has called the Akashic Field, or A-field, a universal information matrix existing throughout space and holding energy and information in the medium of wave interference.*

Figure 4C is a photo of raindrops falling into water and the resulting intersections of waves, a metaphorical image of this wave-interference property of the field or of the creative process itself in which sense impressions, dreams and fantasies, memories of words and images from the work of others, visions during times of high emotion, intuitions, and so on, intersect in myriad ways.

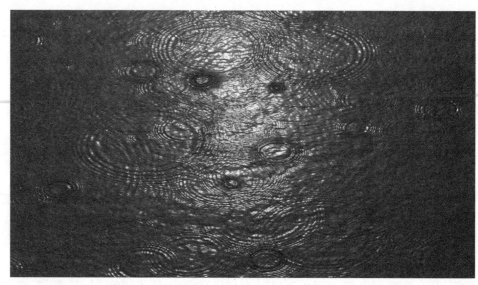

Figure 4C.
*Raindrops in pool.*

Another example of such interconnectedness is the root system of a redwood grove. A redwood tree can grow up to 350 feet (107 meters) in height and weigh a million pounds (450,000 kilos). Yet its roots go only 6 to 12 feet deep into the earth. The redwood compensates by spreading out is roots for hundreds of feet and, in the process, interweaves with other redwood root systems. Thus all the trees together, using a similar pattern as the multiple intersecting raindrops, create a synergetic strength that allows the trees to remain standing for a thousand years or more.

The multiple intersections of circles as a symbol for the synergy of creative work finds geometric expression in the Flower of Life symbol (see drawing 4.7). As noted in the caption, this symbol could also represent what Ervin Laszlo calls the Akashic Field, named after the ancient Indian concept of the *akasha*, or universal field in which all knowledge is contained and from which creation arises. Laszlo considers the A-field to be an information field containing, in the medium of wave interference, a record of everything that has happened in the Universe. He offers a parable to give a sense of how information can be held in interfering waves.

When a ship travels on the sea's surface, waves spread in its wake. These affect the motion of all other ships in that part of the sea. Every ship—and every fish, whale, or object in that part of the sea—is exposed to these waves and its path is in a sense "informed" by them. All vessels and

objects "make waves," and their wave fronts intersect and create interfer-
ence patterns.

   If many things move simultaneously in a waving medium, that medium
becomes modulated: full of waves that intersect and interfere. This is what
happens when several ships ply the sea's surface. When we view the sea from
a height—a coastal hill or an airplane—we can see traces of all the ships
that passed over that stretch of water. We can also see how the traces inter-
sect and create complex patterns. The modulation of the sea's surface by the
ships that ply it carries information on the ships themselves. It is possible to
deduce the location, speed, and even the tonnage of the vessels by analyzing
the interference patterns of the waves they have created.[4]

Another watery symbol of an information field comes from Peruvian shaman
don Antonio in a conversation with Alberto Villoldo. He describes, in a
metaphor of a lagoon, the nature of the energetic realm that seers tune in to in
order to see the past.

   If you change your perspective on the water, see where the sunshines on its sur-
   face and look at it from that point of view, from above, where the eagle flies,
   then you can see into its depths, see what supports the surface, see what lies
   below. . . . That perspective allows you to see not only the present condition of
   the lagoon, but much of its history, everything that has touched its surface and
   sunk to the bottom. You can even see the effect that whatever has penetrated
   the surface has had on the life of the lagoon: a sunken log that plants have
   grown on and fish must swim around. Everything that has ever fallen into the
   lagoon has somehow altered its character. Some things are deeply embedded
   and are no longer distinguishable, but all of them are visible.[5]

The idea of the phenomenon of wave interference as a repository of informa-
tion can be symbolized if we draw two small intersecting circle arcs, which do
not seem, at first, to possess any usable information. But by finding the centers
of the arcs and constructing the vesica and the other circles of the construction
we begin to see the richness of the information contained in the initial seem-
ingly simplistic figure (drawing 4.8, p. 56).

The interpenetration of forms within one another, symbolized by the vesica,
is a natural mechanism through which space is shared among different beings.

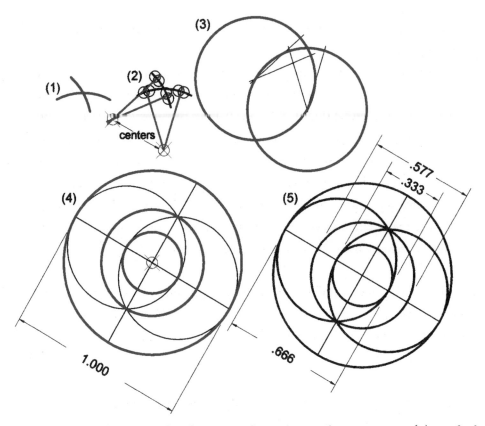

Drawing 4.8. *Beginning with a fragment of a wave-interference pattern (1), we find
the circle centers of the arcs by drawing vesica pisces at any two points on each arc,
bisecting the vesicas and intersecting the bisectors to find the circle centers (2). In
(3) we draw the full intersecting circles, and in (4) and (5) we complete the vesica
construction. This exercise has a holographic quality to it—that is, it shows how the
whole is somehow contained in the part. When we unfold the information contained
in the original crossed arcs we produce a vesica-piscis construction generated from
the tonal fifth interval that contains all the potential numerical and geometrical
information of this important figure.*

\*

In the plant world the intersection of different root systems can be represented by
the same symbol that can represent the intersecting gravitational fields of binary
star systems. The bringing together of two or more things is an idea of great
importance in our internal and external creative processes: the birth of new life
from egg and seed; the joining of two tones to produce an interval; the joining of
paint and canvas to make a painting; the creation of a metaphor that, in joining
two images or ideas, creates a poetic unity. The following example shows a creative
intersection that brings together two disciplines: gardening and sacred geometry.

# THE TEMPLE GARDEN

Our example is an actual garden that was created from an arrangement of φ-based circles and rectangles derived from an enclosing rectangle with a ratio equal to 2.236, or the square root of 5. This figure can also be seen as the intersection of two φ rectangles. The idea of the intersection of energies is very much a theme of the garden. The large central vesica is itself the intersection of two circles that could represent the masculine and feminine, which, when joined, represent the integrated self. Or the two implied vesica-forming circles could represent spirit and matter joined to generate life, or water and soil, which join to nourish plants. The vesica symbol is open to whatever interpretation arises in the mind of the viewer. The garden thus becomes more than a place to grow food and flowers. It is now a place of contemplation filled with symbols interacting with living, growing beings. It is also a place of learning. The construction of such a garden, of which there are endless variations, can educate the builders about the φ proportion and other systems of proportion and will be a practical introduction to the subject of sacred geometry.

In ancient times the making of architectural drawings on the earth was an advanced skill practiced by the *harpedonaptae* as the Greeks called the "rope-stretchers." They would heat-treat their ropes so that their lengths remain stable. A good rope with stakes at each end made an earth compass. Chalklines, then as now, were used to make straight lines. These same tools can be used to lay out a garden. Sometimes measurement is called for but it is good to limit it and let the geometry unfold in a natural way.

# A TEMPLE OF WATER

In these next drawings we again employ the magnitude of the Moon diameter—this time in conjunction with the Earth diameter—to assist us in creating a small temple garden in which the substance of water will be honored. For this project we choose a sacred form—the water molecule, $H_2O$, with its two hydrogen and one oxygen atoms. We will use this molecule as the centerpiece of a ground plan for a Temple of Water. Surrounding the temple we will place four Moon circles representing the main lunation phases. These will symbolically hold and regulate the molecule of water within the temple just as, in the physical world, the Moon structures the water of the seas and of all living

Drawing 4.9. *A geometric garden design whose theme is the golden proportion. The central vesica is constructed according to the directions shown in drawing 2.6. A description of the elements are shown in the following drawings. Figures 4D, 4E, and 4F are photos of the garden under construction and finished.*

Figure 4D.                           Figure 4E.          Figure 4F.

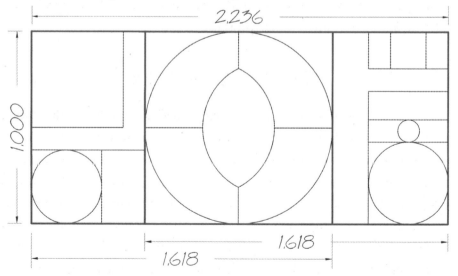

Drawing 4.10. *The overall shape of the garden is a rectangle with a ratio equal to √5 (2.236). The internal structure consists of two overlapping ɸ rectangles.*

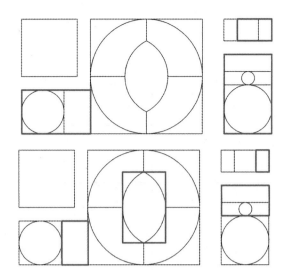

Drawing 4.11. *Other φ
rectangles in the garden*

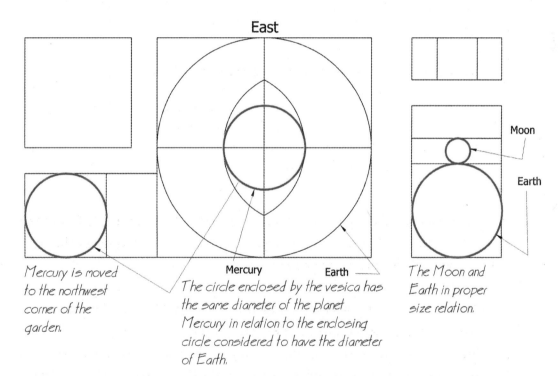

East

Mercury is moved
to the northwest
corner of the
garden.

Mercury          Earth
The circle enclosed by the vesica has
the same diameter of the planet
Mercury in relation to the enclosing
circle considered to have the diameter
of Earth.

Moon

Earth

The Moon and
Earth in proper
size relation.

Drawing 4.12. *Some cosmic relationships in the garden. The diameter ratio of Earth
to Mercury = 2.618 (φ²); the diameter ratio of Earth to Moon = 3.666 (11/3); the
small three-section rectangle in the upper right corner has the same ratio as the
overall rectangle—2.236 (√5)—and thus refers to the ancient dictum "As above, so
below." This was a practical formula of sacred science through which the unknown
could be approached through the known, the greater through the lesser or vice versa;
for example, the correspondences between ring shapes on different levels of being as
discussed in chapter 1.*

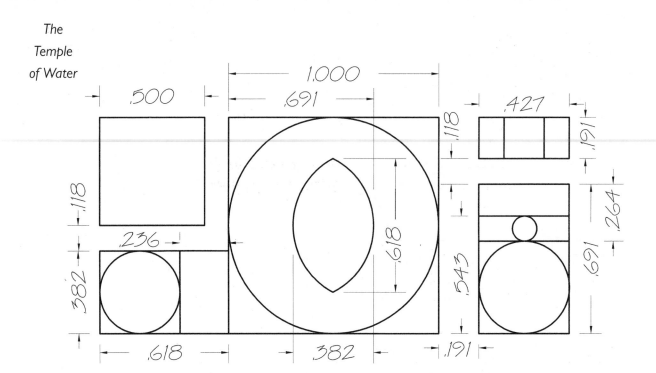

Drawing 4.13. *Some ϕ-family dimensions within the garden:*

$.618 = 1/\phi$             $.191 = 1/2\phi^2$
$.382 = 1/\phi^2$          $.543 = .691/\sqrt{\phi}$
$.118 = 1/2\phi^3$         $.264 = .691/\phi^2$
$.236 = 1/\phi^3$          $.427 = .691/\phi$
$.691 = 1/(1 + 1/\sqrt{5})$

things. Within the temple are three circles—the large oxygen circle and the two smaller hydrogen circles connected with two lines that represent the bond energy that holds the molecule together.

Our first task is to generate the Moon in its proper size relationship to the Earth that is generated by our basic form of the circle contained within the square. This is done through the agency of the golden rectangle, which is constructed as shown in drawings 4.14 and 4.15. We recall from chapter 1 how tonal nodes can be located on the string/diameter of our main circle using various diagonals of our main circle. In drawing 4.18 (p. 63) we make a vesica construction generated from the major-third interval by means of diagonals. The lines drawn between the poles and equator ends of the vesica will be the bond lengths for the water molecule. The internal angle of this musical-third vesica happens to be 104.5°, which is the bond angle of the molecule of water.

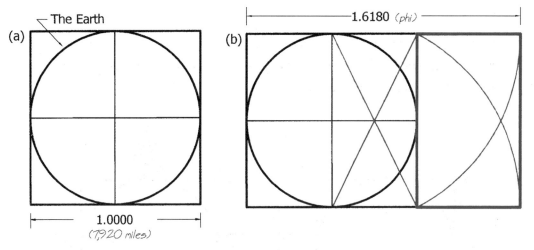

Drawing 4.14. *The Temple of Water construction begins with the circle-in-the-square. (a) The circle represents Earth. (b) Half-square diagonals are drawn, the baseline of the square is extended, and a golden rectangle is drawn.*

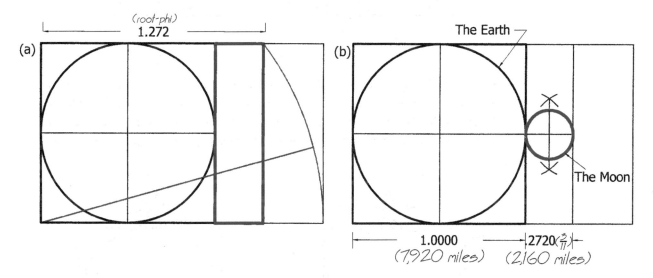

Drawing 4.15. *(a) An arc with a radius the length of the golden rectangle intersects the opposite side (top) at the √φ point. Another rectangle is drawn. (b) The main diameter is extended to the new rectangle. The extension is bisected, giving a center point from which to draw a Moon circle. Its size is in proper proportion to the Earth circle.*

The two poles and one of the equator ends of the vesica will be the centers of the three atomic circles that constitute the water molecule. These circles must be in scale to the bond lengths connecting the poles and equator. Amazingly, we are able to accomplish this without measurement by using the same construction, with a slight variation, that we used to generate the Moon from the Earth in drawing 4.15. The resulting model of the water molecule can thus serve as an accurate symbol in our Temple of Water. Around the Earth square

with its water molecule we construct a *chacana* (drawing 4.19), a structure based on a symbol of the Andean peoples. In this case it is modified so that it holds an imprint of the water molecule.

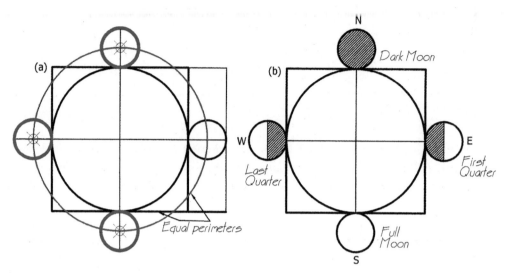

Drawing 4.16. *(a) A larger circle centered on the axis crossing is drawn through the center of the Moon circle. This locates the center points for the other lunation phases (b). In the process we have squared the circle since this new circle and the Earth-containing square have the same perimeters (to within a few thousandths).*

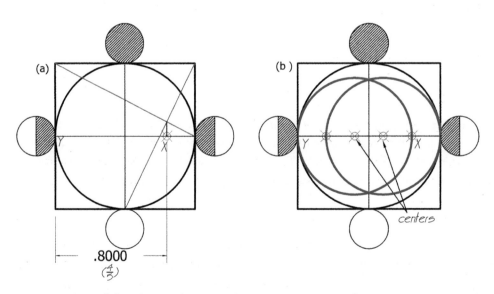

Drawing 4.17. *(a) A diagonal crossing locates the 4/5 node (the major-third point) on the string/diameter. (b) This point is mirrored, the halfway center points are located, and a vesica construction is made.*

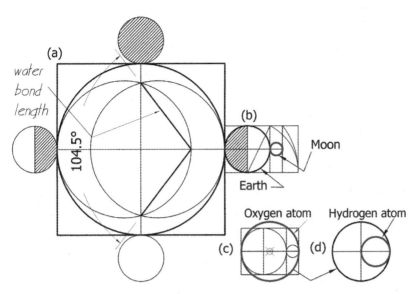

Drawing 4.18. *(a) The inner angle of the major-third vesica is drawn. It is 104.5°, which equals the bond angle of liquid water. (b) Now, the same construction that produced the Moon circle in drawings 4.14 and 4.15 is replicated in miniature. The Moon is considered to be the Earth and the ϕ rectangle and √ϕ rectangle are constructed generating a small Moon. In (c) a circle is drawn around the small Earth-Moon pair. This circle will be the oxygen atom in our water model. (d) Half of the oxygen-circle diameter will be the hydrogen-atom diameter.*

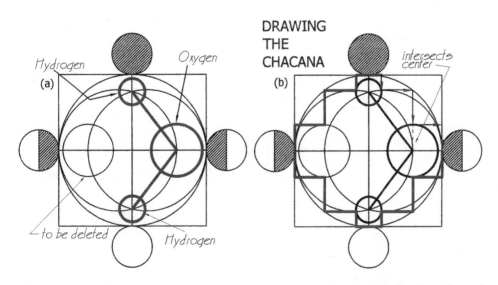

Drawing 4.19. *(a) The oxygen atom is centered at the vertex of the bond angle, and the hydrogen atoms are placed on the ends. (b) Next, a chacana is drawn around the water molecule as shown.*

Drawing 4.20. *A simple design for a Temple of Water with entry and exit*

exit    entry

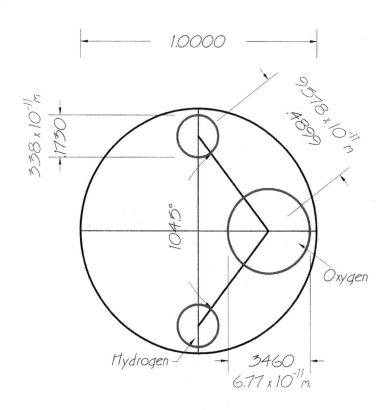

1.0000

538 x 10⁻¹¹ m

.1750

9.578 x 10⁻¹¹ m
.4899

104.5°

Oxygen

Hydrogen

.3460
6.77 x 10⁻¹¹ m.

Drawing 4.21. *The water molecule with its scientifically derived bond lengths and atomic sizes, both of which come very close to our scaled-up and geometrically derived Temple of Water molecular components*

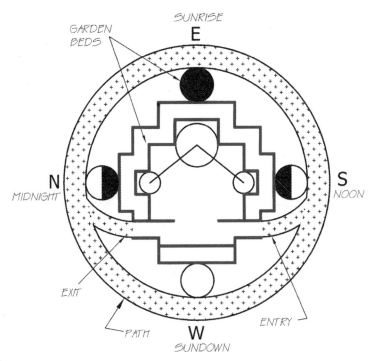

Drawing 4.22. *Here the* chacana *is doubled, providing a raised garden bed surrounding the interior of the water temple garden. In this version we have oriented the temple to face the new moon: to be in the center of the water molecule is to be facing east. The directions correspond to the ideal rising times of the Moon phases. The new moon rises at dawn, the direction of east. The first quarter rises at noon; the full moon at sundown; and the last quarter at midnight. Integral measurements were used in this particular temple garden. The overall length of the inner* chacana *is 11 feet, and the outer* chacana *14 feet. The diameter of the Moon is 3 feet, and the width of the outer circular path is 2 feet. These and the ratios among the dimensions are shown in drawing 4.23.*

Drawing 4.23. *A construction of the Temple of Water garden using integral and φ-based measurements:*

*Hydrogen diameter = 1.909 = 21/11 (3 × √φ/2)*
*Oxygen diameter = 3.818 = 42/11 (3√φ)*
*Oxygen/Moon = 3.818 ÷ 3.0 = 14/11 (√φ)*
*Moon/Hydrogen = 3.0 ÷ 1.909 = 11/7 (√4/φ)*
*Outer chacana/Inner chacana = 14/11 (√φ)*

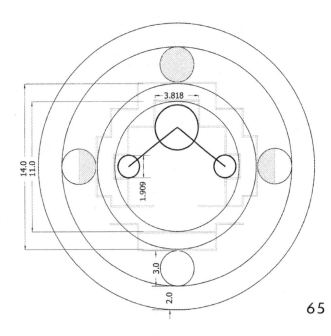

# 5

⸙

# MUSICAL VESSELS

WE ARE BEGINNING TO CONSIDER THE MUSICAL SCALE in a different way: as a repository of numerical tools that can aid us in finding a simpler way to approach creation—whether it be the physical forms of the natural world or the creations of human imagination. It often seems that things exist as members of scales—sometimes within a single species and sometimes across different species—and can be understood as intervals whose relationships can be perceived in terms of musical harmony. This perceptual practice can serve to relate things with no apparent connection and can sometimes result in new insights. Furthermore, we have seen in our constructions of the land-to-water ratio of Earth's surface (in chapter 3) how tonal numbers can be useful in generating forms that closely approximate physical reality. The relative sizes of the inner planets of our system as well as the Moon can also be derived in such a manner—that is, using tonal ratios to generate vesica constructions in which the innermost vesica circle ($C_4$ in drawing 1.7), representing a planet, will be in accurate proportion to the enclosing circle, representing Earth ($C_1$). The accompanying drawings (5.1 to 5.4) illustrate this approach. The resulting tones are listed in the following table.

| Planet | Tonal Ratio | Interval Name |
|--------|-------------|---------------|
| Earth | 1 | fundamental |
| Venus | 19/20 (.95) | semitone |
| Mars | 8/15 (.5333) | seventh |
| Mercury | ±9/13 (.691) | sharpened tritone |
| Moon | 7/11 (.636) | minor sixth |

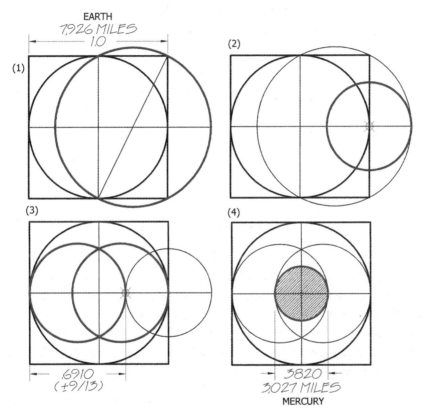

Drawing 5.1. *The ϕ tritone construction results in an accurate representation of the relative sizes of Earth and Mercury. A ϕ section construction of the half diameter is used here resulting in the 1 to .382, Earth/Mercury ratio; .382 = 1/ϕ².*

# Planetary Pottery

In the spirit of play, let us use this odd collection of planetary intervals to generate forms in the shape of pottery vessels. Drawings 5.6 to 5.11 (pp. 70–71) show the planetary pots generated by a single construction—the crossed diagonals of

the square and the half square (the same construction that we have used to generate the fifth interval). We will consider the areas of the pots in relation to the fundamental as their tones. (The pot areas have been determined with a computer drawing program.) The fundamental tone is the area of the enclosing square that is equal to 1. All of the tones of the pots have been brought into a single octave. Our next task is to compare the tones/areas of the planetary vessels to reveal their intervallic relations. A surprising ratio—that between the vessels of Venus and Mars—is the square of φ, or 2.618. This is a good example of the hidden harmonies that might be discovered using such transmutational geometry. Curiously, 2.618 is the same ratio that exists between the diameters of the Earth and Mercury: 7,926 miles ÷ 3,027 miles = 2.618.

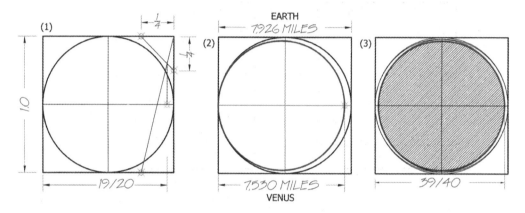

Drawing 5.2. *The construction of Venus in relation to Earth. In (1) we repeat the construction we made in drawing 3.2 of the Venus diameter point at 19/20 of the diameter of Earth. In (2) the Venus circle is drawn to the 19/20 point. In (3) the Venus circle is centered within the drawing, and a vesica is constructed around it. The tone generating this vesica has the ratio 39/40 (.975), an ancient quarter tone cited by Avicenna and Eratosthenes.*

Drawing 5.3. *The diagonal construction of the 7/11 (.636) tone that generates a vesica whose enclosed circle has the ratio of 3/11 in relation to the Earth circle. The actual Moon diameter is 2,160 miles—an accuracy of 99 percent. (See drawing 2.2 for further properties of this construction.)*

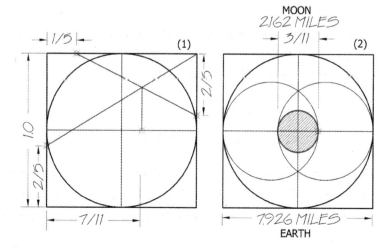

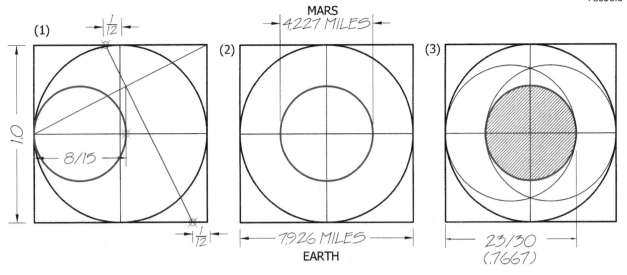

Drawing 5.4. *The construction of Mars in relation to Earth. In (1), using diagonals, a circle is constructed with diameter of 8/15, the tonal ratio of the major seventh. In (2) this circle is centered within the Earth circle. In (3) a vesica is drawn to enclose the Mars circle. The generating tone of the vesica is 23/30 (.7667), a tone lying between the third and the fourth.*

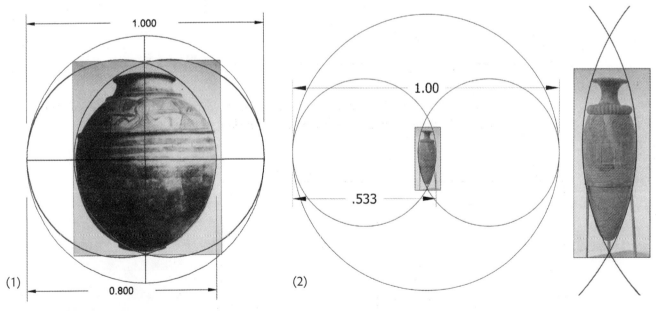

Drawing 5.5. *(1) A storage jar from Susa, third millennium BCE, fits nicely into a major-third vesica with tonal ratio of 4/5 (.80). (2) The Sanctuary Rhyton, Crete, 1600 BCE. It is surrounded by a vesica at the interval of the major seventh with string-length ratio of 8/15 (.5333). The ratio of the vesica = 3.872 = √15.*

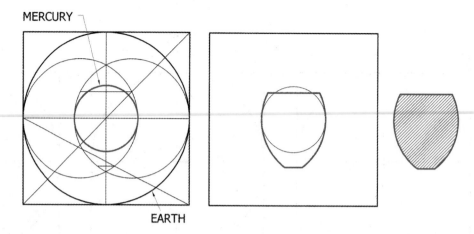

Drawing 5.6. *The construction of the Mercury vessel using crossed full and half-square diagonals. This vessel occupies .1379 of the area of the square that equals 1. Brought into the main octave, the vessel equals .5516, or about 11/20, a minor seventh.*

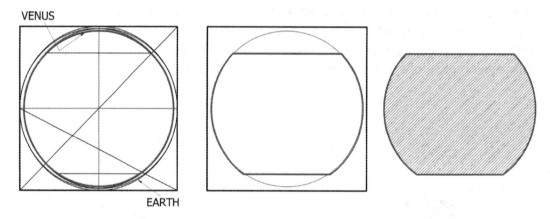

Drawing 5.7. *The Venus vessel occupies .6214, or about 5/8 of the square—a minor sixth. The number .6214 is also very close (within 99 percent) to 1/ϕ.*

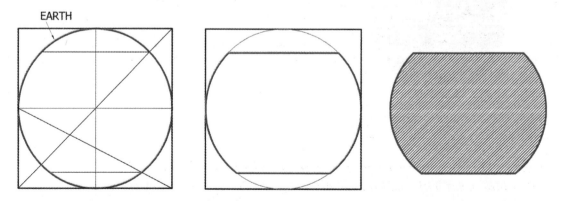

Drawing 5.8. *The Earth vessel occupies 27/40 (.675) of the area of the square. This interval is called a "grave fifth."*

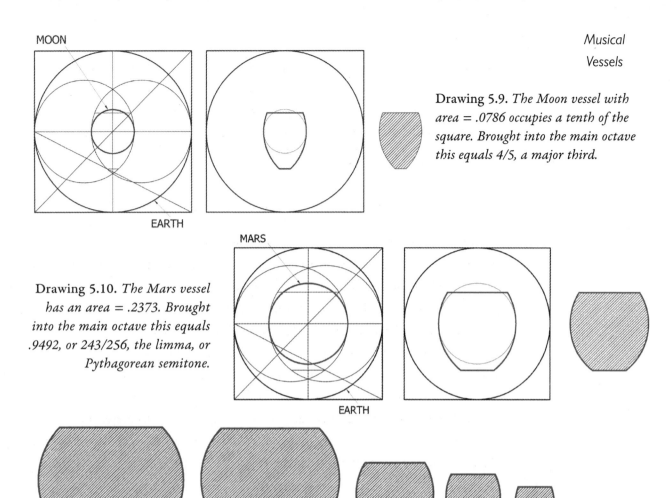

Drawing 5.9. *The Moon vessel with area = .0786 occupies a tenth of the square. Brought into the main octave this equals 4/5, a major third.*

Drawing 5.10. *The Mars vessel has an area = .2373. Brought into the main octave this equals .9492, or 243/256, the limma, or Pythagorean semitone.*

(A) Earth     (B) Venus     (C) Mars    (D) Mercury   (E) Moon

Drawing 5.11. *The ratios among the areas (as noted in drawings 5.6-5.10) of the planetary vessels along with descriptions and historical references. Our translations of the inner planets and the Moon into pottery forms and the further translations of their area ratios into musical ratios hopefully will allow us to appreciate, in a different way, the relations among the planets. The following intervals have been brought into a single octave.*

> A/B = 13/12, a three-quarter tone (Ibn Sina)
> A/C = 1.414, octave of √2, the geometric tritone
> A/D = octave of 11/9, a one-and-three-quarter tone (Partch)
> A/E = octave of 15/14, a semitone (Ptolemy, Al Farabi)
> B/C = 2.618 = $\phi^2$, brought into octave it equals .764, a flatted fourth
> B/D = 9/8, the just whole tone
> B/E = 160/81, the inverse of the syntonic comma of 81/80 ratio
> C/D = 12/7, a septimal sixth
> C/E = 3/2, the perfect fifth
> D/E = 7/4, a just minor seventh (Ptolemy, Mersenne, Partch)
> (See drawing A2.15 on page 210 for more pottery forms.)

Perhaps this sort of exercise can serve as a model for investigations of space by designers who wish to have an anchor in law, in this case the laws of geometry and of tonal intervals, yet wish to *play* with number and form. Such an approach might also appeal to musical composers who would like to experiment with tones derived from geometry.

## THE WORLD IN A GRAIN OF SAND

Throughout the book we have seen the power of the vesica as a tool of form generation. Now let us do another exercise with those most common vesica forms of all: leaves. It is interesting to look at leaves and other vesica-shaped forms such as eyes and fish in a harmonic way—that is, as tonal phenomenon. In figure 5A we have taken three leaves and applied tonal vesicas to their borders. Perhaps these are in some way the primal "tones" of the leaves, which each leaf in a species plays in its own way, some a bit higher and some lower. Could we expand this idea to include different kinds of beings such as a fish whose length-to-width ratio equals that of a chosen leaf? Is there, then, some harmonic relation between them? And what of non-vesica-shaped beings that simply share the same length-to-width ratio?

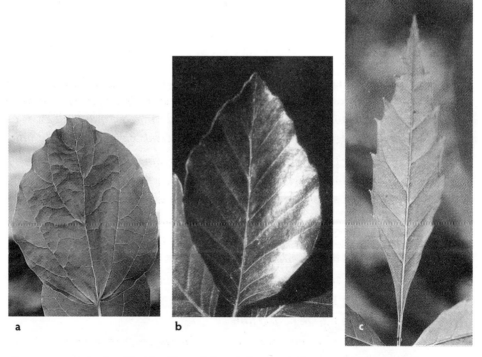

**Figure 5A.** *A scale of leaves. From left, southern catalpa, purple beech, ash.*

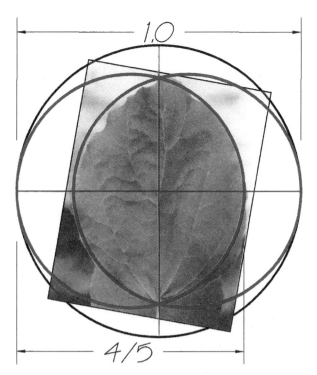

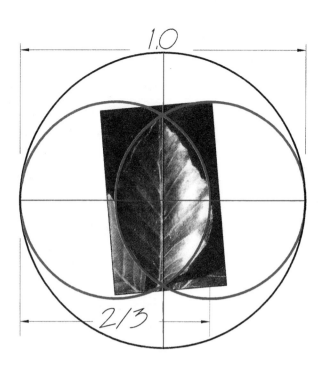

Drawing 5.12. *The southern catalpa leaf surrounded by the major-third vesica generated at 4/5 (.80) of the string/diameter length. The vesica has a length-to-width ratio of 1.291, the square root of 1⅔.*

Drawing 5.13. *The purple beech leaf is enclosed in a fifth vesica generated at 2/3 (.667) of the string/diameter. The vesica has a ratio of 1.732 = √3, making it a vesica piscis.*

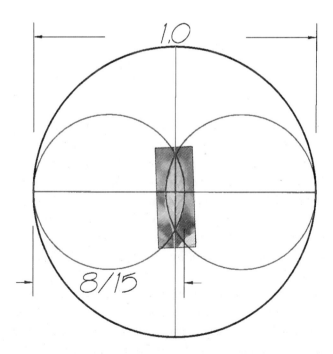

Drawing 5.14. *The ash leaf vesica has a generating tone of 8/15 (.5333), a major-seventh interval. The vesica ratio = 3.873 = √15.*

Let us have a closer look at all the forms a vesica might take within an octave structure. We may say that the vesica of the fundamental is a circle, and the vesica of the octave is a straight line. Thus the innumerable forms between the two represent all possible ratios of height to width and so numerically represent all created beings. Each of these vesicas can, of course, be considered as being generated from a particular tone, and each creature can be associated with a tone.

As the vesicas approach the octave we have seen that they become smaller and thinner. Yet at the same time their height-to-width ratio increases. They are, in essence, moving toward a point of infinitesimal thinness and infinite height-to-width ratio (drawing 5.15). There is an implied form that might help to illuminate the present subject. We recall the structure of the vesica, how its arcs enclose the octave, the center of the string/diameter.

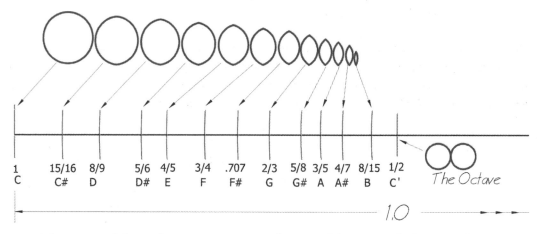

Drawing 5.15. *The vesicas of the twelve tones. Between each vesica there are implied intermediate vesicas that have their own tones. The area between the seventh (note B, 8/15) and the octave, for example, is a region in which vesicas of increasingly larger height-to-width ratios take form even as the vesicas themselves shrink in absolute height. Among those vesicas are the following (none of which are pictured here): An Arabic tone of ratio 33/64 (.5156), for example, generates a vesica of 5.656 ratio. The vesica with ratio = 7 is generated by the double septimal tritone of ratio 25/49 (.5102). The vesicas begin to appear like blades of grass as they approach the octave. The vesica with ratio = 11, which represents the diameter ratio of Jupiter to Earth—that is, Earth is the circle enclosed by the vesica, and the Jupiter circle encloses the vesica—is generated by a tone of 61/121 (.5041). The vesica with ratio = 109 is generated by the 5,940/11,879 tone (.500042084). This is the ratio that relates the diameters of the Sun and Earth—the Earth being the circle within the vesica and the Sun the circumcircle around the vesica. We begin to see the infinite spaciousness in the intervals between tones. In this last section of the scale, the vesicas become microscopic as the tones become more and more impossible to distinguish with human ears. Their numbers, however, reveal that the vesica ratios approach the infinite even as their physical heights approach the infinitesimal. For example, we can imagine a vesica in which the inner circle is the size of an atom and the outer circle the size of the Earth. Yet still, within the octave, space remains.*

Thus, when we consider all the tones as a whole, the result is a nested grouping of vesicas enclosed by a circle. Again, we have the universal ring shape in which an inner essence is held within a protecting vessel, a form shared by all beings from planets to cells to atoms. Here it consists of concentric layers of vesicas that symbolize the length-to-width ratios of beings of all sizes (drawing 5.16). The needle-like vesica generated from the Earth/Sun diameter relation in drawing 5.17 (p. 76) vesica would become almost invisible if it were shrunk to its proper height within drawing 5.16. An interesting fact is revealed when we consider the actual dimensions of this vesica: The Sun diameter (the length of the vesica) equals 864,000 miles, and the Earth diameter (the width of the vesica) equals 7,926 miles. Their ratio equals 109. Now, if we multiply 109 × 864,000 we get the actual size of the $C_1$ enclosing circle in the vesica construction,

$$864,000 \times 109 = 94,176,000 \text{ miles,}$$

which, surprisingly, happens to be the aphelion distance from the Earth to the Sun,

$$\text{Sun/Earth} = \text{Aphelion/Sun} = 109.$$

Thus there are 109 Earths in the Sun diameter and 109 Suns from the Earth to the Sun.

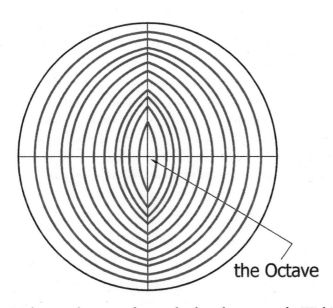

the Octave

Drawing 5.16. *The nested vesicas of a standard twelve-tone scale. Within the central vesica is space for an infinity of vesicas whose ratios become progressively larger as they shrink in size toward the infinitesimal.*

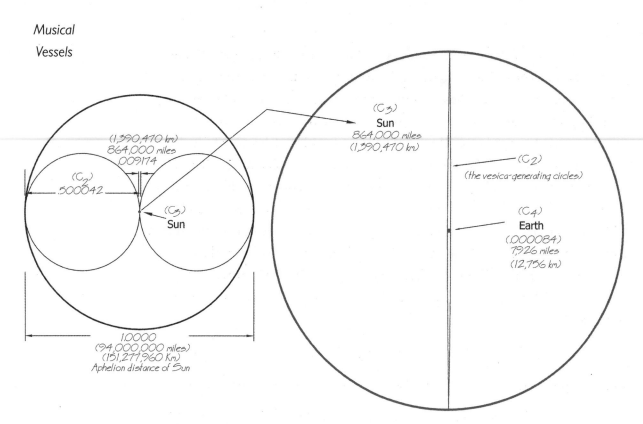

Drawing 5.17. *A computer-generated measured conception of a vesica construction giving a sense of the relative sizes of Earth and Sun. The C₂ vesica-generating circles are very close to the octave (.50) having the string-length values of .500042, which generates the long thin Earth-Sun vesica with length-to-width ratio of 109. In the drawing on the left the C₃ circle that contains the vesica is too tiny to be seen. We scale it up, and the drawing on the right reveals the tiny Earth within its needle-like vesica, both contained within the gigantic Sun. Besides the realization of how small the Earth is in relation to the Sun there is another interesting fact brought out by the geometry— namely, that the containing circle (C₁) (shown on the left) for the C₂ vesica circles has a dimension that translates into the Sun-Earth distance, specifically the aphelion, or farthest away distance, of around 94 million miles (see accompanying text description of this phenomenon and the proportion it generates). A simpler classical construction, of similar accuracy, of the Earth-Sun size relationship can be done using an octave-reduction technique that is demonstrated in the following chapter.*

# 6

⸙

# THE SPIRALING OCTAVE

ONE PURPOSE OF THIS BOOK IS TO ENCOURAGE readers to become familiar with the ancient tools of tone, number, and geometry in order to use them to create new forms—forms that will reflect the harmonies inherent in the numerical structures of the world. We have previously seen a few examples of how such tools might have been used by the ancient temple builders. And, in our exercises with planetary and lunar dimensions we have discovered possible harmonic processes behind their formation.

In this chapter we will use our tools to create harmonious forms using two essential figures of the harmonic realm—namely, the octave and the spiral. The numbers that emerge from these experiments will be expressed geometrically in order that we may visually experience them. Let us begin by again looking at our Earth-Sun construction, yet this time in the context of an octave-halving progression of the Earth diameter. We consider the Sun of 864,000 miles diameter equal to 1 and the Earth of 7,926 miles diameter equal to 1/109. We need to bring this fraction into the main octave, which we can do by doubling it 6 times:

$$2/109, 4/109, 8/109, 16/109, 32/109, 64/109.$$

The sixth double, 64/109 (.5872), can be located on the string/diameter of the Sun circle using crossed diagonals as shown in drawing 6.1 (p. 78). A circle is drawn that intersects the generated point on the horizontal diameter and

**The Number 108 is
important in spiritual
and cosmic contexts.
The Zen priest wears
a juzu, a bracelet with
108 beads. The Hindu
has a japa mala rosary
with 108 beads. The
Tibetan Buddhists
also have a 108-bead
rosary. Some say
there are 108 gopis,
the female disciples of
Lord Krishna. Both
Ayurvedic and Chinese
medicine recognize
108 pressure points on
the body. Yang-style
tai ch'i has 108 moves.
There are 108 dance
forms in the Indian
tradition. The ratio
3/11, the Moon/
Earth diameter ratio,
multiplied by 108 is
equal to 29.455, which
is within .997 of 29.53,
the days in a lunation.
And 108 divided by
4 equals 27, within
.988 of the lunar**

*(continued on p. 79)*

extends to the circumference of the enclosing Sun circle. Locating the center of the initial 64/109 circle gives us the first octave point at 32/109, and we draw a circle through it as we did with the main octave point. We continue until we reach the sixth octave, whose circle is the size of the Earth circle in relation to the containing Sun circle.

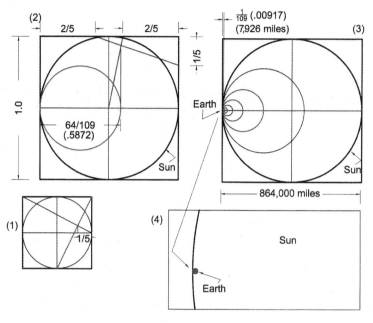

Drawing 6.1. *The Earth-Sun octave construction, clockwise from bottom left, (1) shows us the construction of the 1/5 point on the string/diameter that we can then transfer to our main drawing, (2) in which a 64/109 diameter $C_2$ circle is constructed. Through a sixfold octave reduction, (3) a circle is found that has the size of the Earth diameter in relation to the main enclosing circle that represents the Sun. In (4) the Earth circle is enlarged and shown in relation to a circumference arc of the Sun.*

The 64/109 tone (.5872) is very close (within 99 percent) to the Pythagorean major sixth of 16/27 (.5925) ratio. Their difference is 108/109. If we were to substitute the Pythagorean ratio into our geometry, our octave halving would result in an Earth diameter of exactly 8,000 miles and a Sun/Earth ratio of 108:

$$864{,}000 \text{ miles} \div 8{,}000 \text{ miles} = 108.$$

With these round numbers we seem to have entered the realm of the archetypal, of Plato's world of perfect Forms symbolized by simple integral ratios, pure tones, and straightforward geometry.

# THE SKY SPEAKS

The Sun number of 864 is the octave of 432, which is within the main doubling-generated octave 256–512. In this octave, 432, which is at the Pythagorean-sixth interval position of 16/27—that is, 256/432 = 16/27—we can get an insight into the harmonic nature of the imperial (mile/foot) system of measure.

The Pythagorean-sixth interval position of 432 is also the octave of 216 (2 × 108), the Moon number, the Moon diameter being 2,160 miles, and 216 × 2 = 432. Thus, our "ideal Earth" of 8,000 miles, our Sun of 864,000 miles, and our Moon of 2,160 miles all fit into a seamless harmonic system. It is interesting that the measured Earth of 7,926 miles must be perfected or idealized so as to fit into this cosmic system. Perhaps this is the heavenly message to us—that we, as co-creators, must bring the Earth to a state of cosmic perfection in order to harmonize with the Universe. All these small discrepancies, or "commas," that arise in our harmonic studies remind me of the refrain from Leonard Cohen's song "Anthem": "There is a crack in everything / that's how the light gets in."

sidereal period of
27.32 days. The
number 108 times the
2,160-mile diameter
of the Moon equals
233,280 miles, which
is about the average
distance from Earth
to Moon. (Oddly
enough, about the
same distance, i.e.,
234,054, results from
multiplying Earth's
diameter of 7,926
by the lunation cycle
of 29.53 days.) And
108 times Earth's
diameter of 7,926 miles
equals 856,008 miles
(the Sun diameter
within 99 percent).
Substituting our "ideal
Earth" of 8,000 miles,
as described in the
text, makes the Sun
diameter exact at
864,000 miles; and
108 times this Sun
diameter equals
93,312,000 miles,
which is the average
of the Earth-Sun
distance.

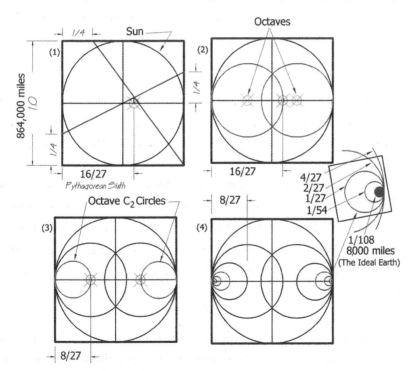

Drawing 6.2. *The octave construction of the "ideal Earth" on the face of the Sun. In (1–2) the Pythagorean-sixth vesica construction is made. In (3–4) octave circles are located resulting in an Earth circle 108th the size of the Sun circle, or, in actual measurement, 8,000 miles.*

Let us look more closely at this discrepancy, or "comma." The difference between the measured Earth (7,926) and the ideal Earth (8,000) is 74 miles. An interesting number results when we divide 8,000 by 74:

$$8,000 \text{ miles} \div 74 \text{ miles} = 108.108108,$$

which mysteriously yet obviously emphasizes the importance of this number 108.

The reciprocal of 74 equals 1/74, which, when brought into the main octave, is 1/74, 1/37, 2/37, 4/37, 8/37, 16/37, 32/37—and

$$32 \div 37 = .864864, \text{ the Sun number repeated.}$$

Also, let us consider the *reciprocal* of the ideal 108 Sun/Earth ratio that we can superimpose on the ideal Earth:

$$1/108 \times 8,000 \text{ miles} = 74+ \text{ miles } (74.074).$$

The physical result of this experiment would be a circular area of 74 miles diameter, representing the Sun, located on Earth. Interestingly, the measured Earth equals the ideal Earth minus the Sun reciprocal: 8,000 miles − 74 miles = 7,926 miles, as if to say that the way to bring Earth into perfection somehow lies with the Sun—perhaps the honoring of the Sun in the manner of ancient civilizations or changing our energy systems to solar power.

Let us apply our Sun/Earth reciprocal to the Moon. Our Earth/Sun reciprocal circle of 74 miles fits within the diameter of the Moon 29.19 times—very close to the 29.53 number of days in a lunation: 2,160 miles ÷ 74 miles = 29.19 miles.

Again we encounter a small discrepancy, or comma, between the calculated and the real. In this case the difference between 29.53 and 29.19 is about a syntonic comma of 80/81, the same little interval that we have used to transform Pythagorean intervals to just-intonation intervals. Thus 81/80 × 29.19 = 29.55, which is within 99 percent of the 29.53 lunation period.

\*

But we have digressed from our themes of octave and spiral. Because the use of φ-family ratios as generating tones in our constructions generally result in harmonious figures, we have used φ-based octave constructions in drawings 6.3 and 6.4 to construct figures related to our now familiar 4/φ number that we first encountered in the Apollo temple ratio.

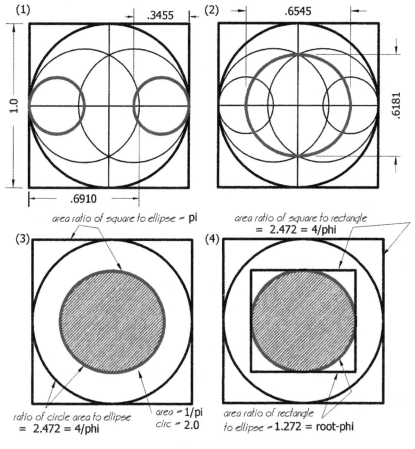

area ratio of square to ellipse = **pi**

area ratio of square to rectangle
= **2.472 = 4/phi**

ratio of circle area to ellipse
= **2.472 = 4/phi**

area = **1/pi**
circ = **2.0**

area ratio of rectangle
to ellipse = **1.272 = root-phi**

Drawing 6.3. *Using the octave construction at the ϕ tritone, a subtle ellipse with length-to-width ratio of 17/18 is produced within a context filled with harmonious relationships. (1) The vesica-generating circles are halved— that is, they are at the octave of the generating tone of .691 since .691/2 = .3455. (2) The centers of the octave circles are joined with the vesica poles to produce an ellipse. In (3) we see the ellipse in relation to the containing circle. Their area relation is 4/ϕ, our now familiar Apollo temple ratio. In (4) the ellipse is enclosed in a rectangle with ratio of 17/18, the string-length ratio of an Arabic semitone. This design could be the plan for a harmonic garden.*

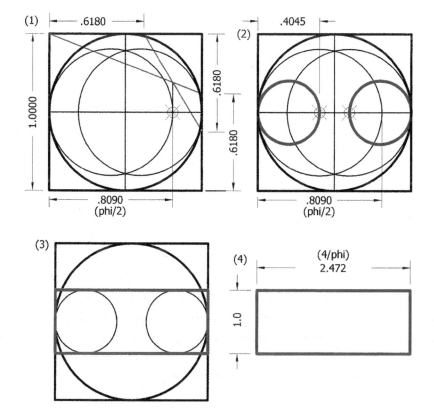

Drawing 6.4. *(1) At the .809 (ϕ/2) point on the string/ diameter a vesica is constructed. (2) Then two octave circles are drawn. (3) and (4) The rectangle joining them has a ratio of 4/ϕ or 2.472, the ground-plan ratio of the Apollo temple described in chapter 2.*

81

# OCTAVE SPIRALS

We have seen how the vesica-construction matrix is able to generate octaves of the fundamental tone. There is another way we can geometrically express octaves with the vesica construction. This is by using the vesica spiral as shown in drawing 6.5. The height-to-width ratio of the vesica determines the ratio of the progression of this straight-line spiral. Thus, in our example we have constructed a vesica with the ratio of 2 from our minor sixth tone. The segments of the straight-line spiral are in 2-to-1 ratio, the ratio of the octave. In our second example (drawing 6.6) the ratio of the vesica is 1.5, which is the frequency ratio of the perfect fifth with string length of 2/3 (.667) of the musical string. The spiral that we then construct contains a progression in which each tone segment is followed by a tone segment that is in a fifth relation to it. This is the ancient spiral of fifths that establishes the tones of the Pythagorean scale. In the process of unfolding twelve tones we traverse seven octaves. There is, however, a discrepancy, a comma, which becomes apparent when we transpose a number of the tones back to the main octave. Among these is the final tone just sharp of the octave by the fraction 73/74—the Pythagorean comma.

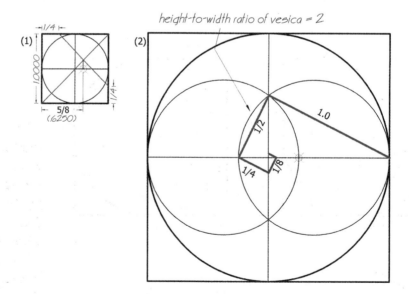

**Drawing 6.5.** *(1) The minor sixth tone with string-length ratio of 5/8 is established. (2) The vesica construction at the minor sixth generates a vesica of height-to-width ratio of 2. A straight-line spiral is then constructed in which adjacent segment lengths are in the ratio of 2. Thus by considering the segments as string lengths we can visually get a sense of the pitch relationships of the successive octaves. We can do this procedure with any vesica: the vesica ratio will determine the progression of tones.*

82

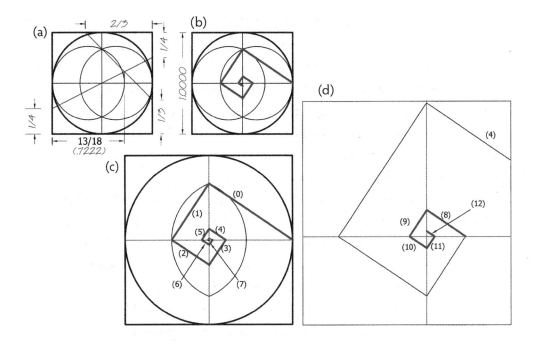

Drawing 6.6. *The spiral of fifths. In (a) the 13/18 tritone (the inverse of the φ tritone of 9/13) is constructed generating a vesica with length-to-width ratio of 3/2, the frequency ratio of the fifth. This allows us to draw a spiral (b) whose successive segments, considered as musical strings, are in a fifth relation to one another. In the accompanying table are the segment-length ratios and their ratios when transposed and adjusted with the Pythagorean comma of 74/73 to the main octave. The result is the tones of the Pythagorean scale:*

| Fifth | Segment lengths | Adjusted to main octave |
|:---:|:---:|:---|
| *(0)* | *1/1* | *C 1/1 fundamental* |
| *(1)* | *2/3* | *G 2/3 fifth* |
| *(2)* | *4/9* | *D 8/9 whole tone* |
| *(3)* | *8/27* | *A 16/27 sixth* |
| *(4)* | *16/81* | *E 64/81 third* |
| *(5)* | *32/243* | *B 128/243 seventh* |
| *(6)* | *64/729* | *F♯ 512/729 tritone* |
| *(7)* | *128/2,187* | *C♯ .9362 × comma = 243/256 minor second* |
| *(8)* | *256/6,561* | *G♯ .6243 × comma = 81/128 minor sixth* |
| *(9)* | *512/19,683* | *D♯ .8324 × comma = 27/32 minor third* |
| *(10)* | *1,024/59,049* | *A♯ .49 × comma = 9/16 minor seventh* |
| *(11)* | *2,048/177,147* | *F .7399 × comma = 3/4 fourth* |
| *(12)* | *4,096/531,441* | *C′ .4933 × comma = 1/2 octave* |

# MUSICAL SPACES

As we have seen, an acceptance of the foot-mile system as valid cosmic measure is important for the understanding of this work. While it is true that the ratios between space and time measures, such as the ones we have been looking at, would be meaningful no matter what the measuring system, the presence of "canonical" mile measures, many of which are related to musical numbers, weaves the systems of harmonic science into a meaningful tapestry—a tapestry that lends color and life to the otherwise ascetic realm of dry number. The Sun number 864 (864,000 miles = Sun diameter) relates to the Moon number of 216 (2,160 miles = Moon diameter) through 4. This would be the same in any system, yet 864 is also a musical number, being an octave up from 432, a number prized by many musicians as an alternative to the A = 440 Hz standard. The 432 A relates to its fundamental of 256 through the Pythagorean-sixth interval of a 16/27 string length—that is, 256/432 = 16/27. It makes sense that 432, the Sun radius number, would set the tone in a meaningful solar system. Although we relate these numbers now to the modern cycles-per-second system, the numbers themselves served the harmonic arts in ancient times. The doubling geometric progression series 1, 2, 4, 8, 16, 32, 64, 128, 256, 512 was well known to the ancients, and they used it to form their musical intervals. They combined the doubled numbers with the tripling geometric series 1, 3, 9, 27, 81, 243, 729 to define the tones of the Pythagorean scale. As we previously noted, when multiples of 5 were included in the numerical toolbox, certain musical ratios became simpler—that is, they could be composed of smaller numbers: thus the Pythagorean 16/27 becomes 3/5 in just intonation. The "5-limit" numbers, though welcome simplifications of interval ratios, unfortunately have obscured the cosmic associations of the Pythagorean ratios such as we have seen with the Pythagorean sixth.

Here is an interesting aspect of our Sun number 864, which John Michell calls the foundation number. He writes: "In the language of symbolic number 864 clearly pertains to a center of radiant energy, the sun in the solar system, Jerusalem on earth, the inner sanctuary of the temple, the altar within it, and the corner stone on which the whole edifice is founded."[1]

The frequency number 864 may be used to create a Pythagorean scale. We begin by reducing 864 along with two of its permutations—namely, 486 and 648—to their tones: 864 is within the 512–1,024 octave. Thus

512/864 = 16/27, the Pythagorean sixth. The number 486 is within the 256–512 octave: 256/486 = 128/243, the Pythagorean seventh. And 648, in the 512–1,024 octave, becomes 64/81, the Pythagorean third. Next we divide the third by the seventh, which equals 2/3, the fifth; and we divide the third by the sixth to give us 3/4, the fourth. Then the seventh is divided by the sixth to give us 8/9, the whole tone. The result is a seven-tone Pythagorean scale: 1, 8/9, 64/81, 3/4, 2/3, 16/27, 128/243.

Other important tones that are rare in practical music making include, as we noted earlier, the undecimal tones. We have seen in chapter 2 how the number 11 had an importance to the ancients rarely found in modern approaches to harmonic thought. In ancient times there were many undecimal tones in use, particularly in the Arabic world: an 11/16 (3¼) tone; an 11/18 (4¼) tone; a 6/11 Arabic neutral seventh that we used in drawing 2.1 to generate the 11/1 Jupiter-to-Earth diameter ratio; an 11/12 tone used on the Arabic lute, which is a tone that refers to the Earth/Sun ratio: 792/864 = 11/12; a 10/11 whole tone cited by Ptolemy; a 22/27 tone of the eighth-century musician Zalzal, whose octaves 11/27, 11/54, 11/108, 11/216, 11/432 are composed of Moon and Sun numbers (see drawing 6.7).

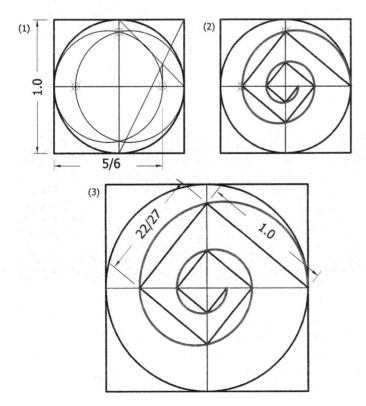

**Drawing 6.7.** *The construction of a spiral whose ratio equals the tone known as the "Wosta of Zalzal." (1) A minor 3rd diagonal construction generates a vesica with the ratio (within 99%) of 27/22 (1.2272). (2) A straight line spiral whose adjacent segments are in the ratio of 22/27 is constructed. A three-point circle arc spiral is constructed on the straight-line spiral. (3) The finished spiral showing the tonal relationship. The Wosta of Zalzal is named after its creator, Mansur Zalzal, an Arabic musician of the early ninth century. The string-length ratio, 22/27 (.8148), is called a "neutral third."*

85

The spiral form that we have been considering is the gesture of the octave progression as its tone spirals inward, sounding higher and higher pitches during its journey within the realm of vibration. We can imagine this form in three dimensions like a spiral staircase as it recedes from sight into the regions where the tones can only be detected by the most sensitive instruments. And still the spiral keeps winding into the realm of unimaginably high pitches.

*Drawing 6.8. (1) The vesica construction at the major third uses crossed diagonals to establish the 4/5 (.80) tonal point. (2) A straight-line spiral is constructed. The segments are in 1.291 ratio. (3) A spiral composed of three-point circle arcs is drawn. (4) This spiral approximates the logarithmic spiral of the nautilus.*

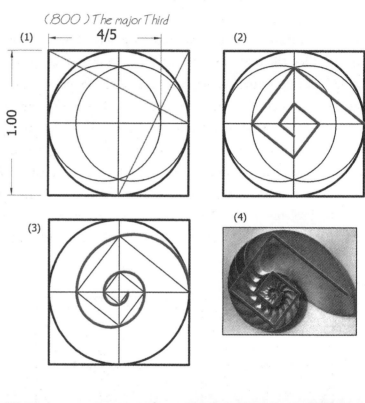

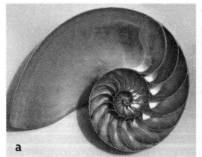

Figure 6A. *Pictured here are (a) Nautilus shell; (b) Begonia 'Duartei' leaf; and (c) spiral galaxy M74. Regarding the spiral, A. S. Eddington wrote: "The form of the arms—a logarithmic spiral—has not yet given any clue to the dynamics of the spiral nebulae. But though we do not understand the cause we see that there is a widespread law compelling matter to flow in these forms." A.S Eddington[2]*

There is one spiral that can be constructed with circle arcs rather than spiral arcs. This is the golden spiral, an archetypal logarithmic spiral that can be constructed with classical geometry—that is, with lines and circles. Drawing 6.9 shows the golden spiral alongside a spiral drawn from points on the border of a nautilus shell.

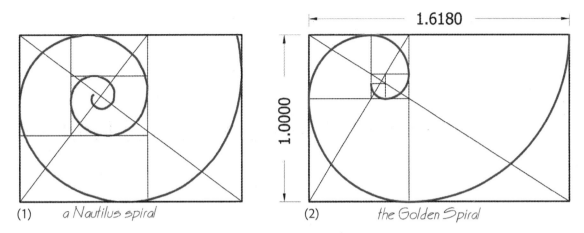

(1)   *a Nautilus spiral*      (2)   *the Golden Spiral*

**Drawing 6.9.** *Two spirals, (1) one produced from points along the edge of a nautilus shell, (2) the other the golden spiral constructed from circle arcs. These are examples of gnomonic growth. The gnomon is a figure that, when added to an original figure, generates a new figure with the same proportion as the original. With the golden rectangle, shown on the right, the gnomon is a square that, when added to a golden rectangle, results in another golden rectangle. Thus the shape of the golden rectangle consists of a spiral of squares. The same gnomonic principle applies to all logarithmic spirals (such as the nautilus spiral): each spiral can be analyzed by a spiraling succession of rectangles of equal ratio.*

# 7

# HARMONIC STRUCTURES

IN OUR WORK SO FAR WE HAVE PRESENTED SOME POSSIBILITIES for form creation using the tools of harmonics—namely, number, tone, and geometry. "Harmonics" refers to a way of knowledge that was practiced by the ancient philosophers and the builders of civilizations. The above-mentioned tools enabled the ancient harmonicists to perceive correspondences among the diverse phenomena of the world and thus to make some sense of the vastness of existence. The discovery of the numerical foundations of music may have been the catalyst that, along with the long-observed astronomical cycles, awakened in humans the concept of recurrence and of higher states of being (octaves), deepened the aesthetic sense that perceives the harmonious relation of parts to wholes and parts to parts (intervals within octaves), and, for the subtle of hearing, suggested hidden properties, a microcosm, within things (the tone and its overtones).

The numbers that arose from the musical scale and from geometry were perceived by the ancients to have an eternal character and thus were able to provide a firm foundation for the study of the ever-changing landscape of existence. While cosmic time cycles had long proven to be fixed and dependable numerical sources, with the discovery of tonal numbers and the continuing solutions of many numerical questions provided by geometry there were now tools enough for a new science based on number. In the present work our emphasis has been the creation of new forms using these tools of harmonics. We will now attempt

to transmute those properties of tone called overtones, or harmonics, into a geometric context so as to continue with the work of form creation.

# THE HARMONIC SERIES

In seeking a natural source for musical intervals we naturally arrive at the study of the overtone, or harmonic, series of ratios, which we briefly introduced in chapter 1. In this book we will refer to the members of the series as harmonics rather than overtones. The first harmonic is considered to be the fundamental tone. The harmonic series arises from the fact that a plucked musical string or a column of air in a wind instrument vibrates as a whole but also simultaneously vibrates in two parts, three parts, four parts, and so on. These divisions are, theoretically, endless in number. The result is that besides the fundamental tone, innumerable other tones are subtly sounded in higher and higher octaves. Division into two produces the octave; into three the octave fifth; into four the double octave; into five the double-octave third; into six the double-octave fifth, and so on. We also note that the tonal string-length ratios are the reciprocals of the frequency ratios (the vibrations per unit of time) of the string. Thus at the octave node of one-half the string length the frequency of the string is twice that of the fundamental frequency. At the fifth node of one-third the string length the frequency of the string is three times that of the fundamental frequency.

The harmonics are integral parts (or partials) of the tone produced by the fundamental and give the tone a richness the quality of which depends on the

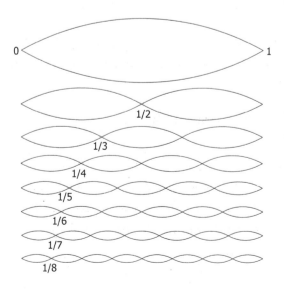

Drawing 7.1. *The first eight harmonic divisions of the musical string. The incomprehensible yet scientific fact is that all of these wave patterns (and others of higher frequency) exist simultaneously on the vibrating string.*

instrument—that is, some instruments will emphasize certain harmonics and others will have a different set of emphasized harmonics.

This is a simplified description of a complex subject, since our purpose here is not to repeat readily acquired facts but to examine the phenomenon of harmonics using geometry to bring this all-important principle of the vibrating world into the realm of the visible. Our hope in so doing is that we may discover new forms that have a foundation in natural law.

## THE MEAN

As we have seen, the harmonic division of the musical string results in segments with lengths of 1/1, 1/2, 1/3, 1/4, 1/5, 1/6, 1/7, and so on. These fractions are the reciprocals of the series 1, 2, 3, 4, 5, 6, 7 . . . , whose members relate to one another through what is called the arithmetic mean. The formula for the arithmetic mean is

$$(a + c) \div 2 = b \text{ (the arithmetic mean)},$$

where $a$ and $c$, any two numbers in the series, are called the extremes that are joined by $b$ (the arithmetic mean), which lies halfway between the two numbers. For example:

$$(1 + 3) \div 2 = 2$$
$$\text{or} \quad (3 + 7) \div 2 = 5.$$

The arithmetic mean is thus the average between the extremes.

When we consider our string-length fraction series of 1/1, 1/2, 1/3, 1/4 . . . , we find that those numbers are related by a different kind of mean—namely, the harmonic mean, whose formula is

$$2ac \div (a + c) = b \text{ (the harmonic mean)}.$$

We find an example of the harmonic mean between the ratios 1/2 and 1/4: $(2 \times 1/2 \times 1/4) \div (1/2 + 1/4) = 1/3$. So in the series 1/2, 1/3, 1/4 the harmonic mean between 1/2 and 1/4 is 1/3. The harmonic-mean relation exists between any three consecutive numbers in the harmonic series. For example, the harmonic mean between 1/9 and 1/11 is 1/10.

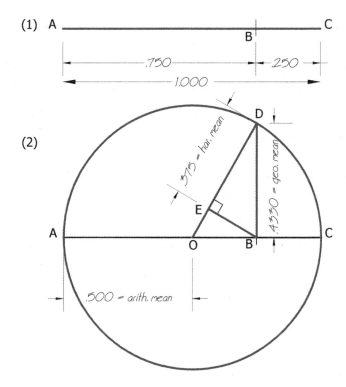

Drawing 7.2. *A construction attributed to Pappus of Alexandria (ca. 300 CE) that yields the arithmetic, geometric, and harmonic means. (1) A ≠≠≠line AC is sectioned at the 3/4 point producing extremes AB and BC. (2) The center O of AC is found, and a circle with diameter AC is drawn. A vertical line is drawn from B intersecting the circle at D. From D a line is drawn to the center O. A line is drawn from B to intersect OD at right angles at E. AO is the arithmetic mean between extremes AB and BC. BD is the geometric mean. DE is the harmonic mean.*

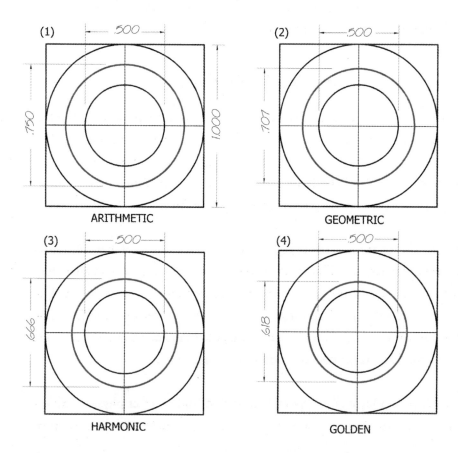

Drawing 7.3. *The arithmetic, harmonic, geometric, and golden means expressed as rings. The red circles are the means between the octave (.500) and the fundamental (1.00). (1) The arithmetic mean (the average) has a diameter of .75, or 3/4, the string-length ratio of the fourth. (2) The geometric mean has a diameter of the irrational .707. . . , the string-length ratio of the tritone, the tonal center. (3) The harmonic mean has a diameter of .666, or 2/3, the string-length ratio of the fifth. (4) The golden mean position on the scale is .618 (1/φ), which is quite close to the minor sixth at .625 (5/8).*

91

We can also find the means between adjacent numbers in the harmonic series. Thus, the harmonic mean between the fundamental (1/1)—that is, the open string—and the octave (1/2) is 2/3, which is the ratio of the perfect fifth. When we apply the arithmetic mean to this interval of 1 to 1/2 we derive the interval of the perfect fourth, 3/4. And, actually, between any two numbers we can calculate the harmonic, arithmetic, or geometric mean.

The formula for the geometric mean is

$$\sqrt{(ac)} = b.$$

In the musical scale the geometric mean locates the center of the scale, which lies between the fourth and the fifth. It is the interval called the tritone that we studied in chapter 2. Between the fundamental 1/1, and the octave 1/2, we calculate the geometric mean:

$$\sqrt{(1 \times 1/2)} = .707. \ldots$$

The root function has taken us out of the realm of rational numbers and located the mysterious center of the scale for which we must find a rational approximation to be able to sound a tone.

# THE RECIPROCAL

A difference between the arithmetic series (1, 2, 3, 4 . . .) representing the frequencies and the reciprocal harmonic series representing the string lengths (1/1, 1/2, 1/3, 1/4 . . .) is that the intervals between the former remain constant at 1 and the intervals between the latter are constantly diminishing in the way, as Hans Kayser notes, telephone poles recede in perspective.

In geometry the reciprocal concept is often used as a way of harmoniously dividing rectangular space. The result is a second rectangle that is smaller than the initial rectangle but possesses the same proportions, such as a rectangle with a ratio of 3 containing a rectangle with ratio of 1/3 (see drawing 7.4). The smaller reciprocal rectangle can also be constructed outside the main rectangle as shown in the Parthenon construction of drawing 2.8.

Ratio and reciprocal form an inseparable unit that finds perfect physical expression in the vibrating string. In a wider sense the idea of number and recipro-

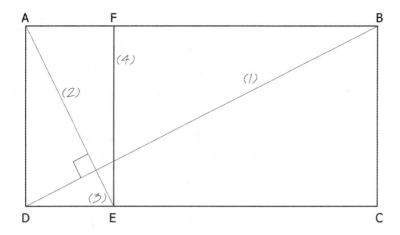

**Drawing 7.4.** *A rectangle may be proportionally divided by a reciprocal construction so that the inner rectangle is self-similar to the whole.*

> *To construct the reciprocal:*
>
> *(1) Draw diagonal DB on rectangle ABCD.*
> *(2) Drop a perpendicular to DB from the corner A.*
> *(3) Extend this line to side DC to point E.*
> *(4) From point E erect line EF perpendicular to AB.*
>
> *Rectangle AFED is the reciprocal rectangle of ABCD, both having the same ratio and resulting in the proportion of sides AB/AD = AD/DE.*
>
> *Relating the construction to the frequency/string-length relation of the harmonic series:*
>
> > *Keeping AD fixed at 1, then AB = the frequency of a string at a particular tone and AF equals the string-length ratio of that tone. If AB = 4, then AF = 1/4; if AB = 7, then AF = 1/7, and so on.*

cal points to the relation of large to small, a universal concept contained in the idea of microcosm, mesocosm, and macrocosm. The mesocosm, the middle cosmos, can be considered as the central place between the infinite and the infinitesimal. It could, in tonal terms, be considered as the central octave between 256 and 512 Hz, from C to C' in which all the tones are gathered. The microcosm is the place of higher and higher octaves as they approach the atomic world. The macrocosm is the place of the very large, of planets and solar systems and galaxies, where the idea of lower octaves can be applied to orbits and galactic time cycles and to the incredibly deep sounds that the cosmologists believe were present in the early universe.

The reciprocal concept can help us to imagine and to connect the microcosmic and the macrocosmic. We might wonder if there are reciprocal connections

between these vast regions of existence. While much has been measured in both regions, what is lacking is a module or mean, representing unity, that is required to place an element in one region into reciprocal relation with an element in the other region. With simple numbers we assign the module to 1. Thus 10/1 ("macro") is in reciprocal relation to 1/10 ("micro"). If there is such a module that joins the large and the small, how might we discover it? Again, it relates to the quest to find the center that we spoke of earlier—the center of the cosmos, or the center of the scale. When we are at the center we can orient ourselves. We are no longer lost. With our present subject we seek the meso-cosmic standard that will help us to see the relation between the large and the small. We have heard that "man is the measure of all things." Let us take that maxim literally.

We will use orders of magnitude in metric terms to give us an example of this idea. (We have, for simplicity's sake, taken the height of a human to be $10^0$, or 1 meter, which is the height of a young human.)

$$\text{diameter of sun} = 10^9 \text{ m}$$
$$\text{height of human} = 10^0 \text{ m}$$
$$\text{size of DNA helix} = 10^{-9} \text{ m}$$

Thus the human becomes the module, and the proportional statement is

$$\text{sun : human :: human : DNA.}$$

This has some meaning. The outside regulator of physical life is in reciprocal relation to the inner regulator of physical life. DNA, as we have found in recent times, radiates photons of light. Thus we are poised between the Great Light and the Lesser Light. Another example:

$$\text{distance from earth to sun (AU)} = 10^{11} \text{ m}$$
$$\text{human} = 10^0 \text{ m}$$
$$\text{diameter of hydrogen atom} = 10^{-11} \text{ m}$$

The human is in relation to the generator of solar energy, the hydrogen atom, as the distance that energy travels is to the human:

$$\text{hydrogen atom : human :: human : AU}$$

A final comparison with the Moon as the mean term:

$$\text{diameter of known universe} = 10^{26} \text{ m}$$
$$\text{moon diameter} = 10^{5} \text{ m}$$
$$\text{proton radius} = 10^{-16} \text{ m}$$

The proton at the center of the Moon feels the moon symbol of the whole known Universe around it in the same way that the Moon feels the actual universe around it.

proton : Moon :: Moon : Universe

# MUSICAL RECTANGLES

The architects of the Renaissance favored commensurable ratios based on musical consonances. Andrea Palladio (1508–1580), for example, recommended the following ratios for the layout of rooms.

1:1, the unison
3:4, the fourth
2:3, the fifth
3:5, the sixth
1:2, the octave

Palladio also included one incommensurable ratio in his list: $1:\sqrt{2}$, the geometric tritone.

Leon Batista Alberti (1404–1472), another Renaissance architect, recommended the following room dimensions.

3:4, the fourth
2:3, the fifth
9:16, a minor seventh
1:2, the octave
4:9, the octave whole tone
3:8, the octave fourth
1:3, the octave fifth
1:4, the double octave
1:1, the unison

Alberti wrote that

the same Numbers by means of which the Agreement of Sounds affects our Ears with Delight are the very same which please our Eyes and our Mind. We

shall therefore borrow all our rules for the finishing of our proportions from the musicians who are the greatest masters of this sort of numbers and from those things wherein nature shows herself most excellent and complete.[1]

This same idea had been expressed during the early medieval period by writers such as Boethius and Augustine, who influenced the Gothic architects in their use of musical numbers in their proportions.

In the nineteenth and early twentieth centuries many concert halls were designed using the ratios of consonant musical intervals. Levy and Levarie list the proportions of a number of concert halls in *Tone*.[2] Some of these with their length, width, and height proportions are listed below.

| Hall | L | W | H |
|---|---|---|---|
| Bern Conservatory | 6 | 3 | 2 |
| Symphony Hall, Boston | 12 | 6 | 5 |
| Severance Hall, Cleveland | 10 | 5 | 3 |
| Gewandhaus, Leipzig | 8 | 4 | 3 |

In these examples, the octave ratio of 1:2 determines the length-to-width ratio, and several other consonances—the fifth, minor third, sixth, and fourth—determine the width-to-height ratios. If it is true that the double square produces good acoustics, this might explain the widespread use of this ratio in the floor plan of ancient temples.

# THE VESICA-HARMONIC CONSTRUCTION

The vesica as tonal matrix lends itself to the expression of the harmonic series. The vesica itself represents a tone, and the harmonics of this tone are then arrayed around the vesica creating a concentric construction that can be manipulated in various ways to generate structures based on tone. Drawings 7.5 and 7.6 (p. 98) are examples of this idea. Both are generated from the interval of the minor third.

# THE MINOR THIRD

The minor third has what Hans Kayser calls "the character of longing, which lies in the innermost nature of this interval." Susan Elizabeth Hale writes:

> Remember some of your earliest songs? Many, like the nursery rhyme "Rain, Rain, Go Away," start with the descending minor third, which is heard when the first two words are sung. It is the first interval that is learned regardless of culture and so seems encoded into us.[3]

There is an important numerical property of the 5/6 ratio that may be mysteriously related to its psychic resonances. It forms a bridge between $\pi$ and $\phi$, or, more exactly, the square of $\phi$ (2.6180339). Thus:

$$5/6 \times \pi \ (3.1415926) = 2.6179938, \text{ and}$$
$$2.6179938 \div 2.6180339 \ (\phi^2) = .999984,$$
$$\text{so } \phi = \sqrt{5/6\pi}.$$

We also note that the 5/6 minor-third interval is important in the overall architecture of the scale. It is the ratio that divides the scale into four parts with about a 3/8 tone (27/28) left over in the central tritone region.

$$\text{fundamental to minor third} = 5/6$$
$$\text{minor third to tritone} = 5/6$$
$$\text{tritone to sixth} = 5/6$$
$$\text{sixth to octave} = 5/6$$

Finally, there is a proportional expression, called the contraharmonic proportion, whose mean term locates the minor-third interval:

$$(a^2 + c^2) \div (a + c) = b, \text{ the minor third}$$
$$\text{Thus: } (1^2 + \tfrac{1}{2}^2) \div (1+\tfrac{1}{2}) = b$$
$$\text{So: } (1 + \tfrac{1}{4}) \div 1\tfrac{1}{2} = 5/6$$

A construction generated from the minor third interval is shown in drawing 7.6 (p. 98).

Drawing 7.6 is a vesica-harmonic construction that gives a sense of the variety of approaches that one can follow within the theme of a single interval. Besides the many interval choices, such as just, Pythagorean, Arabic, or exotic intervals of one's own choosing, there are also innumerable groupings of harmonics that

*"Extremely rich possibilities offer themselves in the harmonical division canon . . . also in the division coordinates and the interval proportions . . . resulting from them. Thus, for example, one can develop the entire plan of a building, or a settlement, etc. on the basis of a third, a fifth, an octave structure, and thus have the advantage of giving these plans a very definite characteristic. At the same time, one knows that these proportions are not taken out of thin air but are psychically anchored, by way of tonal numbers, and therefore are part of our thinking and feeling."*

HANS KAYSER[4]

97

Drawing 7.5. *(1) Using the Pythagorean-sixth diagonal construction to get the length 16/27, as in drawing 6.2, we generate a vesica-harmonic construction using the first, third, and fifth harmonics. In (2) lines are drawn to the vesica-generating circles creating a rectangular pattern. After deletions, what might be a window set is revealed in (3). In (4) we analyze the proportions of the windows. What we have are two intersecting rectangles each with a length-to-width ratio of exactly 5/6, the just minor-third ratio. A whole tone (8/9) ratio exists between the proportions of the outer and inner windows. The three windows together fit into a rectangle of 1.276 within a few thousandths of 1.272, the √φ ratio.*

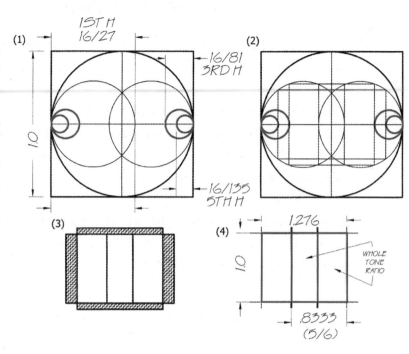

Drawing 7.6. *Beginning with the vesica construction for the just minor third with 5/6 string-length ratio, we (1) draw the circles for the second, third, and fourth harmonics. In (2) and (3) we enclose these harmonic circles in squares enclosed in a rectangle intersecting the poles of the vesica. In (4) we rotate the construction. (5) The finished building ground plan after a number of deletions and refinements.*

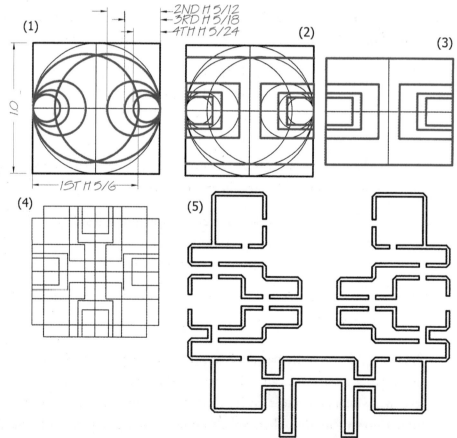

one may choose from to initiate such a construction. Once the initial pattern is established we can use ellipses, squares, rectangles, and so forth to connect elements. And, as we have done in this drawing, we can delete sections, revolve components to different angles, and generally follow our fancy while knowing that our construction has a solid basis in musical number. The finished product in the present drawing could be a ground plan of a building—perhaps a temple or the castle of a princess of Lemuria—or simply a drawing to stroll through in the company of our imagination.

# THE CIRCLE
# OF RESONANCE

AMONG OUR HARMONIC TOOLS IN THIS STUDY the most important is the vesica construction. The vesica itself in its innumerable shapes could be called a symbol for *form* residing within a matrix of connected circles, the whole creating a unity composed of number, tone, geometry, and proportion. To review: the circles of the vesica construction are the $C_1$ containing circle whose diameter represents the musical string; the two $C_2$ circles that form the vesica (each $C_2$ circle sections the string/diameter at a tonal position); the $C_3$ circle that encloses the vesica; and the $C_4$ circle that is enclosed by the vesica. The diameters of these circles are closely related, and the following equations demonstrate their relationship.

$$C_1/C_3 = C_3/C_4 = \text{vesica ratio}$$
$$(C_4 + 1) \div 2 = C_2$$
$$C_3 = \sqrt{C_4}$$
$$C_4 = 2C_2 - 1$$
$$1/C_3 = \text{vesica ratio}$$

We can affirm that each vesica along with its matrix of circles is generated by a particular tonal ratio of which there are infinitely many within the octave.

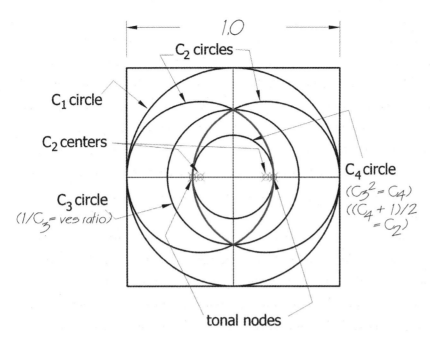

**Drawing 8.1.** *A review of the vesica construction showing its circles and their relationships to each other. The $C_1$ circle that resides within its enclosing square has a diameter equal to 1. This is the string/diameter on which the musical ratios are located. Both of the $C_2$ circles have diameters equal to the string-length of the tone that is being translated into geometry. Their intersection produces a vesica. The $C_4$ circle is inscribed within the vesica, and the $C_3$ circle circumscribes the vesica.*

Thus the creative process as symbolized by the vesica construction can be expressed as *number generates tone, which generates form.*

There is another circle that we can add to the vesica construction. This is the circle that connects the centers of the two $C_2$ vesica-forming circles. We will call this the $C_5$ circle (see drawing 8.2 on p. 103). Since it connects the centers of the two tonal circles, the $C_5$ circle symbolizes the principle of *resonance*.

## RESONANCE

When a musical string is tuned to a certain frequency and plucked, a nearby string of the same frequency will begin vibrating. We call this phenomenon resonance. This applies not just to musical strings but to any two objects of the same or nearly the same frequency. Hans Kayser gives a broad view of the resonance principle:

What strikes us most forcibly is the fact that there are "various bodies of the same natural frequency." This also seems obvious at first, but becomes remarkable when we grasp the phenomenon of resonance absolutely, and observe its autonomous realization, wherever and however it may be. Then resonance becomes a value-form of great amplitude. In physics and its applications to technology we see resonance used copiously. In chemistry, resonance becomes catalysis: the mysterious catalytic processes are scarcely explicable without the analogy of resonance. The same goes for enzymes in the bodies of plants and animals: they can also only be interpreted as being-resonances in the material life cycle, as strengthenings or weakenings of resonance, held in equilibrium by the harmony of the collective organism. But there are also resonances in the psychic and spiritual realms. In the sympathies and antipathies of human relationships, in the simultaneous emergence of identical ideas and discoveries in different minds and nations and even in the great historical resonances, often with gigantic effects both in the positive and the negative sense, we see the resonance principle elevated to a virtually universal principle.[1]

Resonance is a power that joins things together. It is a binding force that operates in the universal realm of vibration.

## TWO FROM ONE

Let us continue with our $C_5$ resonance circle, which can be considered to be the link between elements of a similar nature—that is, in direct tonal relation (including octaves of the tone in question that are also resonated by the sounding of the tone). Thus in our construction model we can imagine a circular wave being formed at the center of our $C_1$ containing circle that, as it widens, intersects the string/diameter at all tonal points. Each of these points, when so stimulated, creates a sound wave ($C_2$) that expands until it is stopped at the containing circle.

This sound-based symbol has affinities with the modern scientific creation story, which resonates with the old creation myths. The modern story hypothesizes that *sound* was a primordial creative energy that organized gas clouds into stars and galaxies after the expansion of space called the big bang. Some of the old myths also suggest that sound was a primary creative force for creation.

Our geometric symbol shows the origin of the resonance wave to be at the center of the field. A verse from the *Tao Te Ching,* translated by Gia Fu-Feng and Jane English, seems to describe the ensuing process:

> Tao begot One;
> One begot two;
> Two begot three;
> Three begot the ten thousand things.

The Tao is the unknown or unknowable Cause, a dimensionless point or seed filled with limitless potency. The One is the original wave ($C_5$) that ripples out from this point generating the field. The two is embodied in the two $C_2$ circle/waves that are brought into existence by the movement of the one and that move through the tonal spectrum generating sound. The three is the vesica that is formed from the intersection of the two waves within the main octave. The ten thousand things are the infinite shapes that the vesica may take from the slenderest slivers representing tones near the octave to the almost circular vesicas at the other end of the scale near the fundamental.

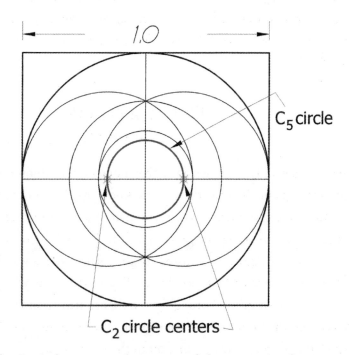

Drawing 8.2. *The $C_5$ circle connects the centers of the two vesica-forming circles. These centers are at the octave positions of the two tones. The $C_5$ circle can thus be considered a resonance circle since the two identical tones are joined together by resonance.*

# ONE FROM TWO

There are various ways of using the dynamics of the vesica construction as a model of creation. As we have just seen, the $C_5$ circle can be seen as the originator of the creative process—a two-from-one model like the mitosis process of a living cell. Another approach is the one-from-two model as embodied in the human fertilization cycle in which two elements, the male and female carriers of genetic material, join to produce the first cell. This corresponds to the phenomenon cited earlier of two stones simultaneously dropped into a pool of water that create two waves that gradually intersect one another. The $C_5$ circle is also present in this model and connects the two elements. In this case it is shrinking or condensing as the two wave-circles grow in size.

Within the ovum the male and female pronuclei are very close to the same size as they move toward one another. They soon merge their genetic material, which is transported on a vesica-shaped "mitotic spindle" composed of micro-tubules that emerge from twin centrioles located at the poles of the vesica. A zygote, the primordial cell, is now formed that contains the chromosomes of both parents. We can use this very process to imagine a story called "The Birth of the Moon."

# THE BIRTH OF
# THE MOON

While it is generally acknowledged that none of the Moon-origin theories are adequate to explain all of the facts, we do know that Earth's crust and the surface of the Moon are composed of the same materials. We can therefore hypothesize that the Moon was somehow generated from Earth. The most widely accepted theory is that during the early history of the solar system a wandering planet-size object about the size of Mars, known as Theia, struck the young Earth, sending tons of matter into orbit. Through gravitational attraction the matter gradually coalesced into the Moon. The accompanying drawings are a mythical-geometrical interpretation of the events leading up to the birth event.

We begin with two circles on either end of the main diameter, drawing 8.3 (2). Each of these has a diameter that is 1/11 of the main diameter. We will consider

Book in which this card was found _____

☐ Check here if you would like to receive our catalog via e-mail.

Name _____ Company _____

Address _____ Phone _____

City _____ State _____ Zip _____ Country _____

E-mail address _____

**Please check the following area(s) of interest to you:**

☐ Health            ☐ Self-help              ☐ Science/Nature   ☐ Shamanism
☐ Ancient Mysteries ☐ New Age/Spirituality   ☐ Ethnobotany      ☐ Martial Arts
☐ Spanish Language  ☐ Sexuality/Tantra       ☐ Children         ☐ Teen

**Please send a catalog to my friend:**

Name _____ Company _____

Address _____ Phone _____

City _____ State _____ Zip _____ Country _____

Order at 1-800-246-8648 • Fax (802) 767-3726

E-mail: customerservice@InnerTraditions.com • Web site: www.InnerTraditions.com

# INNER TRADITIONS
## BEAR & COMPANY

**Inner Traditions • Bear & Company**
P.O. Box 388
Rochester, VT 05767-0388
U.S.A.

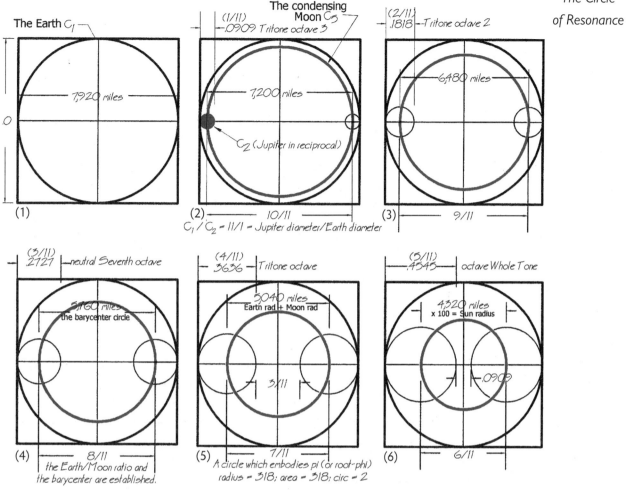

Drawing 8.3. *The Birth of the Moon, parts 1–6. (1) The Earth awaits the
insemination of the Moon seed. At (2) the seed of the Moon has been planted by
Jupiter. Its size is 1/11, which is the reciprocal of the Jupiter/Earth diameter ratio
of 11/1. It is connected by the $C_5$ resonance circle to its twin at the other end of the
diameter. The resonance circle represents the condensing Moon. In (3) the condensing
proto-Moon is 6,480 miles in diameter, 3 times its final diameter of 2,160 miles. At
(4) the Earth/Moon barycenter circle with diameter of 5,760 miles is established.
The barycenter is the center of gravity, within the Earth, of the Earth-Moon system.
At (5) the resonance circle is the size of the combined radii of Earth and Moon. At
(6) the resonance circle × 100 = the radius of the Sun.*

the 1/11 circles to be the masculine and feminine pronuclei generated from
Earth and Jupiter and the condensing ($C_5$) resonance circle to be the gestating
Moon itself as it moves from idea to reality, from conception to birth. We can
now watch our opposing circles as they move toward conjunction. The ratio

105

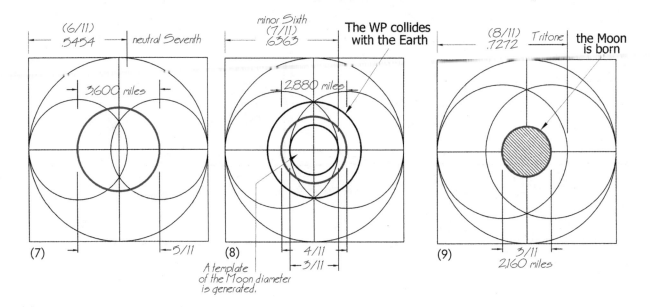

Drawing 8.4. *The Birth of the Moon, parts 7–9. In (7) the Moon at 3,600 miles in diameter embodies the universal standard used in measuring time and space such as 360 degrees in a circle, or the Mayan* tun *time period. In (8) a template of the final Moon size can be found encircled by the vesica as if to inform the Moon-resonance circle of its final size. At the end of this period of perhaps 100 million years after the forming of the Earth the Wandering Planet (WP), propelled toward Earth by Jupiter, strikes Earth. In (9) the Moon is born, emerging from the womb of the Earth.*

1/11 is the third octave of the 8/11 tritone derived from the harmonic series, and 8/11 will be the interval at which the Moon is born. The ratio 1/11 also connects the planet Jupiter and Earth since the average diameter ratio of Jupiter to Earth is 11/1.

Richard Heath notes some surprising connections between the Moon and Jupiter: "Earth resonates with Jupiter through the Moon. The slingshot effect of Jupiter's gravitational field propelled the meteor that collided with Earth and created the Moon." Jupiter has, in mythic terms, impregnated Mother Earth. Heath goes on to explain some of these connections: "Jupiter is synchronized to the Moon using units based on the number twenty-five (five squared),"[2] and he gives the following example:

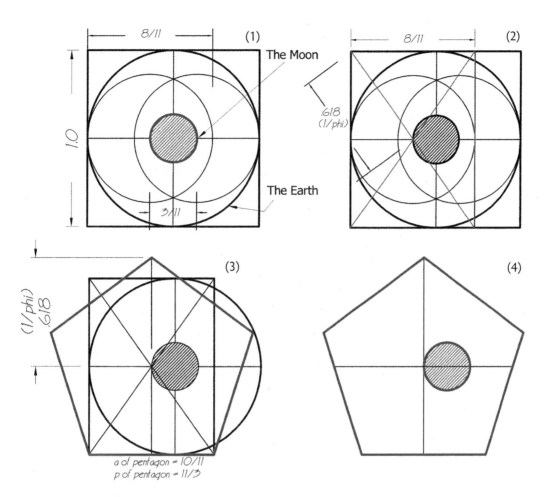

**Drawing 8.5.** *The Birth of the Moon. (1) The moment of birth as shown in drawing 8.4 (9). (2) An 8/11 to 1 rectangle is drawn enclosing the vesica, the moon, and the left half of the square. This rectangle has a diagonal of 2/ φ. Its center point at 1/φ coincides with the crossing of the moon and the horizontal axis. (3) The base of the 8/11 rectangle becomes a side of a pentagon. The vertex of the next side intersects the main circle. The next side intersects the central axis of the rectangle. (4) The pentagon containing the newly born moon. The perimeter of the pentagon = 11/3, the same ratio as that of the Earth/Moon diameter.*

25 of Jupiter's synodic period of 398.88 days = 27.321 practical years
of 365 days.

Now, 27.321 days is the sidereal orbital period of the Moon. Thus there are 365 of these periods in 25 Jupiter synods. Heath notes that the other important

lunar period—the lunation between new moons of 29.531 days—relates to both φ and the number 25, the Jupiter number.

There are 309 lunations in 25 practical years,
and $309 = 618 \div 2 = 1{,}000 \div 2\phi$.

We now continue our geometric creation myth, which is illustrated in drawings 8.3 to 8.5. We have established our undecimal theme that will find its final expression at the cataclysmic birth of the Moon with its diameter equal to 3/11 that of Earth. The drawings illustrate the process of gestation as the ($C_5$) resonance circle that represents the gestating Moon condenses in undecimal increments within the womb of the Earth. It is interesting, as described in drawing 8.5, that at the time of birth a pentagon, the vessel of the golden proportion and symbol of life, forms around the Moon—and that the perimeter of the pentagon equals 11/3 (3.66), the Earth/Moon diameter ratio. These seem to be auspicious signs for the birth of an entity that will so profoundly influence life on Earth through its stabilizing effects on the Earth's orbit and its power over the substance of life, water.

# CROSSINGS

In considering the $C_5$ resonance circle we should note that besides moving along the horizontal diameter of the $C_1$ containing circle it also moves along the vertical diameter. It thus intersects four nodes at a time. A resulting vesica construction would then consist of two crossed vesicas. This construction may have been used by ancient architects and sculptors to generate regulating lines for their creations, such as we see in drawing 8.7 (p. 110). This construction begins with one of the simplest beginning gestures in geometry: the arc generated by the quarter-square diagonal, shown in drawing 8.6. When mirrored, it generates a vesica. In terms of tone we are in the realm of √2 (1.414 . . .), the irrational region of the geometric tritone, the center of the scale. Within the octave its numerical expression is .707 . . . , which equals √2/2. Another identical vesica drawn at right angles to this vesica generates a central region in which we can draw an intersecting circle and a square whose area measures happen to be extremely close. The circle-squaring property of this figure may be one of the reasons why it was a natural setting-out construction for ancient architects.

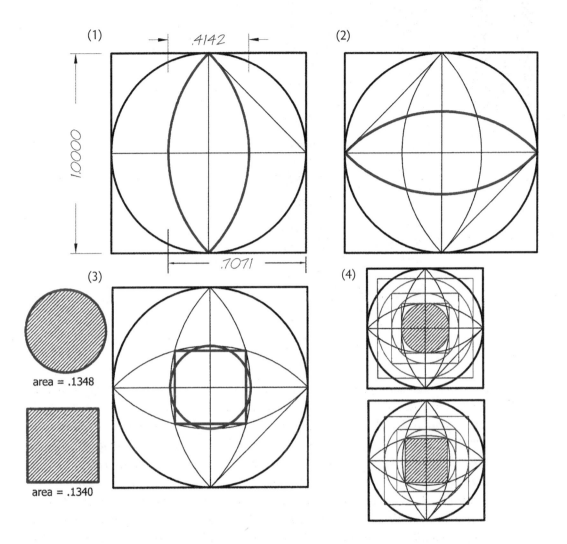

Drawing 8.6. *(1) An arc with radius of the quarter-square diagonal is drawn and mirrored and a vesica is formed. (2) The same construction is done on the horizontal axis resulting in crossed vesicas. (3) A square and a circle are inscribed within the common area of the crossed vesicas. Their areas are within 99 percent of being equal. (4) A succession of circles and squares are constructed around both figures. This space-dividing technique, called quadrature, was used as a ground plan layout in ancient architecture. The .707 point of the arcs on the diameters, considered as musical strings, is at the geometric tritone section point, the center of the scale. Two more examples of quadrature in architecture are shown in appendix drawings A2.29 and A2.30 (pp. 223–24).*

(1)                                                                                    (2)

Drawing 8.7. *Examples of crossed-theta vesica constructions as possible setting-out patterns for ancient sculpture and medieval architecture. On the left (1) is the Doryphoros of Polycleitos, a Roman marble copy of the Greek bronze original, circa 440 BCE. The center of the body-as-monochord is the octave position at the genitals. Like the octave this is the place of generation. The vesica arc intersects the string/diameter at the tritone, the tonal center of the scale. The vital lung-heart area is defined by the vesica arc and quadrature circle. Mirroring this on the other side of the octave are the knees, those mechanisms that allow humans an upright and hands-free stance and all that this implies. The size of the head is determined by the containing circle and a quadrature circle that circumscribes the square and circle generated from the crossing of the vesicas. The pattern square-circle-square-circle, and so on, is the pattern of the quadrature technique. The upraised hand, originally holding a spear, lies at an intersection of the crossed vesicas and a quadrature circle, perhaps a clue from the artist about his design canon.*

*On the right (2) is the ground plan of Amiens Cathedral (begun 1220 CE). The crossed theta vesicas create not only a width but also an inner space that can serve as the starting point for quadrature. Other elements such as the bay width and the beginning of the apse can then be determined: the space between the two squares is the bay width. The semicircle above the outer square is the apse. The vertical vesica also establishes connections between distant points of the plan and thus provides an overall unifying structure.*

Drawing 8.8. *(1) A crossed-vesica construction composed of the vesica construction at the minor third (5/6 string length) and its inverse—the major-sixth construction (3/5 string length). (2) The vesica circles are drawn and enclosed in squares. (3) After a number of deletions, the result is a ground plan of a building.*

The crossed vesicas each have a length-to-width ratio of 2.414, a number sometimes called the silver number, or theta (θ), a reference to the golden number, φ. The θ ratio has a similar property to φ: its fractional part is the reciprocal of the ratio

$$2.414 = 1 \div .414,$$
$$\text{like } \phi \text{ in which}$$
$$1.618 = 1 \div .618.$$

We have seen in drawing 6.9 how the square is the gnomon of the golden rectangle. In a similar way the gnomon of the θ rectangle is the double square, which is to say that a double square added to a θ rectangle produces another θ rectangle.

**Figure 8A.** *Bruno's* Figura Mentis.

111

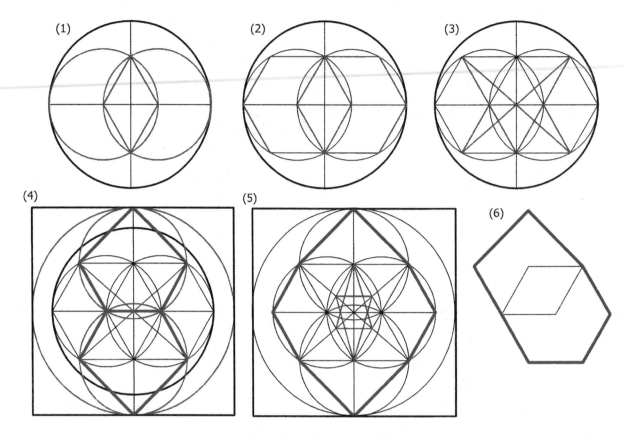

Drawing 8.9. *An analysis of Giordano Bruno's* Figura Mentis (Drawing of the Mind)
*shown in figure 8A. The geometrical theme is the joining of 5 and 6. (1) A vesica piscis
with an inscribed rhombus is drawn. (2) Two intersecting hexagons are drawn using
the sides of the rhombus as the initial two sides. (3) The doubled-hexagon diagonals
are drawn. (4) Two circles with centers on the vesica poles and radii extending to the
hexagon vertices are constructed. These locate the points on the vertical axis from which
two irregular pentagons are drawn. (5) The inner irregular star hexagon is drawn to
existing points, and the composite hexagon-pentagon figure is drawn. (6) A section of
the drawing is isolated showing the hex-pent composite. The joining of 5 with 6 has
several possible meanings. The hexagon, which embodies the number 6, has the perfect
radial symmetry often found in nonorganic matter such as crystals. The pentagon,
which embodies the number 5, has the offset symmetry found in organic life-forms.
The joining of the two produces a unifying symbol of the created world that includes
both principles. John Anthony West notes that "to the Pythagoreans . . . Five [was] the
number of Life. We may call Six the number of the world. . . . Five, in becoming Six,
engenders or creates time and space."*[3]

*Tonally, 5/6, the minor third, is the ratio that transforms π into φ:*

$$5/6 \times \pi = \phi^2, \text{ so } \phi = \sqrt{5/6}\,\pi.$$

Continuing the theme of the crossing as a creative foundation gesture we consider Giordano Bruno's *Figura Mentis* (figure 8A) in which the hexagon is joined with the pentagon (drawing 8.9). We can consider such intersections as symbols of the joining of two *principles*. A brief description of this concept is discussed in the caption accompanying the drawing. A further application of this idea is shown in drawing 8.10 in which a pottery form is created from the joining of the hexagon and octagon.

## HARMONIC SCIENCE

In this book I have assumed the existence of an ancient science of number, tone, and geometry. My approach toward this science has consisted of using the numbers and shapes of geometry and of the musical scale as tools for discovery— as I imagine that the ancients must have done. What has resulted is a way of approaching the creation of harmonious form using techniques based on the firm foundation of eternal number. I have used as my central diagram a figure I call the vesica construction, which can be generated by any ratio. For the most part I have chosen ratios from musical scales. The reasons for this are the compelling constructions that these ratios generate. For example, we have seen how the harmonious interval of the fifth generates the useful vesica piscis with its $\sqrt{3}$ ratio. Similarly the interval of the fourth generates a vesica with the important $\sqrt{2}$ ratio.

While we have not limited ourselves to musical numbers as generators of vesica constructions, it is interesting that, in the process of creating these constructions, one can get in the habit of thinking of all numbers as tones. Through the octave doubling and halving process any number can be brought into the main octave that resides between 1 and 2 or, more precisely, on the musical string between 1/2 and 1. We need only take the reciprocal of the number and double it as many times as required to bring it into the main octave. For example, the reciprocal of 27 is 1/27 so:

1/27, 2/27, 4/27, 8/27, 16/27, which is the Pythagorean sixth.

Another way to proceed is to determine which octave the number in question is within and divide it into the fundamental of that octave to find the string-length ratio. Thus 27 is in the octave 16–32, and 16/27 is the ratio. Or, let us take the number 84, which is in the octave 64–128 and 64/84 reduces to 16/21, a tone called the septimal fourth.

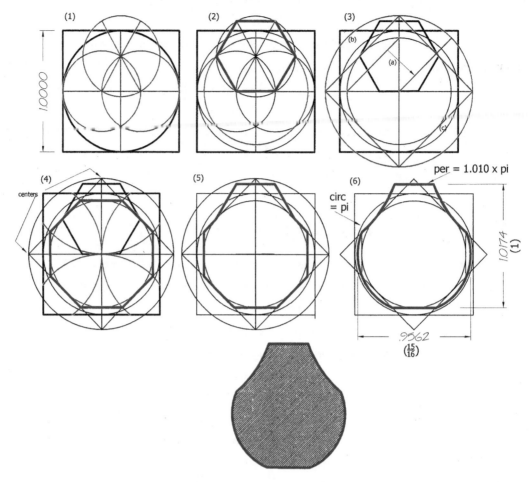

**Drawing 8.10.** *A composite construction of the hexagon and octagon generates a pottery shape. (1) A vesica piscis is constructed. A circle with the same radius as the vesica piscis circles is centered on the upper pole of the vesica. Two construction lines are drawn within this upper circle as shown. (2) The upper circle now has points to which a hexagon may be drawn. A large circle is drawn through circle-hexagon intersections as shown. This is the octagon circle. (3) A larger circle with radius equal to the quarter-circle diagonal of the previously constructed circle is drawn. The axis ends of this circle are connected with a square. (4) The corners of the square are the center points of four circle arcs with radii intersecting the center. These arcs divide the square at points allowing us to draw the octagon. (5) Parts of the octagon are deleted and it is joined to the hexagon. (6) Three-point circle arcs join the vertices of hexagon and octagon resulting in a pottery shape. The ratio of the pot is 16/15, the frequency ratio of the major semitone musical interval. The perimeter of the pot is equal (within 99 percent) to the circumference of the original circle.*

*The hexagon, symbol of crystalline elementary matter, is the first shape to emerge from the primal circle, its sides being equal to the length of the circle's radius, and is constructed by walking the compass around the circle circumference. The octagon is associated with the cube with its eight vertices and is the ancient symbol of the element earth with its quality of stability. These two earthen principles are joined to form the pottery vessel. Musically the number 8 refers to the eight tones in an octave from C to C'. From these are formed the seven intervals and six whole tones of the basic scale. Thus 6 and 8 are joined in the octave and embodied in our pottery form.*

*

Thus, the vesica constructions seem to be natural structures for the bringing together of the three tools of ancient harmonic science: tone, geometry, and number. I believe that working with the vesica constructions can bring us closer to the spirit of ancient harmonics. More importantly, however, is the opportunity that this geometry presents to the creative imagination in the realm of harmonious design and space division. The musical intervals being inherent in both nature and the human psyche present a foundation upon which a system of design based on Law can be constructed—a system that will resonate between the inner and outer worlds.

# 9

⊷⊷

# THE MUSICAL UNIVERSE

THE REVIVAL OF THE ANCIENT PRACTICE of arranging phenomena in systems of correspondence can contribute much to our understanding of the world. The idea that seemingly separate things in different scales and modes of being are related to one another resonates deeply with the human soul that hungers for a meaningful vision of the world in which things are connected in ways that are simple and understandable. An example of a correspondence structure that gives a sense of this idea is shown in drawing 9.1. Here the relation of diverse phenomena draws forth a deeper understanding of the unity that joins different cycles of nature and of human life. Its purpose is simplification and understanding. The words are combined within a geometric matrix and are joined by implied proportional expressions, for example,

spring : childhood :: winter : old age.

The elements are connected through the mechanism of correspondence that arises from a relational harmony that permeates the Universe.

## AS ABOVE, SO BELOW

The ancient theory of correspondence is now being revived as an alternative to a reductive science that finds itself increasingly unable to explain the world in terms understandable to the majority of people. Physicist Richard Feynmann wrote:

Winter Solstice
Dark Moon
Midnight

*Rest*
*Harvesting*
*Old Age*
*Wisdom*

*Inspiration*
*Planting*
*Childhood*
*Innocence*

N

Autumn Equinox
Last Qtr Moon
Sundown

W

E

Spring Equinox
1st Qtr Moon
Dawn

*Completion*
*Fruiting*
*Maturity*
*Knowledge*

*Creation*
*Growing*
*Adolescence*
*Experience*

S

Noon
Full Moon
Summer Solstice

Drawing 9.1. *An example of a correspondence diagram demonstrating the relation of plant and human growth and the lunar and solar cycles.*

> It always bothers me that, according to the laws as we understand them today, it takes a computing machine an infinite number of logical operations to figure out what goes on in no matter how tiny a region of space, and no matter how tiny a region of time. How can all that be going on in that tiny space? Why should it take an infinite amount of logic to figure out what one tiny piece of space/time is going to do?[1]

This is an example of how we can get so involved in explaining the details that we miss the whole—how we can't see the forest for the trees. Correspondence in the context of harmonic science offers an alternative way of understanding the world as a whole, just as holistic medicine offers an alternative, not a replacement, for allopathic medicine.

Systems of correspondences were an important part of ancient sacred science that emerged naturally from the perceptions of similar patterns at different levels of being. Such self-similarity is a characteristic of, for example, the ever-smaller branching patterns in blood vessels, in plant branching, and in river systems. Thus arteries and capillaries of animals correspond in form and in

function to the patterns created by main channels and streams of river systems. The principle that is elucidated is liquid flow, which also corresponds to nonmaterial processes such as the many streams of thought, memory, dreams, and so forth, that feed into the river of creative work. We begin to see that correspondence is often expressed through metaphor, the language of poetry and myth. In the mythic vision our life becomes a meaningful journey filled with synchronicities and magical initiations rather than a series of random events.

*

There was a desire among the ancients to validate their metaphorical insights with exact knowledge—that is, to find numerical correspondences that could support their findings. In this book we have explored some of these numerical-physical correspondences using, for the most part, the numbers of the musical scale and the numbers derived from the golden section.

The inverse correspondences between the movements of the sun and the moon are interesting. In midwinter when the Sun is low in the sky and its light is at its weakest, the Moon is at its highest in the sky and shines the brightest. This is reversed in midsummer. At the summer solstice the Sun and Moon set in opposite locations, the Sun north of west and the Moon south of west. This is reversed in midwinter. At the equinoxes the Sun and Moon set at the same points.

There is a harmony and a dance between the two. One lights up the night most brightly at the darkest time of year. One lights the days the longest while the other dims her light. Just as with the tides in which the work is shared, the task of lighting the world is harmoniously divided between the two luminaries. These mysterious goings-on in the sky led the megalith builders to erect observatories so that they might better understand the principles at work. The numerical knowledge that resulted became the foundation of ancient sacred science, so called because the events in the sky were considered to be the workings of the gods.

*

The use of musical numbers to describe celestial events seems appropriate in a universe where harmony and dissonance are ever-present realities. The interval of unison is considered the highest harmony, and the exact unison of the sizes of the Sun and Moon in the sky is a significant message to us about the rela-

tionship of the two that, for the majority of ancient civilizations, have represented the masculine and feminine principles. They share their duties according to their powers. The Sun dispenses the greater light while the Moon provides the greater pull on the waters. While they appear to be the same size in the sky, their diameters are in the ratio of exactly 400 to 1. The sizes of their diameters expressed in the harmonic numeration of the imperial system are 864,000 miles and 2,160 miles. Their essential numbers are thus 864 and 216, which are in double-octave relation using the doubling system of octave calculation. Thus the octave from 128 to 256 contains the 216 tone at the Pythagorean-sixth interval (16/27). Similarly, 864 is at the Pythagorean sixth in the octave 512 to 1,024. The central 256–512 octave lies between them.

Furthermore, we have seen in chapter 2 how the yearly cycles of Earth and Moon are related by 20/ϕ and how the diameter ratio of Earth/Moon is 3.66, which corresponds to the temporal measure of 366 revolutions of Earth during its 365-day journey around the Sun. We mention these again in order to emphasize that the beautifully choreographed dance of Sun, Moon, and Earth has a foundation in numerical correspondences, which are universal in scope, a fact that will become apparent in the final chapters of this book.

Figure 9A. *The* taiji, *or* yin-yang, *symbol is an expression of the principle of correspondence that manifests as reciprocation, inversion, complementarity, resonance, and reflection.*

## THE WATER OF LIFE

Leonora Leet in the *Secret Doctrine of the Kabbalah* writes about the correspondence between the biblical days of Creation and musical intervals. For example, the third day of Creation in which dry land, or "earth," is created is associated with the interval of the fifth. Leet then shows how the fifth day of Creation, in which "creatures inhabiting the flowing elements of water and air" are created, corresponds to the major-third interval.

The fifth interval, as we have seen, is associated with the third harmonic and the third with the fifth harmonic. The interval of the fifth also generates the vesica piscis, whose internal angle between poles and equator ends is 120 degrees, an angle from which a hexagon can be constructed. The hexagon in this Creation scenario is the first form to be differentiated from the circle, the original form symbolizing the fundamental tone. The hexagon emanates from the circle as spontaneously as a hexagonal snowflake takes shape from its dust mote seed, or as the interval of the fifth arises from the singing voice. The

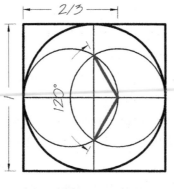

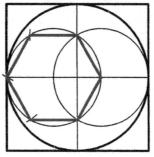

Drawing 9.2. *In the top drawing the vesica piscis generated from the musical interval of the fifth (see drawing 1.4) contains the first two sides of the hexagon. In the middle drawing the length of a hexagon side is stepped around the circle to complete the hexagon. In the bottom drawing the outline of the hexagon is shaded, resulting in a three-dimensional representation of a cube, the Greek symbol for the element of earth.*

Drawing 9.3. *The icosahedron, the water symbol of the ancient Greeks, has an internal structure consisting of three intersecting φ rectangles.*

radius of the circle becomes the sides of the hexagon whose vertices are located with six equal gestures with the compass. The fifth, the first tone after the fundamental, can be said to correspond to the element of earth, the biblical "land," the symbol for nonorganic matter. The "waters" are created from the major-third interval whose generating vesica has an internal angle of 104.5 degrees (drawing 4.18, p. 63), the bond angle of the water molecule.

According to Leet the fundamental is associated with the first day. She writes that "the first day can be associated with heaven," which combined with the land (the fifth) of the third day and water (the third) of the fifth day, produces a major chord containing the essential elements of a living creation: spirit, water, and land. From this harmonious beginning the song of Creation can proceed.

With water there are other correspondences—to both 5 and $\phi$. We recall the diagonal construction that locates the major third on the musical string (chapter 1) in which the crossing of two half-square diagonals locates the 4/5 third node on the string. The half-square diagonal is the generator of $\phi$, which itself has an affinity with the number 5 both through the pentagon and the $\sqrt{5}$—that is,

$$(\sqrt{5} + 1) \div 2 = \phi.$$

The Greeks assigned the symbol for water to the icosahedron with its twenty equilateral triangular sides. Twenty and its first few multiples and divisors all reduce, through octaves, to 4/5 (.80), the major third—1.25, 2.5, 5, 10, 20, 40, 80, 160:

$1 \div 2.5 = .4$ and $.4 \times 2 = .80,$
$1/20 = .05$ and $.05 \times 2 \times 2 \times 2 \times 2 = .80,$
$1/80 = .0125$ and $.0125 \times 2 \times 2 \times 2 \times 2 \times 2 \times 2 \times 2 = .80,$
and so on.

The twenty triangular sides of the icosahedron join to form twelve intersecting pentagons, which again emphasizes the theme of 5, the number of the third, and of $\phi$. And the inner structure of the icosahedron consists of three intersecting $\phi$ rectangles (drawing 9.3).

"Earth" for the Greeks corresponded to the cube with its six faces recalling the six sides of the hexagon—from which an isometric cube can be drawn (drawing 9.2). The association of water with the number 5 and the pentagon shows its affinity with $\phi$ and its relation to life-forms such as flowers, which frequently have a

pentagonal pattern, and to those plants such as sunflowers that incorporate the ϕ-based Fibonacci series in their seedhead patterns. The major-third interval gives "life" to the primal scale of the fundamental and the fifth as water joined with the mineral matter of Earth gives life to the buried seed.

# THE GREAT CENTRAL SUN

In esoteric lore there exists another sun around which our Sun orbits. This is the Great Central Sun (GCS), an entity of transcendent power. It has been considered variously to be Alcyone, a star in the Pleiades cluster, as well as the star Sirius. Others hold that it is a spiritual energy that resides within us. Some believe that the GCS is at the center of our Milky Way galaxy, a region whose mass is four million times that of our Sun and is the site of a supermassive black hole. We can affirm that our Sun and all the other stars in our galaxy orbit around this region and thus, if there is such an entity as the GCS, this would be a good place for it.

We may find more clues to the idea of the Great Central Sun in ancient number lore. Let us hypothesize that this GCS is indeed located at the Galactic Center and that it is the source of cosmic energies that radiate into our galaxy. There is a number in numerology that seems to describe the effects of the GCS, and that is the number 3,168, one of the most sacred numbers of gematria. John Michell describes it this way:

> The general character of the number 3,168, as conveyed by its position in ancient cosmological diagrams and the phrases associated with it through gematria, is that it represents the spirit which passes through and encircles the universe, Plato's world soul. The Christian term for this spirit, developed from the number 3,168, was Lord Jesus Christ. . . . The pre-Christian reference of this number seems to have been to the twelve gods of the zodiac.[2]

The symbolic number 3,168, which we will now identify with the Great Central Sun, happens to be in relation to the Sun-diameter number as the Earth-diameter number is to the Moon-diameter number. Using the Sun (864), Earth (792), and Moon (216) numbers as previously established we have

$$3,168/864 = 792/216 = 11/3 \text{ or } 3.666$$
(366 being the number of yearly revolutions of the Earth).

The important synchronicity here is the Earth/Moon diameter ratio has the same essential numbers as that of the yearly revolutions of Earth. This very number becomes a symbol relating the GCS to the Sun and thus connecting us by means of number to the Galactic Center.

It also happens that 3,168 is in major-third relation (the water tone) to the Earth number:

$$7,920 \times 2/5 \text{ (octave third)} = 3,168.$$

This could tell us that Earth baptized by cosmic water (carried by the primordial rain of water-bearing meteorites and comets onto Earth) attains life and consciousness.

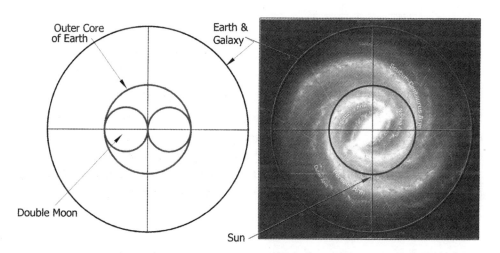

Drawing 9.4. On the *left* is a drawing of Earth with its outer core, whose diameter is 4,320 miles, which is equal to 2 × 2,160 miles, or twice the Moon diameter. In decimal terms the Moon diameter is .272 x the Earth diameter, which here is equal to 1. If we expand the Earth circle to the size of the galaxy (pictured in an artist's conception on the right), estimated as 100,000 light-years in diameter, then the Moon circle would equal 27,200 light-years in diameter, which happens to be the estimated distance of the solar system to the galactic center. The scaling-up of the outer-core circle of Earth, consisting of a doubled Moon, then represents the ideal circular orbit of the solar system around the Galactic Center. We have placed this outer core/orbit circle in the center of the galaxy. The position of the Sun and its solar system is shown by the arrow pointing to the orbital circle. In this we have continued with our correspondence practice as a means of bringing the heavenly down to earth, in this case, literally. The intention is not to make scientific claims but rather to open our minds to the possibility that universal correspondence may exist among different levels of reality as the ancients believed.

*"Behold, reader, the invention and substance of this little book! In memory of the event I am writing down for you the sentence in the words from that moment of conception: 'The Earth's orbit is the measure of all things.'"*

JOHANNES KEPLER
FROM *MYSTERIUM COSMOGRAPHICUM*[3]

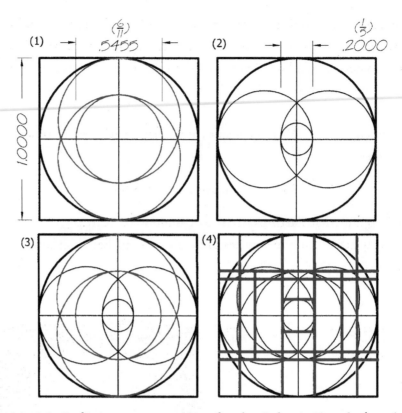

Drawing 9.5. *Preliminary constructions for the Galactic Temple (see the Earth drawings in chapter 3). The three primary circles are established: those of the outer (1) and inner (2) cores within the containing circle representing both Earth and the galaxy. In (3) they are intersected, and in (4) lines are drawn inscribing circles and vesicas. Deletions and refinements result in drawing 9.6.*

In chapter 3 we constructed the inner layers of the Earth. The inner core construction, generated from the just-sixth interval of 3/5 string length, results in an inner core of 1,584 miles in diameter, or 1/5 the diameter of Earth:

$$1/5 \times 7,920 = 1,584.$$

The inner core is a sphere of solid iron and nickel of tremendous density and with a temperature equal to that at the surface of the Sun. Its diameter is in octave relation to the number of the Great Central Sun since

$$1,584 \times 2 = 3,168.$$

The physical position of the inner core and its concentration of mass and high temperature at the center of Earth corresponds to the Great Central Sun at the center of the galaxy. Surrounding the inner core of Earth is the seething mol-

Earth and Galaxy

Earth Outer
Core &
Sun Orbit

Earth & Galaxy
Inner Core

Drawing 9.6. *The Galactic Temple.
The ring shape of the inner Earth
and its correspondence to the
position of the solar system within
the galaxy (top) produce this
temple plan (bottom).*

ten ring of the outer core with its diameter of 4,320 miles, equal to a double
Moon diameter. The relation of diameters of outer core to inner core is

$$4{,}320/1{,}584 = 2.72 = 1/.3666,$$

a number we are familiar with—366 is the number of revolutions of Earth in one
year and the number that relates the diameters of Earth (7,920) and Moon (2,160):

$$7{,}920/2{,}160 = 3.66.$$

It is interesting that the Great Central Sun number 3,168 is located within the
Earth (in octave form) as 1,584, the inner core diameter. In the ancient geocentric
view the Sun does indeed orbit around the core of Earth, around its internal
Great Central Sun. (We can add that the inner core revolves in an easterly direc-
tion, and the outer core turns around it in a westerly direction.) Thus

$$3{,}168/864 = 792/216 =$$
Great Central Sun/Sun = Earth/Moon
$$= 1{,}584 \text{ (inner core) } (\times 10)/4{,}320 \text{ (outer core)}$$
$$= 3.66.$$

# THE GALACTIC CORE

We have noted that the outer core of Earth has a diameter equal to a doubled Moon. If we consider Earth's diameter equal to 1, then the outer core equals $2 \times 3/11$ (.272), or 6/11 of Earth's diameter. If we expand Earth's diameter so that it equals the diameter of the galaxy of 100,000 light-years (LY), then the outer core diameter would equal

$$100,000 \text{ LY} \times 6/11 = 54,545 \text{ LY, with radius} = 27,272 \text{ LY,}$$

which is about the estimated distance from the Sun to the Galactic Center. So the circumference of Earth's outer core corresponds to an orbit of the Sun around the Galactic Center—that is, the outer core is slowly rotating around the inner core, and this corresponds to the movement of a ring of stars, which includes our solar system, around the Galactic Center. The outer stars of the galaxy in increasingly less dense concentrations correspond to Earth's mantle and crust, which also becomes less dense as its distance from the center increases.

# 10

<center>∼∞∼</center>

# THE TREE OF TIME

IN THIS CHAPTER WE WILL USE OUR GEOMETRY TO INVESTIGATE the subject of time. We have mentioned this subject in past chapters in which, for example, we have found that the number of yearly revolutions of the Earth—366—resonates with the 3.66 diameter ratio between the Earth and the Moon. We have also discovered that the discrepancy between the lunar and solar cycles produces a φ-family relationship: 20/φ, or 12.36, the number of lunations in a year. We have also used tonal numbers, an aspect of time, in our vesica constructions to investigate properties of space.

<center>*</center>

We will now undertake a project that involves the Mayan calendar and its elucidation by Carl Calleman in his book *The Purposeful Universe.* The title comes from his theory that the purpose of the universe is to generate and to evolve life. In this theory he develops a conception of cosmic time originated by the Maya that consists of nine "underworlds," each of which has a duration twenty times less than the previous (older) underworld and twenty times greater than the following underworld (see figure 10A, p. 128).

Each underworld consists of thirteen "heavens," each of which is ruled by a spiritual energy or god. For example, the tenth heaven in each underworld is ruled by Tezcatlipoca, the dark lord who presides over destruction. The

# THE PERIODIC SYSTEM OF EVOLUTION
## FOR THE FOUR LOWEST UNDERWORLDS

| Ruling Quality | Cellular Underworld[a] of 13 hablatuns | Mammalian Underworld[b] of 13 alautuns | Anthropoid Underworld[b] of 13 kinchiltuns | Human Underworld[b] of 13 kalabtuns |
|---|---|---|---|---|
| 1st Heaven is Day 1 **Sowing** | 16.4–15.1 | 820–757 First multicellulars? | 41–38 First monkeys | 2.05–1.90 *Homo habilis* |
| 2nd Heaven is Night 1 | | 757–694 | 38–35 | 1.90–1.74 |
| 3rd Heaven is Day 2 **Germination** | 13.9–12.6 | 694–631 Early multicellulars? | 35–32 *Aegyptopithecus* | 1.74–1.58 Early *Homo erectus* |
| 4th Heaven is Night 2 **Reaction** | | 631–568 | 32–28 | 1.58–1.42 |
| 5th Heaven is Day 3 **Sprouting** | 11.4–10.1 | 568–505 Ediacaran, Trilobites | 28–25 | 1.42–1.26 |
| 6th Heaven is Night 3 | | 505–442 | 25–22 | 1.26–1.11 |
| 7th Heaven is Day 4 **Proliferation** | 8.8–7.6 | 442–379 Fishes | 22–19 | 1.11–0.95 Late *Homo erectus* |
| 8th Heaven is Night 4 | | 379–316 | 19–16 | 0.95–0.79 |
| 9th Heaven is Day 5 **Budding** | 6.4–5.1 | 316–252 Reptiles | 16–13 *Kenyapithecus wickeri* | 0.79–0.63 *Homo antecessor* |
| 10th Heaven is Night 5 **Destruction** | 5.1–3.9 Meteor bombardment, water | 252–189 Perm-Tri Extinction Gymnosperms | 13–9.6 | 0.63–0.47 |
| 11th Heaven is Day 6 **Flowering** | 3.9–2.6 Prokaryotic cells | 189–126 Early mammals | 10–6.4 *Australopithecus afarensis?* | 0.47–0.32 Archaic *Homo sapiens* |
| 12th Heaven is Night 6 | 2.6–1.3 End of anaerobes, oxygen | 126–63 Angiosperms | 6.4–3.2 | 0.32–0.16 |
| 13th Heaven is Day 7 **Fruition** | 1.3–0.0 Higher eukaryotic cells | 63–0.0 Higher placental mammals | 3.2–0.0 *Australopithecus africanus* | 0.16–0.0 *Homo sapiens* |

[a]Billions of years ago.   [b]Millions of years ago.

Figure 10A. *The Periodic System of Evolution of the Mayan calendar as proposed by Carl Calleman. The diagram is from his book* The Purposeful Universe. *Here the first four (out of a total of nine) underworlds of the calendar are shown. Each underworld consists of thirteen periods—seven days and six nights—called heavens. The heavens have themes that correspond to the growing cycles of plants. The days are periods of manifestation, while the nights are periods of preparation that often involve destruction. The durations in the Cellular Underworld are in billions of years (BY). The durations of the Mammalian, Anthropoid, and Human Underworlds are in millions of years (MY). In the Cellular Underworld each of the thirteen heavens has a duration of 1.26 BY. In the next underworld, the Mammalian, each heaven is 1/20 the duration of the Cellular Underworld heaven: 1/20 × 1.26 BY = 63 MY. So each successive underworld and its heavens are reduced by a factor of 20. (Table used by permission)*

eleventh heaven signifies a flowering time and is ruled by Yohualticitl, the goddess of birth. The durations of the calendar were specified by the Maya in multiples of the *tun*—a period of 360 days—a highly divisible number that enables the large numbers of the calendar to be simply expressed and calculations to be simply made. Here we have used Calleman's translation of the tun-based durations into years. For those interested, the mechanism of the tun system is readily available in books such as Calleman's or on the Internet. (We might add that there is a tonal relation between the tun and the year: $360/365 = 72/73$, virtually the same (within 99 percent) as the Pythagorean comma of $73/74$ that brings the circle of fifths into congruence with the octave (see drawing 6.6, p. 83).

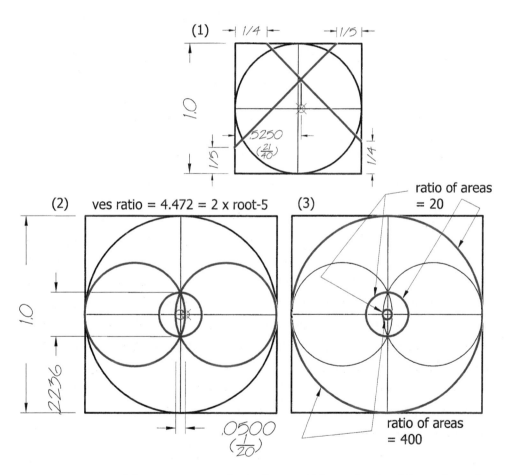

*"Since the sacred and strong time is the time of origins, the stupendous instant in which a reality was created, was for the first time fully manifested, man will seek periodically to return to that original time. This ritual reactualizing of the* illud tempus *in which the first epiphany of a reality occurred is the basis for all sacred calendars."*

**MIRCEA ELIADE**[1]

Drawing 10.1. *(1) We construct the 21/40 = .525 tonal point (the reciprocal of the harmonic mean between 1 and 20) with crossed diagonals. (2) From this point the vesica construction is generated. The ratio of its vesica is 4.472 = 2 × √5 (3) The area ratios between adjacent circles in the ring equal 20.*

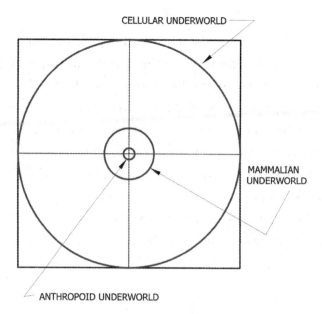

**Drawing 10.2.** *Drawing 10.1 is applied to the first three underworlds of the Mayan calendar, whose areas are in 20-times relation. We can imagine similar patterns repeating within the circle of the Anthropoid Underworld as six more underworlds whose circle areas are 20 times smaller at each iteration. These circle areas represent both the durations of the underworlds, which are in 20-times ratio and, according to Calleman, the 20 times faster rhythms of time that are experienced by the inhabitants of the Universe during each successive period.*

The tun-based numbers of the Mayan calendar proceed in a rhythm of octaves times 10 (2 × 10), a process that has the benefits of both the doubling and decimal systems. The decimal component allows for an expotential increase or decrease in the duration of underworlds while the doubling component allows for the durations to retain musical meaning in the sequence of their numbers. Viewed in this way they are simply in octave relation, a familiar way of looking at numbers. The number 16.38 BY (which we round off to 16.4) is the duration of the Cellular Underworld and of the calendar as a whole. The number 1,638 is the eighth octave of 64—that is, 64, 128, 256, 512, 1,024, 2,048, 4,096, 8,192, 16,380. So 16.38 BY ÷ 20 = 819 MY, the duration of the next underworld, the Mammalian, and so on.

My own purpose in this chapter is to draw forth hidden properties of the calendar using the harmonic tools of number, geometry, and musical interval. One result of this analysis is a date for the big bang that corresponds to the scientifically determined date. A number of new possibilities results from this approach including a pre-big-bang era and a time structure that I call the Tree of Time.

(1)

(5th night)
METEORS BRING
DESTRUCTION AND WATER.
FOLLOWING THIS THE FIRST
PROKARYOTES EMERGE.
*3.667 BYA*
(6th Day)

(1st Day)
MAMMALIAN
UNDERWORLD
BEGINS
*820 MYA*

(1st Day)
CELLULAR
UNDERWORLD
BEGINS
*16.4 BYA*

(2)

(1st Day)
ANTHROPOID
UNDERWORLD
BEGINS
*41 MYA*

(1st Day)
MAMMALIAN
UNDERWORLD
BEGINS
*820 MYA*

(5th Night)
A HUGE EXTINCTION
FOLLOWING THIS THE
FIRST MAMMALS
EMERGE.
*183 MYA*
(6th Day)

Drawing 10.3. *Beginning with the same geometry as in drawing 10.1, we construct a straight-line spiral representing the succession of underworlds. The adjacent segments of the spiral are in 4.472 (√20) relation. The vertices represent the critical points of the beginning of an underworld and its flowering/fruition ending when the purpose of the underworld is attained (sixth day) and refined (seventh day). Preceding each sixth day flowering is the fifth night, a time of destruction, which prepares the way, for the flowering of the sixth day.*

131

There are several geometric ways to imagine the Mayan time conception. Using our vesica-ring construction we draw an inner circle $C_4$ contained within a larger circle $C_3$ in which the area ratio of $C_3$ to $C_4$ equals 20. Then a circle $C_1$ circumscribes both of them, resulting in area ratios of

$$C_1/C_3 = 20, \text{ and } C_1/C_4 = 400.$$

Drawings 10.1 and 10.2 show the three oldest underworlds imagined as circle areas. This ring structure of these drawings is familiar to us as the proportional structure of the rings in our vesica constructions, although we have been used to comparing the diameters rather than the areas as we are doing here. To have the adjacent circle areas in 20/1 ratio we require a ratio between adjacent diameters of 4.472 ($= 2\sqrt{5} = \sqrt{20}$). This 4.472 ratio will then equal the length-to-width ratio of the vesica (drawing 10.1). From this fact we can find a tone with which to generate a vesica construction using the vesica-circle formulas described at the beginning of chapter 8.

So when the vesica ratio = 4.472,

the $C_2$ generating circle diameter = 21/40.

The frequency ratio 40/21 happens to be the harmonic mean

between 1 and 20:

$$2(1 \times 20) \div 21 = 40/21.$$

And the vesica ratio is the *geometric* mean between 1 and 20:

$$\sqrt{(1 \times 20)} = 4.472.$$

These important mean properties demonstrate the harmonious position of the 21/40 ratio in the vigesimal system.

<p style="text-align:center">*</p>

So we have generated a vesica construction in which the area ratios of the $C_1$ to $C_3$ circles and the $C_3$ to $C_4$ circles are both 20 to 1, which represents the relation of one Mayan underworld to the following underworld.

This vesica-ring structure also reflects the Mayan time structure in that the older periods *contain* the more recent. It is their beginnings that precede and follow one another.

The Mayan time conception results from an intention that evolutionary history should be divided into consecutive periods whose relation will be in

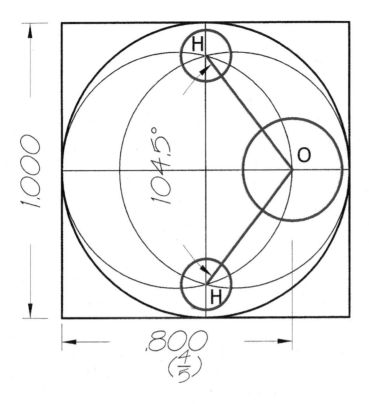

Drawing 10.4. *The angle of the bond between the oxygen and hydrogen atoms in the water molecule of 104.5° is formed within the vesica construction at the major third.*

multiples of 20. Why 20? We have seen the usefulness of the number 20, which combines the computing power of the decimal system with the descriptive power of the octave. There is another more subtle fact about the number 20. If, as Calleman has written, the universe is purposeful and that its purpose is the generation and evolution of life, then at its very inception there must have been some seed, some intention, some indication of the need for the element of water, the substance of life. We have noted in chapter 9 that there is evidence for a tonal connection between the interval of the major third and water. Intuitively we know that there is no life without water, and there is no true harmony without the interval of the third. And, in the Mayan calendar, whose structure is based on the third, we again find intimations of the connection between this interval and water. Specifically, as we have seen and shall further discover, the number 20 and its multiples relate to the third and thus to the element of water.

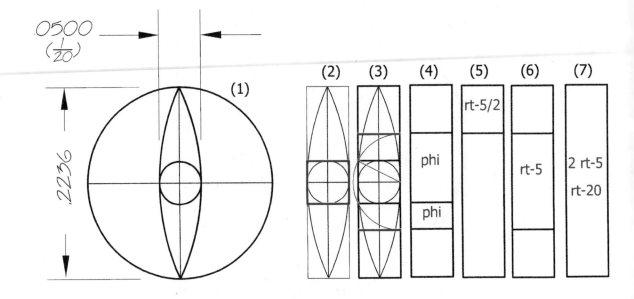

Drawing 10.5. *The inner structure of the vesica whose 4.472 (2√5 = √20) ratio we have used as a factor to locate the beginnings of the underworlds of the Mayan calendar. The geometry of the rectangle that surrounds the vesica is filled with φ, √5, and √20 harmonies. (1) The 4.472 ratio vesica is shown. It is the geometric engine driving the Mayan calendar. The rectangle that encloses the vesica has the following internal properties: (2) The circle-in-the-square, the primal generating form of geometry. (3) Its first generation of the square-root of 5 rectangle consisting of 2 intersecting φ rectangles. In (4) is another version of the √5 rectangle consisting of a φ and a 1/φ rectangle. (5) This √5 rectangle leaves a √5/2 rectangle. The ratio of this rectangle is 1.118 = 1/.8944. .8944 is the string-length of the meantone whose function in the Mayan calendar is described in the text. (6) shows the √5 rectangle framed by √5/2 rectangles. (7) The 4.472 (2√5) rectangle.*

## A SPIRAL OF TIME

The succession of underworlds follows a progression based on a particular tonal interval called the meantone. This is one of a number of whole-tone intervals, the most common being the just major whole tone of string-length ratio equal to 8/9. Another whole tone is the minor whole tone of 9/10 ratio. The geometric mean between the two is the meantone, and it is derived thus:

$$\sqrt{(8/9 \times 9/10)} = .8944 \ldots$$

The meantone is an irrational number closely approximated by the fraction 25/28. We will use its .8944 equivalent in our equations. The major-third interval is composed of two meantones:

$$.8944 \times .8944 = 4/5,$$

which is the string-length ratio of the major third.

The meantone is thus intimately involved with the third, and this involvement relates it to the factor of 20, which is the generating number between adjacent Mayan underworlds. The ratio 1/20, the ratio between the duration of underworlds, is the fourth octave of the third: 4/5, 2/5, 1/5, 1/10, 1/20. Thus

$$1/20 \times 16.4 \text{ BYA, the beginning of Cellular Underworld}$$
$$= 820 \text{ MYA, the beginning of Mammalian Underworld}$$
and
$$1/20 \times 820 \text{ MYA} = 41 \text{ MYA beginning of Anthropoid Underworld.}$$

Division by 20, the fourth octave of the third, thus takes us to the beginning of each underworld. We can use the component of the third, the meantone, to travel *within* the underworlds. In particular we use the second octave of the meantone, or .2236, for this function:

$$.8944 \div 2 = .4472 \text{ (first octave)}$$
and
$$.4472 \div 2 = .2236 \text{ (second octave).}$$

(The reciprocal of this *string-length* ratio of .2236 is 4.472, the *frequency* ratio of this double-octave meantone.)

When we multiply any beginning underworld number by .2236 or divide it by 4.472 we find ourselves in the sixth day of the cycle, the flowering period when the intention of the particular underworld achieves realization. This process is shown in drawing 10.3 in which a straight-line spiral, whose segments are in 4.472 ratio, demonstrates the time progression from the beginning of an underworld to its sixth day and then to the next underworld. (We have, in chapter 6, used this technique in which the ratio of progression equals the vesica ratio, to geometrically demonstrate the circle of fifths.)

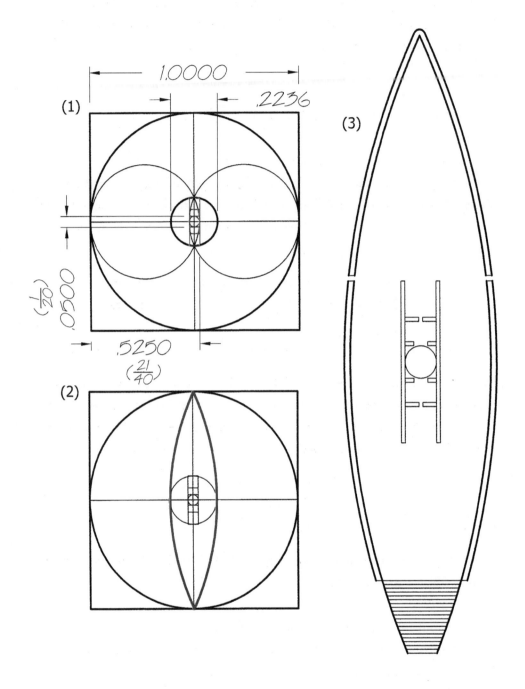

1.0000

.2236

(1)

(3)

$(\frac{1}{20})$
.0500

.5250
$(\frac{21}{40})$

(2)

Drawing 10.6. *The Ship of Time Temple formed from the 4.472 (√20)
ratio vesica that embodies the time ratios derived from the rhythms of
the Mayan calendar as described in the previous text and drawings.
The center circle could be a pool of water beneath a clear dome or a
circular space open to the sky.*

The number that emerges at this double-octave meantone position in the Cellular Underworld is a surprise:

$$16.4 \text{ BYA} \div 4.472 = 3.66 \text{ BYA}.$$

We are familiar with 3.66 as being the diameter ratio of Earth to Moon as well as 366 being the number of revolutions of Earth in one year. There thus appears to be a reference to Earth in this flowering of life day, or perhaps it is Earth that references, through number, this day six when its purpose was first manifested. At this time the intention of the Cellular Underworld was brought forth in the form of the first cells, prokaryotes or one-celled organisms. Just before this, during the 1.26 billion years of night five, Earth itself was formed, and about a 100 million years later the Moon is believed to have been formed. This was followed by a long period of meteorite bombardment of Earth that caused widespread chaos but also brought meteorite-borne water to Earth, the absolute prerequisite for life to emerge. It is believed that the presence of the Moon gradually stabilized the erratic rotation of Earth in preparation for the flowering of life.

Another iteration of our 4.472 factor brings us to the beginning of the Mammalian Underworld:

$$3.667 \text{ BYA} \div 4.472 = 820 \text{ MYA}.$$

## THE VESICA OF TIME

At the core of our construction is the vesica with its ratio of 4.472. Let us look more closely at this figure (see drawing 10.5 on p. 134). At the center of the vesica is an inscribed circle of 1/20 diameter in relation to the enclosing $C_1$ circle. We now draw a square around this inner circle and with half-square radii we drop arcs on both sides to the extended baseline of the square (drawing 10.5[3]). We have generated two points from which two $1/\phi$ rectangles can be drawn that are joined with a central square. We recognize this central element as a $\sqrt{5}$ rectangle. The remaining rectangles attached to the ends of the $\sqrt{5}$ rectangle each has a ratio of $1.118 = \sqrt{5}/2$. This 1.118 ratio is the length of the diagonal of the half-square from which $\phi$ is generated. It is also the frequency of our meantone with string length of .8944:

$$1/1.118 = .8944.$$

*When our "canonical" 3.667 BYA date for the emergence of life is multiplied by 1.272, the square root of $\phi$, we get 4.667 BYA, which closely approximates the dating of the formation of the solar system and Earth, which has been estimated to be about 4.6 BY old. It is believed that the Moon was formed about a 100 million years after the Earth. All of this activity is within the dramatic night five of the Cellular Underworld, which lasted between 5.1 and 3.9 BYA. Recent analyses of traces of bacteria in ancient rocks in Australia and Greenland indicate that life was present on Earth between 3.5 and 3.7 BYA.*

This inner vesica structure is full of geometrical and numeric power and thus serves as a fitting engine to generate the vital changes required for the Mayan calendar. The structure contains the $\sqrt{5}$ function that is the generator of $\phi$, the golden proportion, which is encoded into life-forms. The structure also contains the meantone, the root of the major-third interval, which is associated with water, the element of life. The ratio of the 4.472 rectangle equals $\sqrt{20}$, which sets the rhythm for the unfoldment of the underworlds. This structure is held within the vesica, a symbolic interference pattern, the repository of information, whose generating circles/waves have diameters of 21/40, which is the harmonic mean between 1 and 20.

*The Aborigines of
Australia possess the
most ancient cosmology
describing the origin of
the Creation.
"In their view, the
ancestor first dreams
his objectifications
while sleeping in the
camp. In effect, he
visualizes his travels—
the country, the
songs, and everything
he makes—inside
his head before they
are externalized.
Objectifications are
conceived as external
projections of an
interior vision: they
come from the inner
self of the ancestry into
the outer world."*

NANCY D. MUNN[2]

# THE ERA BEFORE TIME

Taking recent pre-big-bang cosmological hypotheses into account, the 16.4-BY-long Mayan calendar allows for an era before the Primordial Expansion (big bang), which we have called the Dreamtime, a period of preparation for the Creation that recalls the Aboriginal sequence of events as described in the accompanying quote: "the ancestor first dreams his objectifications . . ." This dreaming or imagining is the first stage of Creation whether of the work of an individual or the work of the creator gods. The universally pervasive principle of correspondence that is at the core of harmonic science frees us to imagine such conclusions particularly, as in the present case, when we are working with numerical evidence. Since the Wilkinson Microwave Anistropy Probe (generally called the WMAP probe), which studied the microwave background to ascertain a date for the big bang, gave a date for the Expansion of 13.73 BYA ± 0.12 BY, our 13.66 BYA harmonic calculation is within the scientifically derived date for the beginning of creation.

The great questions are when and how universal creation began. It makes sense to me that there must have been a time of preparation before the Primordial Expansion. Perhaps during the first day, the sowing time of the Mayan calendar—the Dreamtime—the idea of a universe was planted within the Cosmic Soul. Modern cosmologists have considered the possibility of such a time before the Expansion. One scenario is that there was a time of contraction of a previous Universe back to a singularity that then "bounced" out into a new expansion—the present Universe.

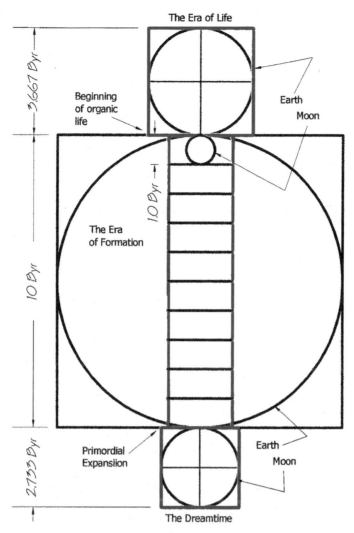

The Era of Life

3.66 Byr

Beginning
of organic
life

Earth

Moon

1.0 Byr

The Era
of Formation

10 Byr

Earth

Moon

2.73 Byr

Primordial
Expansiion

Earth

Moon

The Dreamtime

Drawing 10.7. *A diagram showing the primary time periods in universal creation and their affinity with the Earth/Moon diameter ratio:*

*Era of Formation 10 BYA ÷ Dreamtime 2.73 BYA = Earth/Moon ratio;*
*Era of Life 3.66 BY ÷ 1BY segment of Era of Formation = Earth/Moon ratio of 3.66.*

*The central "ladder" divides the cosmic formation time, which occurred between the Primordial Expansion and the emergence of the prokaryotes, into ten 1-billion-year sections—possibly the cosmic source of the ubiquitous decimal system. The Moon, which seems to be a major factor in measurement (the root of the word* moon *comes from* mens, *which means "to measure") happens to fit perfectly into one of the sections, which reinforces this possibility. Other measures relating to the Moon: the 2.73 BY Dreamtime relates to the 27.33-day sidereal lunar cycle; half of this equals 13.66 days, which relates to the 13.66 BY period from Expansion to the end of the calendar. The Moon, the ancient timekeeper of Earth, thus appears to be in resonance with universal time. We will further explore this possibility in drawing 10.8.*

*Other harmonies include the Dreamtime multiplied by the Era of Life equals the Era of Formation: 2.73 × 3.66 = 10. The Dreamtime is exactly 1/6 of the whole calendar and 1/5 of the time from the Expansion to the end of the calendar.*

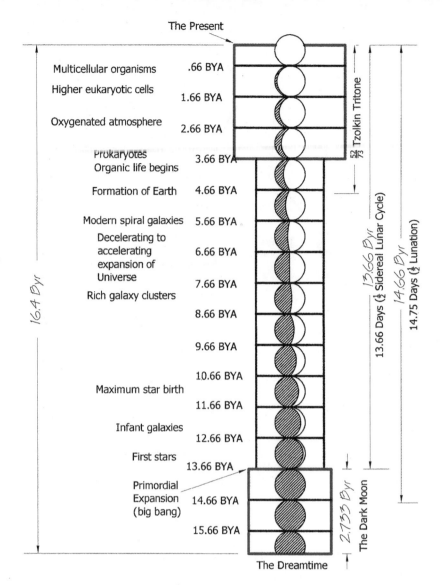

The Present

| | |
|---|---|
| Multicellular organisms | .66 BYA |
| Higher eukaryotic cells | 1.66 BYA |
| Oxygenated atmosphere | 2.66 BYA |
| Prokaryotes Organic life begins | 3.66 BYA |
| Formation of Earth | 4.66 BYA |
| Modern spiral galaxies | 5.66 BYA |
| Decelerating to accelerating expansion of Universe | 6.66 BYA |
| | 7.66 BYA |
| Rich galaxy clusters | 8.66 BYA |
| | 9.66 BYA |
| | 10.66 BYA |
| Maximum star birth | 11.66 BYA |
| Infant galaxies | 12.66 BYA |
| First stars | 13.66 BYA |
| Primordial Expansion (big bang) | 14.66 BYA |
| | 15.66 BYA |

16.4 Byr

52/73 Tzolkin Tritone

13.66 Days (½ Sidereal Lunar Cycle)

13.66 Byr

14.66 Byr

14.75 Days (½ Lunation)

2.733 Byr

The Dark Moon

The Dreamtime

Drawing 10.8. *In this drawing events in cosmic history are set in a structure with lunar correspondences. The lunation circles demonstrate the correspondence between the Expansion-to-Present duration of 13.66 BY and the 1/2 lunar orbital period (27.33 days) that equals 13.66 days. When we add a new moon day from within the Dreamtime we generate half a lunation cycle (29.53 days) of 14.75 days.*

*These dark new moon circles within the 2.73 BY Dreamtime, which correspond to the approximate three days that the new moon is invisible, could symbolize the final stage of a black hole, a remnant of a previous universe that has contracted to a singularity and is now about to expand out into a new universe.*

*The lunar cycle thus serves as a highly visible reminder of universal creation, a correspondence that is both metaphorical and rests on verifiable numbers. It is interesting that the end of the calendar is 2/3 of the way through the full moon, perhaps indicating that though we have come to the end of this evolutionary phase of the Mayan calendar we will still, for quite some time to come, be within the bright influence of its climax.*

At this point, in the absence of any proof, we will allow ourselves to imagine a time before the Expansion that generated our Universe. The numbers of the Mayan calendar, as mentioned above, suggest several clues with which we may work. What was the character of the period before time? Perhaps it was an era in which number was the only reality apart from the Cosmic Soul itself. Perhaps the Cosmic Soul imagined a universe filled with trillions of life-forms and then contemplated what must be in place for this to happen? Were there creator gods such as the Aboriginal ancestral spirits who worked in collaboration with the Cosmic Soul? At this point we must turn to the imagination to take us to regions that are beyond our rational understanding.

Yet, there are numerical clues within the Mayan calendar that might guide us. We have, in chapter 7 (and drawing 10.9), described some aspects of the minor-third ratio of 5/6 and how it can be used to transform $\pi$ into $\phi$:

$$\phi = \sqrt{5/6}\pi.$$

The value $\pi$ is the most ancient relation. It arose with the circle, the primal Platonic form. In order, at the very beginning, to infuse the intention of life into the cosmos it was necessary that $\pi$ be transformed to $\phi$, the ratio that shapes living forms. A ratio, a tone, within the eternal scale was employed to bring this about. When the minor third was sounded on the 16.4 BY musical string of cosmic time in the presence of the seed, the intention for a living Universe—which had been sown during day one and which lay dormant during night one—this seed germinated, and the living Universe radiated into being during the morning of day two at 13.66 BYA:

$$5/6 \times 16.4 \text{ BYA} = 13.66 \text{ BYA}.$$

The date also happens to resonate with the date of the beginning of organic life at 3.66 BYA as described above, the two dates being exactly 10 billion years apart. This 10-billion-year period poised between material creation and the arising of life firmly establishes an imperishable decimal standard with which we can make sense of the numerical harmonies in time and space. The leftover period in the Mayan calendar before the Expansion is 2.73 BY, a number that we explore on p. 145. We have also hypothesized a musical aspect of the calendar as demonstrated in drawing 10.9.

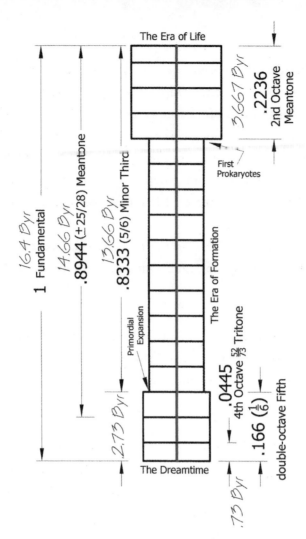

The Era of Life

3.667 Byr

.2236
2nd Octave
Meantone

First
Prokaryotes

16.4 Byr
1 Fundamental

14.66 Byr
.8944 (±25/28) Meantone

13.66 Byr
.8333 (5/6) Minor Third

The Era of Formation

Primordial
Expansion

.0445
4th Octave $\frac{52}{73}$ Tritone

.166 ($\frac{1}{6}$)
double-octave Fifth

2.73 Byr

.73 Byr

The Dreamtime

Drawing 10.9. *If we consider the duration of the 16.4 BY Mayan calendar as a musical string, then we discover that there are certain tones associated with the main sections of the calendar. We first pluck the unstopped string of length 16.4 and sound the fundamental tone. The next tone to sound is the whole tone called the meantone situated at .8944 of the string length. The number .8944 is at the geometric mean between the major whole tone (8/9) and the minor whole tone (9/10). The meantone has important properties. It is related to √5, since*

$$1 \div .8944 = 1.118 \quad and \quad 1.118 = \sqrt{5}/2.$$

*The .8944 meantone is also the square root of 4/5, the major-third interval whose fourth octave, 1/20, sets the rhythm for the unfolding of the underworlds.*

*The 1/6 interval, second octave of 2/3, the fifth, defines the duration of the Dreamtime.*

*The next interval to consider is the minor third with string length of .8333 (5/6). The minor third is the tone through which π is transformed to φ. Thus (5/6 × π) = φ².*

*In our diagram it is located on the string at 13.66 BYA, the time of the Primordial Expansion.*

*The next interval has a string length of .2236, the second octave of the meantone, which locates the beginning of biological life. The frequency of this interval is 4.472 = 2 × √5. As demonstrated in drawing 10.3, this interval can be used to locate the beginnings of each underworld as well as the flowering periods within underworlds.*

The fundamental (1) establishes the Field of Creation whose duration is
16.4 BY.

The meantone, .8944, establishes the potential for $\sqrt{5}$ and $\phi$ and the third.

The fifth, in double-octave form of 1/6, establishes the seeding time, the
Dreamtime.

The minor-third tone 5/6, which transforms $\pi$ into $\phi$, when applied to the cal-
endar as a whole, would signal the expansion, the beginning of universal
creation: $5/6 \times 16.4$ BY = 13.66 BYA.

The next tone, 4/5, the third, would, in octave form, determine the rhythm
of the evolutionary periods, the underworlds. And 4/5 also, in its
vesica construction, generates the blueprint of water, the element of life
(see drawing 10.4). The duration of each heaven, 1.26 BY, is also a fre-
quency number of the third.

There may have been others who dwelled with the Cosmic Soul and who
assisted in the work of dreaming a universe into being, dreaming each atom
and cell and each constant of nature—who tuned the seed so that the strong
and weak force would separate at the right infinitesimal moment of time, and
that protons would form in the ten-thousandth of a second after the Expan-
sion. And the great cycles must also be tuned so that the trillions of beings
necessary for the fulfillment of the Dream of the Cosmic Mind would evolve
and act their parts in the play whose climax would be when the created ones
themselves become creators.

## THE TREE OF TIME

Calleman notes the recent discovery by cosmologists of a vast structure that
he calls the Central Axis of the Universe. He then demonstrates that this
Central Axis may well be what many cultures have called the Tree of Life,
the central regulating physical and spiritual presence from which Creation
emanates. In the Mayan calendar we can also perceive the form of a tree
complete with roots, trunk, and branches. It is a Tree of Time composed of
numerical harmonies, those Platonic elements from which spring the eternal
sacred geometry that is the foundation of space and time. Many of the ratios
that we have studied throughout this book can be applied to the structure of
the Tree of Time, of which we will here attempt a rough sketch.

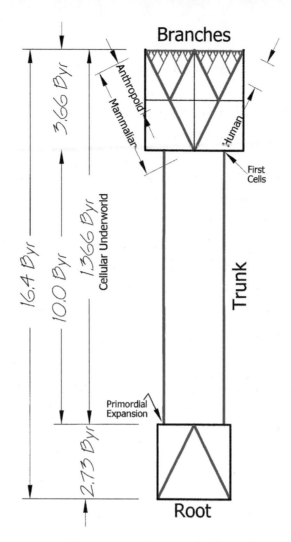

Drawing 10.10. *A construction showing, at the top, the branches of the Tree of Time that, along with the all-inclusive Cellular Underworld, lists the next three of the remaining eight underworlds. Instead of the factor of 20 that is the actual multiplier from one underworld to the next, we have here used a factor of 2 between the branchings. (We note the impossibility of representing an accurate Tree of Time with its successive branchings in 1:20 ratio. If a branch in the final, or universal, underworld were one foot in length then the height of the whole tree would be several million miles!) The present drawing is a simplification to get a sense of the evolutionary dynamics of the calendar. The dual branching after the establishment of root and trunk recalls Joseph Campbell's comment on the structure of creation myths: "The first effect of the cosmogonic emanations is the framing of the world stage of Space; the second is the production of Life within the frame: life polarized for self-reproduction under the dual form of the male and female."*[3]

*The middle structure is the trunk of the tree, a period of 10 billion years during which matter was organized into galaxies, solar systems, and planets in preparation for the evolution of organic life. At bottom is the root of the tree of time, an era that we have called the Dreamtime, referencing the legendary time before creation of the Australian Aborigines. Staying with our plant metaphor we can imagine this as a time of seeding. What were the seeds? Perhaps they were harmonic numbers or heavenly music or a dream of a living Universe.*

It reflects well on the imagination of the Mayan calendar makers who perceived a Creation whose evolutionary processes correspond to the life cycles its chief living inhabitants, the plants. The plant metaphors that we see in the "Periodic System of Evolution" table (figure 10A) give credence to the larger plant metaphor of the tree. During day one of the Mayan calendar the seed of the Tree of Time was planted. This period is the foundation time characterized by the interval of the fifth (drawing 10.9, p. 142), whose string-length ratio equals 1/6:

$$1/6 \times 16.4 \text{ BY} = 2.73 \text{ BY}.$$

On day two it germinated and on day three it sprouted creating the infant universe. The date is 13.66 BYA. Ten billion years pass during which time stars are born and die in novas that spread essential elements throughout the Universe. New stars, then galaxies, and finally solar systems and planets are formed. The first organic life-forms on Earth arise 3.66 BYA. The Dreamtime with duration of 2.73 billion years is the root of the 16.4 BY high Tree of Time. The 10 billion years that follow is the trunk. The remaining 3.66-billion-year period of biological evolution forms the branching of the tree (see drawing 10.10, p. 144).

## WITHIN
## THE ROOT OF TIME

The root of the Tree of Time must be, if the metaphor has validity, a source of numerical knowledge from which we can predict the main temporal patterns of creation. Since many of the numbers under consideration are based on Earth-Moon system measures there is an assumption that is required. We must assume that the Earth-Moon system is a repository of numerical proportions and measures that describe not just our own system but the Universe as a whole. There is no scientific proof of this, yet this idea resonates with some esoteric sources that hold that Earth is a library of cosmic knowledge. Perhaps it is an ideal type of planet, a model, for the emergence and flourishing of life.

We have determined that the duration of the root is 2.73 BY, which we have subdivided into three sections, two of 1 BY and one of .73 BY (see drawing 10.8). First, working with the 2.73 number:

*"Here is one of the most important tasks of harmonic study: to provide a sensible grasp of temporal forms, especially periodicities. As a foundation for this, harmonic 'chronometry' or 'form mathematics'—analogous to harmonic geometry—must be established or re-created; the time-forms must have their own discipline, analogous to that of the space-forms. The establishment of psychic values in the numbers of the time-forms will not only allow these numbers to be understood in a deeper sense, but will also place them in a domain of our cognition that is closely connected with time: temporal tone perception."*

HANS KAYSER[4]

2.73 = 1 ÷ .366, and

366 days = number of Earth revolutions in one year

3.66 = Earth/Moon diameter ratio

3.66 BYA Life begins on Earth

13.66 BYA Primordial Expansion (big bang)

2.73 − 1 = within 99 percent of 1.732, the √3, the ratio of the vesica piscis. The vesica piscis generates the regular polygons as well as the Flower of Life, symbol of the Field of Creation.

73 × 2 × 2 × 2 × 2 = 11.68, the time, in billions of years, from the beginning to the formation of Earth at 4.72 BYA: 11.68 + 4.72 = 16.4.

.73 ÷ 16.4 = .0445, the ratio of the fractional part of the root to the calendar period. This is in octave relation to the "Mayan tritone," discussed in chapter 2:

.0445 × 2 × 2 × 2 × 2 = .7122 = 52/73, which determines the Mayan ritual period, the tzolkin: 52/73 × 365 = 260 days; and

52/73 happens to equal the Arabic tritone of 729/1024:

729/1,024 ÷ 52/73 = .999.

When the numerator and denominator of the ratio 729/1,024 are factored with the numbers 2 and 3, the result produces all the numbers necessary for generating the Pythagorean scale.

Thus 729/3 = **243**; 243/3 = **81**; 81/3 = **27**;
27/3 = **9**; 9/3 = **3**; and 1,024/2 = **512**;
512/2 = **256**; 256/2 = **128**; 128/2 = **64**;
64 /2 = **32**; 32/2 = **16**; 16/2 = **8**; 8/2 = **4**;
4/2 = **2**; 2/2 = **1** giving us

the numbers required for building the Pythagorean scale:

unison: 1/1

minor second 243/256

major second: 8/9

minor third: 27/32

major third: 64/81

fourth: 3/4

tritone: 512/729

fifth: 2/3

minor sixth: 81/128

major sixth: 16/27

minor seventh: 9/16

major seventh: 128/243

octave: 1/2

For the Pythagoreans, *number,* and particularly musical numbers, form the foundation of the cosmos. Here we see an intimation of this idea in the numerical contents of our metaphorical Root of the Tree of Time. We mention that the spiral of the Pythagorean tones, which we constructed in drawing 6.6 using the generating ratio of 13/18 (a tritone), relates to the Mayan time system since 13/18 equals 260/360, the tzolkin divided by the tun. 13/18, as previously mentioned, is the inverse of our $\phi$-tritone ratio of 9/13.

The number 73 itself, as we have seen in chapter 2, has interesting properties.

73 days × 5 = 365 days

73 ÷ 29.53 (lunation) = 2.472 (4/$\phi$)

73 × 29.53 = 2,156, within 99 percent of lunar diameter of 2,160 miles

72.6 = 7,920 (Earth diameter) ÷ 109 (Sun/Earth ratio)

73.3 = 7,920 (Earth diameter) ÷ 1,080 (Moon radius)

And the number 73, as we have noted, is the denominator of the tzolkin-to-year tritone ratio of 52/73 (in musical terms the most dissonant interval). When applied to a year's duration the resulting 260 days marks the beginning of the time of travail for the pregnant mother, being the minimum period from conception to birth. Let us now apply the tzolkin 52/73 tritone ratio to the Mayan Long Count calendar, a period of 5,125 years that began in 3114 BCE and ended in 2011 or 2012:

52/73 × 5,125 years = 3,650 years, the time from the beginning of the
Long Count to its tonal center.

Subtracting the Long Count starting date from 3,650 gives the tonal center:

3,650 − 3,114 = 536 CE.

The Long Count thus divides into two durations with temporal resonances:

5,125 years = 3,650 years + 1,475 years, and
3,650 years references the 365-day year, and
1,475 years references the half-lunation cycle of 14.75 days.

Their ratio equals the 4/ϕ ratio of the Apollo temple:

3,650 ÷ 1,475 = 2.474, within 99 percent of 2.472 (4/ϕ).

An additional interesting synchronicity:

3,114 − 1,475 = 1,639, which references the 16.38 BY
length of the Mayan calendar.

The year 536 CE, the tonal center of the Mayan Long Count calendar, embodied the dissonance of both the tritone interval and the influence of this period's ruling deity, Tezcatlipoca (the Aztec name for the lord of darkness, the Mayan name having been lost). It was a time of worldwide catastrophe generated, it seems, by a super-volcano that dispersed a dense cloud of ash around the globe, darkening the Sun and causing many seasons of frigid weather, drought, crop failures, and famine and contributing to political and economic collapse throughout the world. In the Mayan world the catastrophe may have been the cause of the decline and eventual abandonment of Teotihuacan, the political and cultural center of the empire. The results of the eruption, if that was indeed the cause of the chaos, was felt acutely for a number of years. For the Maya it led to a political realignment of their city-states and a gradual cultural flowering. The book *Catastrophe* by David Keys describes in detail the global effects experienced as a result of this event that is so precisely pinpointed when the tzolkin ratio is applied to the Long Count calendar. In the Mayan world, according to the scholar of Mayan sculpture Tatiana Proskouirakoff, there was, after 534 and continuing to 593 "a dark period in the history of Maya sculpture." She continues ". . . the changed artistic mode seems to be a reflection of some momentous historical event that disturbed the normal artistic development . . . and was followed by a restoration of order and a new pulse of creative activity. . . . It may be tentatively assumed that the historical events which acted as incentive to change affected all aspects of culture simultaneously. . . ."[5]

When the 52/73 Mayan tritone ratio is applied to Calleman's Mayan Periodic System of Evolution the following data emerges:

$$52/73 \times 16.4 \text{ BY} = 11.682 \text{ BY}.$$

Taken from the beginning this gives a date:

$$16.4 \text{ BY} - 11.682 \text{ BY} = 4.718 \text{ BYA},$$

which is the modern estimate for the formation of the solar system and of Earth. Like the yearly and Long Count tzolkins, the time ratios are in 2.472 (4/φ) relation:

$$260 \text{ days} \div 105 \text{ days} = 4/\varphi,$$
$$3650 \text{ years} \div 1{,}475 \text{ years} = 4/\varphi, \text{ and}$$
$$11.682 \text{ BY} \div 4.718 \text{ BY} = (4/\varphi).$$

And, along with the tzolkin-indicated maternal labor crisis followed by the birth of a child, they all mark a period of travail followed by new life: the 536 CE eruption followed by a Mayan cultural renewal.

The 4.718 BYA period when Earth was in a state of crisis, suffering birth throes in the form of constant meteorite bombardment, a toxic atmosphere, and a chaotic orbit. In Mayan terms this period was also ruled by Tezcatlipoca, who, through destruction, prepares the way for a flowering. With the help of the newly born Moon, who helped stabilize her orbit and with the precious water brought by the bombarding meteorites and comets, Earth gradually became a suitable vessel for life as it moved into the flowering time, the time ruled by Yohualticitl, goddess of birth, and around 3.66 BYA brought forth the first single-celled life-forms.

# *11*

⎯⎯⎯

# THE COSMIC FLOWER

Figure 11A. *The radiant gesture of the Sun is mirrored in the forms of life that expand out from a center to a bodily periphery and even beyond to spheres of sound and fragrance and awareness. Bees on a globe thistle,* Echinops ritro.

THE SUN GENERATES ENERGY AT ITS HIDDEN CORE and manifests it as light that streams forth from its blazing surface. This is the universal radiant gesture. In like manner each being has its own expression of the energy at its core: the slithering of the snake, the delicate walk of the deer, the swooping dance of the swallow, the rippling of wheat in the wind, the sparkling geometry of the crystal. The unique signature of each type of being has its source in the species soul, the devic energy that animates it. Their bodily expressions are their ways of radiating, or *unfolding,* their life energies as a bud unfolds into a flower. It may be said that all Earth life-forms knowingly or unknowingly pay homage to the Sun in their radiant unfoldings; it is in the flower, however, where this is most clear. And the polygonal shapes of many flowers that unfold from vesical buds can serve as geometric metaphors for the unfolding of time and life.

## THE SYMBOL IN THE SKY

For our understanding of the principles of creation to transcend mental concepts and language we require symbolic imagery that opens pathways to deeper modes of knowing, with feeling and with intuition. This is what the geometric art can provide to us. A great symbol forms in the sky when the new moon passes in front of the Sun—the solar eclipse. The equality of their apparent sizes then becomes obvious—a synchronicity beyond all random coincidence that naturally demands our attention. Like all symbols there are several or many interpretations.

**Figure 11B.** *The new moon in the process of eclipsing the Sun.*

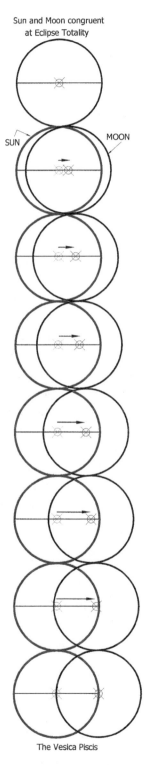

Sun and Moon congruent
at Eclipse Totality

SUN          MOON

The Vesica Piscis

The two—the bright masculine Sun and the dark feminine Moon—become one. Then the separation begins as the Moon continues to move across the Sun's surface. The image is one of scission similar to the movement between the daughter somatic cells during mitosis. This is a gesture of creation, of Unity dividing in two. As geometers we examine the symbol in its details. We reduce Sun and Moon to simple circles and witness in drawing 11.1 the series of vesicas formed by the tonal nodes that the edge of the Moon silently sounds as it moves along the musical string of the Sun's diameter. The yin and the yang join and are parted again, and during this process much has happened. The "ten-thousand things" have arisen in the form of the innumerable vesica shapes with their associated ratios and their tones that have symbolically sounded. Before the parting of the circles, however, we note an important position in the progression: when the circumference of the Moon encounters the center of the Sun, and, conversely, the circumference of the Sun touches the center of the Moon, they form the vesica known as the vesica piscis.

Drawing 11.1. *A symbolic meaning of the geometry of the eclipse of the Sun by the Moon.*

*At totality darkness completely dominates, a surprising and shocking development to the ancients who perceived heavenly messages and warnings in the sky. Darkness could be interpreted as the eradication of consciousness or of life. Such events are possible and have nearly happened during the cataclysmic history of the Earth filled with meteorite and comet strikes, mass extinctions and post-glacial floods. Yet the message is not necessarily so dire. The darkness is not evil. It is a part of who we are. The eclipse reminds us to consider the dark hidden parts of ourselves and to integrate them into our consciousness, our light.*

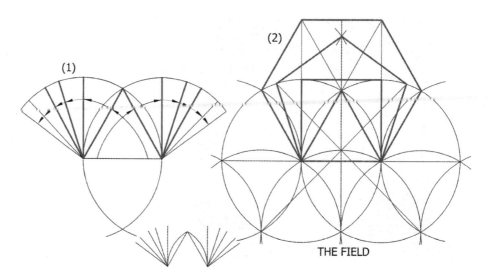

Drawing 11.2. *The primal unfolding. Part (1) is a gestural drawing showing the unfolding, or flowering, that is abstracted from the classical construction in (2) in which this dual unfolding symbol is placed within the matrix of intersecting circles representing the Akashic Field, a section of the Flower of Life symbol (see drawing 4.7). In this context we can construct the polygons (here: triangle, square, pentagon, hexagon) using the inherent points and lines of the figure. The sides of the central triangle connecting equator ends and poles of the vesica can be seen to be folding out and around the vesica-forming circles like a flower blooming from the vesica bud. Next the sides of the square unfold. They are verticals drawn perpendicular to the baseline that intersect the vesica-forming circle and are then connected with a horizontal line. Next, the crossed lines intersecting points on the field as shown are extended to the vesica-forming circles to establish pentagon vertices from which two sides of the pentagon can be drawn. With our side lengths known we can, with compass, cross arcs on the extensions of the vertical axis to establish the point with which we can complete the pentagon. For the hexagon the right and left field-vesica poles provide points to which the lower sides can be drawn. The points where the extensions of the sides of triangle and square intersect provide points to which the upper sides of the hexagon can be drawn. The ends are connected, and the hexagon is complete.*

The vesica piscis is the figure from which polygonal geometry unfolds outward from the triangular inner structure of the half vesica, like a flower unfolding from a bud. Drawing 11.2 illustrates the geometry that gives rise to this opening gesture. In placing this geometry within a matrix of vesica pisces we are able to locate the construction points from which many regular polygons can be generated.

## SACRED COSMOLOGY

"As above, so below." This is the ancient esoteric guide to those seeking to understand the workings of the world. The seeker who accepts this dictum

looks for "the world in a grain of sand"—for clues to the whole contained within the part, for eternity within the moment. The stillness that we can connect with inside ourselves, like the quantum vacuum of deep space, contains tremendous power. The light within is our inner sun that we are drawn to as a sunflower is drawn to the Sun in the sky. The sound of the wind in the trees is continuous with the inner beehive hum of our neurons. The outer reflects the inner. The macrocosm is reciprocal to the microcosm.

Let us now create a symbolic geometric map of cosmic evolution with the assistance of the powerful tools of geometry, number, and the musical scale. These ancient tools have not been displaced by modern science and technology. In fact, they have been enhanced by them. On a practical level computer drawing programs have removed much of the drudgery of calculation and the attainment of accuracy while still allowing a classical approach to construction. On a deeper level the resurgence of the harmonic vision of the world owes much to the discoveries of modern science that have made available accurate measures of time and space, which enhance the accuracy of harmonic symbology. Harmonics, in turn, has brought a breath of fresh air to a science that is in need of simplification so that the ordinary person can partake of our common birthright: some understanding of our living Universe.

Musical geometry is able to accomplish this by creating symbols that awaken parts of us that purely mental constructs cannot reach. These are the realms of the sacred that were, until modern times, the province not only of mystics but also of those who studied the natural world. This study was called sacred science because it did not limit itself to the material world but entered the realms of soul and spirit that were also considered parts of the natural world and thus worthy of study.

In the previous chapter we presented a possible harmonic time line behind the evolution of the Universe as portrayed in the Mayan calendar. It is interesting that the period before Creation, which we have called the Dreamtime, had a duration of 2.73 BY, which is 1/6 the duration of the whole calendar (16.4 BY) and 1/5 the duration of the period (13.66 BY) since the Primordial Expansion (big bang). These ratios suggest that there might be hexagonal and pentagonal properties in universal creation. Both polygonal structures (see drawing 11.2) unfold from the vesica piscis, which itself is the result of the scission of circular unity into two circles. Drawing 11.2 also reveals these circles to be part of a

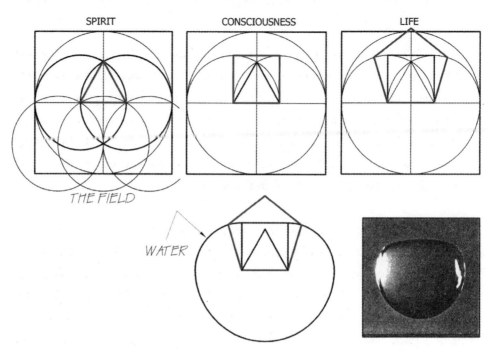

Drawing 11.3. *From the universal field. shown on the left, the triangle emerges. This is Plato's demiurge, the Creative Spirit who takes on the task of creation. As the sides of the triangle unfold outward in an opening gesture (center), the square is generated. This is the symbol of consciousness, the awareness of what needs to be accomplished before the main purpose at hand, the creation of life, can unfold. When the ground is prepared the pentagon (right), symbol of life, unfolds from the square. The construction lines that form the symbols also produce the outline of a waterdrop, below, the substance that is essential to the evolution of life.*

matrix of intersecting circles whose finished symbol is the Flower of Life illustrated in drawing 4.7. As we have noted, this symbol can represent the universal energy field known as the quantum vacuum, or, as Laszlo calls it, the Akashic Field, a sea of colossal energy and information from which Creation is believed to emanate. In our present context we can imagine the polygonal structures of time and life arising from this field.

Our construction of the polygons that blossom forth from the bud of the vesica piscis have the following properties and interpretations.

(1) The generating form is the triangle, the underlying structure of the vesica piscis, which unfolds from the heart of the vesica bud and sweeps out arcs in both directions locating the construction points for square, pentagon, and hexagon. Musically, the number 3 is represented by the interval of the fifth.

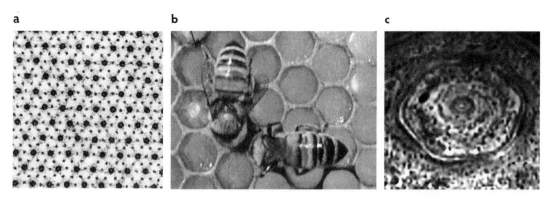

**Figure 11C.** *Natural hexagons from microcosm to macrocosm: (a) micrograph of cross section of fibers in a fly's flight muscles; (b) cells in a beehive; (c) the great hexagonal cloud structure at the north pole of the planet Saturn*

(2) The second regular polygon to be constructed is the square, the symbol of reason and consciousness, the organizing principles behind Creation. The square is also the traditional symbol of Earth and provides a unifying symbol of our fourfold perceptions of space and time: the four directions, the four seasons, the four phases of the Moon, and the four daily positions of the Sun—dawn, noon, sundown and midnight. The fourfold square also represents the four organizing forces of nature: gravity, electromagnetism, the strong and weak nuclear forces; the four letters of the DNA code; and the four main sectors of the human brain—reptilian, limbic, neocortex, and prefrontal lobes. The inner structure of the square is a matrix that can generate innumerable geometric constructions. We have seen throughout the book a few examples of this in the intersections of two of the many kinds of diagonals that crisscross the square and whose intersection points, when projected to the string/diameter of the enclosed circle, give us the tonal nodes from which to produce vesica constructions. Musically, 4 refers to the octave.

(3) The next polygon is the pentagon, the embodiment of the number 5, the number of the major-third interval, which, as noted in chapter 10, plays an important role in the Mayan calendar and is associated with the substance of water. The inner structure of the pentagon is dominated by φ-family ratios that are involved with biological life-forms. (See appendix drawing A2.16 on page 211 for a demonstration of this property.)

(4) The next polygon generated by the triangle within the vesica bud is the hexagon, symbol of primal matter, of the atomic and crystalline realms that make up material creation. In our time analysis of the Mayan

Drawing 11.4. *A hexagonal time structure representing the evolution of the Universe from the pre-Creation period we have called the Dreamtime through the Primordial Expansion (big bang) until the present, a duration of 16.4 billion years, the proposed time span of the Mayan calendar. The sides of the hexagon are 2.73 billion years in duration, which is also the length of the pre-Creation Dreamtime (bottom) period that establishes the rhythm of the calendar. The progression proceeds clockwise in 2.73 BY increments and gives a rough idea of the timing of events, like star formation, which took place over billions of years. The diagram is meant to give a general picture of evolutionary time. The outer heptagon showing the stages of plant growth and their correspondences with Creation and evolution is more in the spirit of the Mayan calendar and in the spirit of this book, which seeks correspondences between above and below, and here, between the growth of the Universe and the growth of a plant.*

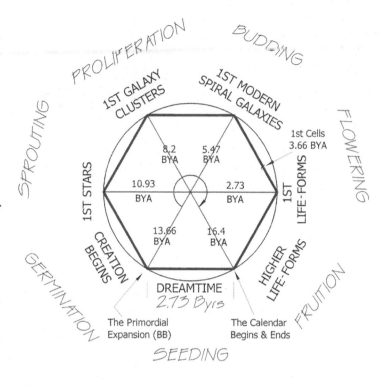

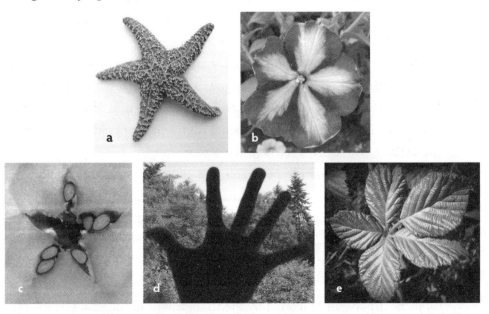

Figure 11D. *The number 5 manifests often in life-forms: (a) starfish, (b) flower, (c) apple cross section, (d) hand, (e) blackberry leaves.*

calendar the hexagon describes the entire calendar, including the pre-Creation Dreamtime. The inner structure of the hexagon is filled with relations based on √3 (1.732), which is the height-to-width ratio of the vesica piscis (see appendix drawing A2.17 on page 211). Musically, the number 6, like the number 3, relates to the interval of the fifth.

We now return to the generating equilateral triangle at the heart of the construction. It is intimately related to the hexagon, being a sixth part of its structure. In the drawing it occupies the lower part of the hexagon, the area that we have referred to as the Dreamtime, the 2.73 BY period before Creation. The position and function of this triangle recall a feature of the Great Pyramid in which the bedrock of the base area was mostly leveled except for a section that was allowed to protrude into part of the lower section of the pyramid. This provided a stabilizing anchor for the structure as well as a connection to the Earth and its energies. A similar feature is found in the Dome of the Rock, the temple in the Old City of Jerusalem, in which the rough, exposed bedrock occupies much of the floor of the temple. In a similar way the triangle in drawing 11.3 represents the Creative Spirit emanating from the Dreamtime, the eternal matrix of existence from which it generates consciousness, life, and time continues to inform evolution as a universal collective unconscious.

**Figure 11E.** *Six polygonal diatoms embodying the numbers 3 to 8. From left, (a) Triceratium, (b) Perissonoe, (c) Actinoptychus, (d) Aulacodiscus, (e) Asterolampra, (f) Asterionella.*

The property of threeness inherent in this period relates to many of the Creation myths of humanity that have a triune creator or a creator, preserver, destroyer, representing the most universal trinity of existence—birth, life, and death—that are intertwined with the three dimensions of space and the three properties of time: past, present, and future.

## THE SYMBOL SPEAKS

Our nested polygons might be interpreted as follows: The field of intersecting waves, the Akashic Field, produces the vesica piscis when two waves intersect each other's center. The inner structure of the half vesica is the equilateral triangle, the Creative Spirit, who assumes the task of creation. Its first creation is consciousness or psyche, represented by the square that mediates between spirit and life.

Life is the next emanation and is represented by the pentagon, the embodiment of the golden ratio and of the fivefold patterns found throughout the biological world, the more advanced realm of life. The next emanation is time, which is represented by the hexagon. Perhaps time serves as a container and regulator of evolution or a tool that life uses to perfect itself. Or time might be compared to a shell that contains a sea creature, life, which *precedes* time as the pentagon precedes the hexagon in the geometrical symbol.

It seems that while life appears contained in time it is, in some ways, independent of time. Thus, "timeless" moments can occur spontaneously in our lives. Or we can choose to enter into timeless states of mind. The dream state and deep meditation are portals into these timeless regions. The triangle represents such a place. It is the place of dreaming where existence was dreamed into being. According to the symbol, it is embedded within the ring of time, consciousness, and life, as night dreams are embedded within our daily lives. This place is a part of us and thus is forever accessible to the seeker, to the dreamer.

## CEREMONY

We have seen that with a foundation of sacred number and geometry we can enter confidently into regions that are inaccessible to ordinary reason. The

*"None of the hundreds of Aboriginal languages contain a word for time, nor do the Aborigines have a concept of time. As with creation, the Aborigines conceive the passage of time and history not as a movement from past to future but as a passage from a subjective state to an objective expression. The first step in entering into the Aboriginal world is to abandon the conventional abstraction of time and replace it with the movement of consciousness from dream to reality as a model that describes the universal activity of creation."*

ROBERT LAWLOR[2]

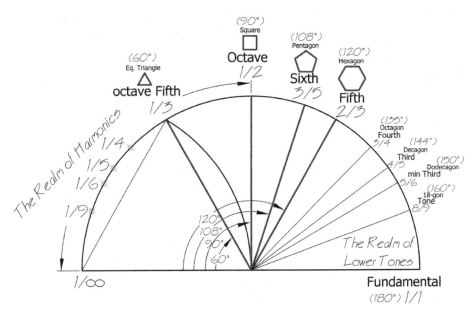

Drawing 11.5. *A wheel of tones and polygons, a construction, generated from drawing 11.2, in which the polygonal angles are framed in terms of tonal intervals. The semicircle with angle of 180° is considered to be a musical string equal to an open string that sounds the fundamental tone. The difference is that this musical string is curved instead of straight. The left half sounds the realm of harmonics from 1/∞ to 1/2. The right half sounds the tones of the main octave. At the 1/3 point of the semicircle is our first regular polygon, the equilateral triangle, whose base angle of 60° is 1/3 of the fundamental angle of 180°, which designates it as an octave fifth. The semicircular string (a logical impossibility in the physical world but a conceptual tool in the realm of harmonics) can be compared to a curved guitar string. When you stop it at 1/3 its length and pluck it, as you would with a guitar, you will sound an octave fifth. The 1/3 length in the present conception not only sounds an octave fifth but, being part of a circle, also creates an angle. Next, at 90°, the octave, the next regular polygon, the square, is generated. The pentagon with its 108° angle (108°/180° = 3/5) is the major-sixth ratio. At the fifth ratio, at 2/3 of the perimeter, the hexagon is formed from the 120° angle. We have also included several other tones that arise from the angles of regular polygons: octagon, the fourth; decagon, the minor third; and an 18-gon, which represents the major whole tone with ratio of 8/9. Between the 8/9 tone at 160° and the fundamental at 180° are innumerable tones and their associated polygons whose perimeters gradually approach the perfect half-circle of the fundamental. (The number of sides of each superparticular-ratio-derived [superparticular ratios are those with the numerator and denominator separated by 1] polygon is twice the number of the denominator of the tonal ratio.)*

*At the other end of the fundamental semicircle we see the realm of the harmonics. These increasingly smaller intervals represent the higher and higher frequencies of the harmonic series. Near the limit, which is at an infinitely high vibration, are the vibrations of the quantum world.*

traditional purpose of these tools is the creation of symbols that invoke spiritual energies for personal and social benefit. A practical application of this purpose is the building of temples proportioned by cosmic principles. George Michell writes of the philosophy behind the building of Hindu temples:

> Only if the temple is constructed correctly according to a mathematical system can it be expected to function in harmony with the mathematical basis of the universe. The inverse of this belief is also held; an architectural text, the *Mayamata,* adds "if the measurement of the temple is in every way perfect, that there will be perfection in the universe as well." Thus the welfare of the community and the happiness of its members depend upon the correctly proportioned temple, and the architectural texts stress that only work that is completed "according to the rules" will gain the desired merit for its builder.[3]

**Figure 11F.** *Itzhak Bentov wrote, "The seed carries not only the information about the* shape *of the tree but also its* unfoldment *in time. . . . The seed is a unique structure because in it space-time has been condensed and stored, awaiting the proper objective time for its unfoldment. . . . It is the representation of the tree in an altered and higher state of consciousness."*[4]

*The seed contains the plant in a highly compressed form, demonstrating the reciprocal relation: the larger the quantity, the smaller the reciprocal. The point is the seed of geometry. The geometric point contains the whole of geometry within itself as a seed contains the plant within itself. The point radiates out in all directions creating a sphere in which all geometric figures can be constructed. This principle gave rise to the modern creation myth of the big bang in which an infinitesimal point of infinite density expands out and becomes the Universe.*

*And, if we follow Bentov's insight, the singularity/seed represents the higher consciousness from which the Universe emanates. This seed gestates within the seeding period, the Dreamtime. In our previous drawings it is represented by the triangle, the symbol of Spirit.* Above, *pumpkin seeds.*

The beliefs that generated temple building had their origins in prehistoric shamanic cultures in which ceremonial practices were developed for the same purpose: to invoke healing energies. Like the temple builders, the shamans' first priority was to establish sacred space within which ceremonies could unfold. A common practice was (and is) the calling in of the energies of the four directions, thereby creating a symbolic square. Within this square a circular ritual area might be scribed on the ground, as in some vision-quest ceremonies, or built, as with the round sweat lodge, or suggested, as with a central fire around which ceremonialists gather or dance. In such sanctified rings we may perceive the primordial symbol of the circle within the square (mentioned in chapter 1) representing Spirit held within the vessel of matter. In such spaces the prayers of the ceremonialists are infused with power. The temple architect and the shaman thus share a common purpose in their work—the reestablishment of harmony in the world.

Figure 11G.

Thus open out the Tao
and it envelops all of space
and yet how small it is
not enough to fill the hand!
HUAI NAN TZU

# APPENDIX 1

———⟨⟩———

# THE VESSEL OF CEREMONY

ORDINARY WAKING EXISTENCE IS, FOR MANY OF US, a fairly unconscious journey through the days of our unexamined lives. More and more people, it seems, have decided that this way of life is unacceptable and that there must be a way to deepen our experience of this amazing opportunity we have as participants in the living universe. One way that humans have traditionally addressed this issue is to participate in sacred ceremonies—to select a precise piece of time and craft it into a meaningful and beautiful work of art—that will restore meaning to life by infusing it with the sacred.

We have, in this book, given a few examples of how musical ratios and other meaningful numbers and geometry are embedded in cosmic structure. There is an ordered harmony that pervades the cosmos, a cosmos that seems to be conscious and whose purpose seems to be the flourishing of life. When we look at natural forms it is hard to imagine the swallow or the bear or the shark or the redwood wanting anything other than a long and flourishing life. They are completely pro-life. This alignment with life's purpose so natural for animate beings can be a challenge for humans, particularly for those living in civilizations.

*

We must remember that in our Universe, in which the flourishing of life is the priority, help is available for the asking. At some unknown period humans

realized the value of requesting help from Spirit in a formal way. The power of a sincere prayer, which often arises spontaneously in times of travail, had long been noted by humans for its efficacy in transforming whatever difficult issue has presented itself by injecting a mysterious energy, which humankind has called "grace," into the situation. After such experiences it was natural to study the matter for future reference when inevitably a similar situation would arise—a situation requiring grace-full help from the unseen world. But perhaps spontaneous prayer would not always be forthcoming, and regular ceremonies, formal prayers, were arranged so that there was less need to depend on an unpredictable soul-wrenching traumatic situation to draw forth our prayer. Of course, there will always be such situations, but in the midst of them we often forget about the availability of help, or we have not formed the habit of asking. And when we just *think* a prayer it often does not reach our heart, our feeling center. Ceremony can help us form the habit of asking by tuning our whole selves—our bodily senses, our minds, our feelings, our imaginations—to resonate with the world of Spirit. Our prayer is not simply thought or spoken but is integrated within a ceremonial context designed to elicit the essential components of true prayer such as sincere intention and gratitude from the participants. Ceremonies are symbolic prayers that have the power to open the heart and give us access to the hidden depths within ourselves. There we can find the resources to approach the spiritual realities being invoked in the ceremony.

> *"Symbolism in the ancient world was always related to practical function, and the symbolic features of the temple were intended to assist the purpose for which the building was designed, as an instrument of invocation."*
>
> JOHN MICHELL[1]

## CEREMONY WITHIN GEOMETRIC SPACE

Ancient temple architecture often embodied an abstract symbolism composed of geometrically designed spaces that represented the ratios derived from cosmic structures of space and time. Such geometric spaces as the ones described throughout this book will be our vessels of ceremony. In creating a vessel of invocation from geometry we are attuning our ceremony to that which is—like the musician who tunes his strings to the eternal intervals that are forever new. Carefully listening, he turns the tuning pegs just as Zalzal or Pythagoras had done, for they knew that to make music the strings must be set to the universal order, must resonate with the ratios that are unchanging. Spaces can also be tuned to resonate with the cosmic order through the careful setting of their proportions to resonate with the eternal ratios. Space is thus transformed to symbol. When we enter symbolic space we are more likely to experience the feeling of the sacred and thus be able to play a part in the theater of ceremony, since the *feeling* of the sacred is what draws the sacred to us.

The theater of the ancient Greek mystery plays was staged within that most powerful geometric form, the circle. Humans had sat or danced, drummed, and sung in fire circles since the earliest times, as today they still do. This primal symbol of humans gathered around a fire corresponds to and resonates with the orbit of the Earth around the central fire of the Sun or the orbit of the solar system around the Galactic Center. A more intimate interpretation of this symbol is the idea of the central fire of the Self around which are gathered the contents of the unconscious psyche and the conscious mind-body.

There are other shapes besides the circle that can hold sacred space, can be vessels of ceremony. These are the temple spaces created by ancient civilizations, such as Indians, Egyptians, Mayans, medieval Europeans, and many others, whose builders knew the sacred ratios and encoded them into their temples so that their ceremonial spaces would resonate with the geometry of Creation. We previously considered an example of this in chapter 2: the temple of Apollo Epikourios at Bassai, Greece. These ceremonial spaces were descendants of older spaces, the megalithic observatory/temples, such as Stonehenge, which embodied the dynamics of the Sun and Moon in their structures. Still older were the ceremonial spaces within Paleolithic caves, sanctified by the wall paintings of spirit animals, messengers of the divine. As humans we are inheritors of these ceremonial traditions. They are encoded within us waiting to be reactivated—like a fine powdered tea—by the water of ceremony.

Ceremony is thus a way to experience the sacred through the use of appropriate symbols. The principal symbols that we will use in our ceremonies are large geometric drawings that represent the subjects of the ceremonies. By literally placing oneself within these constructions the participant can more easily make the shift to an imaginal mode in which revelation becomes possible.

*

When we carefully make representations of cosmic structures such as Earth, Sun, Moon, the water molecule, and the structure of evolutionary time we are honoring and appreciating the Creation and are setting the stage for the invocation of the energies of nature to be present in our ceremonies. Their presence assures us that the quality of the sacred will permeate our ceremony. With this assurance we may feel confident that our prayers of honoring and gratitude will

be heard, and divine feelings of wonder and joy will have a good chance of manifesting for the participants.

We can use these formal prayers, these ceremonies, for anything we want—if none thereby shall be harmed. Thus financial success, health, loving relationships, blessing for a home, and so forth, are all subjects for sacred ceremony. And yet there are ceremonies in which the prayer is simply to walk in beauty or to be of service in helping to transform the world. Whenever ceremonies have this kind of intention, a certain vibration seems to take over. The ceremony can magically draw forth the *trust* that is required to walk the beauty way—the path of love and service.

We have, in the previous pages of this book, learned to use some geometrical tools that we will now put into practice by creating ceremonies of invocation and honoring directed toward the sacred entities that are foundational to our existence: Earth, Moon, Water, Sun, and evolutionary time. We will learn to generate large-scale geometries that are based on the dimensions of these entities. And we will suggest some ways of invocation and journeying that will draw us into the feeling of the sacredness of these powers that sustain our lives.

# CLASSICAL GEOMETRY

To repeat what we have mentioned earlier, in our explorations of sacred spaces we will be using what is called *classical* geometry—that is, geometry drawn using only compass and straightedge. In addition, we will not be laboriously *measuring out* the elements of the drawing but rather letting the potencies of the lines and circles themselves take us from one stage of the construction to the next. What is marvelous about this approach, as we shall see, is that by using a few simple techniques, drawings naturally arise that accurately represent actual cosmic structures.

Practically speaking, the conditions of the ground are not always conducive to receiving drawings. While the ancient temple builders may have leveled bedrock to accurately scribe giant geometric building layouts, we often must work on uneven ground. In this case we can use measurements with the condition that all drawings *could* have been constructed using only compass and straightedge.

## CREATING SACRED SPACE

In the Earth-Honoring Ceremony, as in all of our ceremonies, the cardinal directions are first established and then the invocation can be made. For the indigenous ceremonialist the calling in of the energies of the four directions and above and below has always been an essential element in the establishing of sacred space, the field within which the ceremony can unfold. The principle behind this is that certain unique creative energies reside in the north, south, east, and west and in heaven and earth and that these may be called upon to be present within the ceremonial space. Their presence ensures that the ceremony will unfold in a sacred way.

When the invocation is made, the geometric construction can begin with conversation limited to the work at hand. The participants in the ceremony who are not creating the geometry can silently watch the unfolding of the drawing. Or, if so desired, they can join their voices in a simple toning accompaniment to the work. The facilitator could begin by intoning a note and participants, if they so choose, could join in by imitating the note or improvising variations of the sound. This practice has a calming effect as well as uniting the participants in the ceremonial work. Also, when appropriate, the meaning of the geometry can be explained to them as it proceeds.

## AN EARTH-HONORING CEREMONY

The restoring of honor to the Earth is an essential step in bringing about balance within the ecosystem of our world. To honor the Earth means to live within her laws, to not pollute or waste, and to align ourselves with her wisdom. How can we bring such consciousness into our lives in a real way? There is a disconnect between what we know to be true and our ability to act. We have an abundance of information about environmental destruction, but we seem to be unable to act. The reason for this is that we have lost the ability to *feel* what is happening and so remain powerless. Knowledge and feeling must be joined for real change to manifest. The awakening of the critical feeling power is the function of this ceremony.

In the Earth-Honoring Ceremony when we begin by calling in the directions we are invoking the powers of the ecosphere to work with us in such a way that

*There are many ways to call in the directions. Find one that you like and work with it. Here is a composite drawn from different traditions (ahshay is the Dagara word for "So be it!").*

*To the winds of the South, great Serpent, spirit of healing, you who know the secret places of the Earth. Hear us! Help us to move softly on the Earth as you do, leaving no trace of our passing. Ahshay! To the winds of the West, mother Jaguar, hear us! Protect our ceremonial space. Teach us the way of the peaceful warrior that we may release all things within us that do not serve the Creation. Ahshay!*

*To the winds of the North, ancient ancestors and helpers of humanity, hear us! Show us the way of wisdom, the joining of head and heart. Ahshay!*

*To the winds of the East, great Eagle, you of eternal vision, hear us! Teach us to see our true path. Give us a vision of beauty. Ahshay!*

we may be more in tune with the laws of nature. This kind of invocation is an essential element in all our ceremonies, for without a direct collaboration with Nature and her limitless wisdom we will be working in a vacuum.

An important part of ceremony is the individual offering. Each participant can bring a physical object to offer to the energies being invoked—perhaps a natural object, a stick or a flower or a written poem or a talisman—something one is comfortable with giving away. Or, conversely, the participant could bring a treasured object that is more difficult to part with. It might be a burnable object if the intention is to burn the offerings. Otherwise it could be buried.

*

The actual conduct of the ceremony can take many forms. First the geometry (see Earth Ceremony drawings 1–14 on the following pages). If the ceremony is to take place on the beach or on a cleared and leveled piece of ground, the geometry can be marked out with lines inscribed in the sand or dirt using a stake-and-cord compass for circles and a chalk line for straight lines. If the ceremony is held indoors the circles can be made with stake-and-cord compass but with the difference that the lines are generally not scribed into the floor. Instead, one person can hold the center of the compass and another person the scribing end. As the scribe slowly and lightly passes the scriber around the floor a third person carefully deposits pebbles or corn kernels close behind the scriber to form the arcs and circles. While a chalk line could be used indoors, an alternative method may also be used: a line is held taut from both ends and beneath it the corn kernels are laid out. If so desired, when the final drawing is produced the construction lines can be erased or removed leaving the essential geometry to stand alone.

When the geometry is completed, the drawing can be decorated by all the participants. For example, in this Earth-Honoring Ceremony the circles of the finished drawing can be outlined with flowers or natural objects gathered from the surrounding land or brought by participants. In Earth Ceremony drawing 14 (p. 173) we see that portals leading from one layer to the next have been made resulting in a spiral pathway into the center. The portals can also be decorated with natural objects. If the ceremony takes place at night candles could outline the ring circles. In general, the decorations can be left to the discretion of the participants.

The purpose of this ceremony is to journey to the center of the Earth and there to connect with the Spirit of the Earth to give honor and gratitude for all the gifts that we have received. The journey can also be a time of questions that can be directed to the Spirit of the Earth. Other intentions may arise, and the participants are free to follow their own inclinations in this regard. In the same vein we should note that the details—such as the words of the journey or the musical accompaniments—are left to the discretion of the facilitator and/or participants. The following are only suggestions.

*

A possible scenario: After the drawing is complete and an explanation of the conduct of the ceremony is made, the participants gather around the outer circle of the Earth drawing and begin meditation. At a certain point they begin toning—perhaps the vowel sound *aaahh*. A drum begins and the toning fades out and the facilitator begins the guided journey.

*Close your eyes and feel yourself relaxing. Begin breathing in to the count of seven: one, two, three, four, five, six, seven . . . holding for a count of seven: one, two (etc.) . . . breathing out for a count of seven . . . holding for a count of seven . . .*
(facilitator continues for several rounds).

*Feel your spirit body rising up from your physical body. You are walking in a meadow. The sun is shining in a blue sky. Look at your feet as they walk through the grass. Are there flowers? You look around yourself as you walk along. What do you see? You approach a great tree rising out of the meadow. Its branches are so high that they disappear into the clouds. Gigantic roots enter the earth. You walk up to the tree and place you hand on its trunk and greet it. Tell the tree that you would like to enter the earth. You see a cavelike opening at the base of the tree, and you enter it and feel yourself going down, down into the Earth, passing the roots of the great tree, passing huge boulders. You pass through the geological layers, through the crust and upper mantle and down into the lower mantle toward the core. You pass through the molten river of the outer core. As you pass through the liquid fire you feel it taking away any impurities that you have brought from above. . . . And now you enter the solid iron of the inner core and come to rest at the center of the Earth. Here you greet the Great Mother and make your prayer of gratitude. . . . You ask Mother Earth if there is anything you need to know to serve Her. You listen for her answer. . . . You receive an answer and thank Mother Earth.*

*Now you begin your journey back up. You ascend out of the solid inner core and*

*through the molten outer core, through the lower and upper mantle and the crust and back out the opening beneath the tree. You walk out onto the meadow and across the grass and return to your body seated around the Earth symbol.*

(The drum stops.)

*Take a deep breath and move your fingers and toes and begin toning as you integrate the message from the Earth Mother.*

The toning gradually fades out, and the participants sit in meditation for a while. The toning begins again, and one by one the participants enter the first portal, where they are purified with sage smoke. They travel the spiral path illuminated by candles, through the second, the third portals. They enter the final portal and place their offering to Earth Mother on the altar. Then they return the way that they came back to the outer circle. When all have made the journey the toning fades and the ceremony closes. The offerings can be burned or buried in the earth.

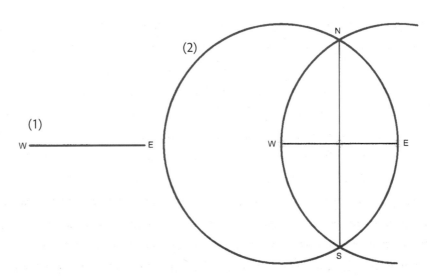

**Earth Ceremony drawings 1 and 2.** *(1) Draw an east-west line This will be the diameter of the circle representing the Earth. (2) Draw two intersecting circles each with a center at an end of the east-west line and a radius extending to the other end of the line. Join the intersection points of the resulting vesica with a line that locates the center of the original line and also gives the north-south line.*

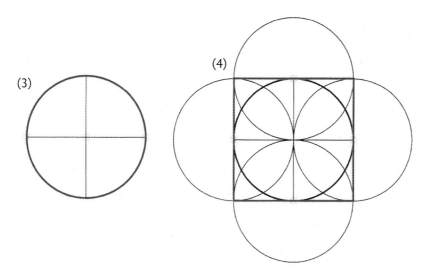

Earth Ceremony drawings 3 and 4. *(3) We now have a center for our Earth circle with its diameter the length of the original line. Draw the circle. (4) With the four axis ends as centers draw four circles with the same diameter as our Earth circle. Then connect the intersections of these circles to generate a square that encloses the Earth circle.*

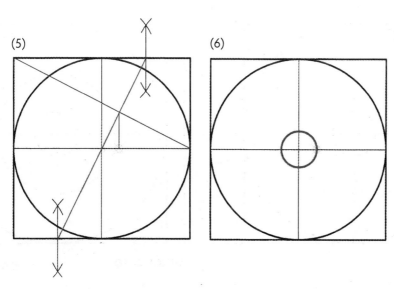

Earth Ceremony drawings 5 and 6. *(5) Find the midpoints of two quarter-square sides and draw two diagonals as shown. Drop the intersection of the diagonals to the horizontal diameter giving a point that defines the radius of the inner core of the Earth. (6) Draw the inner core.*

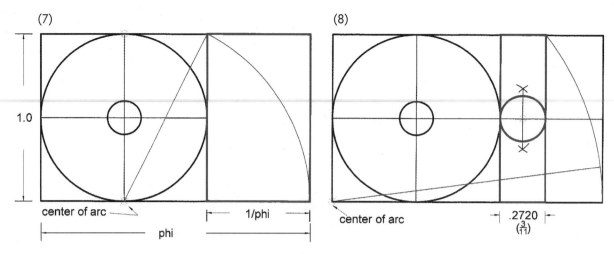

(7)  1.0

center of arc

phi          1/phi

(8)  center of arc          .2720
$\left(\frac{3}{11}\right)$

Earth Ceremony drawings 7 and 8. *(7) Draw a circle arc with half-square radius to intersect the extended baseline of the Earth square. Mirror this on the opposite side and draw a rectangle adjoining the Earth square. (8) Draw another arc with radius the length of the Earth square plus rectangle. Mirror as in (7) and draw a new rectangle within it. Within this smaller rectangle draw a circle. This circle is the size of the Moon in relation to the large circle which represents the Earth.*

(9)          (10)

outer core          inner core

Earth Ceremony drawings 9 and 10. *The diameter of the Moon circle from drawing (9) becomes the radius of a circle drawn in the center of the Earth circle. Draw this new circle. (10) This circle represents the boundary of the outer core of the Earth.*

Earth Ceremony drawings 11 and 12. *(11) Using the 1/phi length from drawing
(7) section off the Earth square three times as shown. (12) Connect the phi section
points with diagonals. Drop their intersection to the horizontal diameter and draw a
circle, whose center has been determined by the bisection of the horizontal diameter,
between the resulting point and the far end of the diameter.*

Earth Ceremony drawings 13 and 14. *Center the new circle on the Earth circle.(13)
This represents the boundary between the inner mantle and the outer mantle/crust.
(14) Cut out portals into each layer as shown.*

# A BIRTH OF
# THE MOON CEREMONY

This ceremony will educate us, using sacred geometry and the tools of ceremony, about the origin of the Moon and its importance in the history of the Earth and the history of humanity.

The study of the Moon is a most ancient human occupation. The Moon with its regular phases was probably the earliest timekeeper for humans. Archaeologists have found lunar notations in the form of counting lines incised on bones that have been dated to the Paleolithic era. Later, the study of the Moon led humans to erect stone-circle observatories to predict lunar positions during annual and multiyear cycles and to observe the changing relations of the Sun and Moon.

We know that the Moon working with the Sun raises and releases the water level in harbors and on beaches twice a day and, in a slower rhythm, increases and decreases the volume of this water twice a month at full and dark moon times. And we know that the Moon, breaking the Earth's hold, draws the moisture from the ground up through the soil to dampen and help awaken the dormant plant seeds. As it becomes clear that the Moon has an intimate connection with life and its cycles, we can begin to understand why our ancestors studied the Moon for thousands of years.

The modern scientific story of the birth of the Moon tells us that relatively shortly after Earth was formed a planet about the size of Mars (which we will call the Wandering Planet) crashed into Earth. Some of the debris from the explosion remained on Earth, some went into space, and the remainder went into orbit around Earth. Through gravitational attraction this debris gradually coalesced into the Moon.

As shown in the drawings, we will construct a geometric space that will bring together the elements of the story. Within this space there will be the four phases of the Moon, as well as Earth and the Wandering Planet. And there is a figure that we will use to consolidate these elements into a unified whole. This figure is the well-known chacana, the symbol of the native Andean peoples, which we will modify to contain the elements of our modern mythic Moon story.

In Birth of Moon drawing 15 (p. 180) we have inserted the Sun into the blank space left when the Moon was thrust from the Earth and into space. It fits perfectly because the sizes of the Sun and the Moon in the sky are the same, both occupying a half a degree—a congruence that defies any sort of standard explanation. Perhaps, as the ancients believed, the sky speaks to us about the nature of things. The Sun was symbol of the masculine principle, the Moon, the feminine principle. Though quite different in their ways of expression, the sky tells us they are ultimately equal. There are many such correspondences that relate to the feminine Moon and the masculine Sun. In a feminine way, moonlight mysteriously transmutes the light of the Sun and bathes the landscape in a soft beauty in stark contrast to the harsh radiance of noon. And the *power* of the feminine Moon is not to be belittled. Regularly, during eclipses, she completely blocks the Sun. Yet, during a lunar eclipse, even she is eclipsed by the shadow power of her Mother Earth. Thus speaks the sky.

These things did not go unnoticed by early humans living within a mythic consciousness in which the happenings in the sky had meaning. They were also aware that the Moon influenced human behavior, a phenomenon confirmed by modern cosmo-biologists as well as many, including myself, who have experienced her effects. For example, around the time of the full moon human energy is amplified, and this energy often is expressed in both creative and destructive ways. For fragile early societies, this kind of knowledge was of great importance and led them to erect the standing-stone sky observatories so that they could better understand the cosmic forces that influenced their lives.

*"With the use of ceremony and ritual, we are engaging with, playing with, the symbols and poetry of a primitive consciousness, bypassing the question-and-answer discourse of our rational minds. There are no hard-and-fast rules. Our only obligation is to be fully present . . . to free ourselves to whatever we experience."*
ALBERTO VILLOLDO[2]

While constructing the geometry for our ceremony we will follow the procedures explained previously regarding the calling in of the directions and the maintaining of silence except for necessary communications. When the geometry is complete the participants can decorate the Moon phases and the chacana with flowers, candles, and natural found objects. Then they can gather around the chacana and make themselves comfortable. The facilitator can begin toning a note and others can join in if so desired in order to help clear the mind and relax the body for the journey to come. The drum begins and the toning fades out, and the facilitator begins the guided journey.

*Relax and breathe deeply . . . long breath in . . . long breath out. . . . Feel your spirit body moving out from this place to a grassy meadow. You walk across the meadow noting what is around you. Are there flowers? Are there animals? You look up at the sky. . . . Are there clouds? Are there birds? In the distance you see a great tree rising into the sky. It is so high that you cannot see its top. You walk up to the tree and place your hand on its trunk and greet the tree: "Greetings, O great Tree of Life. I would like to journey back to the birth of the Moon."*

*You walk around the tree and take flight. You sail over mountains and lakes and back into time. You see the Moon rising over ancient Rome where citizens stand in front of a marble column. Then you fly over a forest and come to a cliff where people wearing animal skins are huddled in the entrance to a cave. They stare up at the Moon that you see reflected in their eyes. You travel back further in time to when dinosaurs walked the Earth and further back to ancient swamplands where giant dragonflies flit among the ferns with the pale daytime moon overhead. Back further in time, you fly over an ocean that covers the whole Earth. The Sun is setting and the full moon is rising. You fly billions of years further back in time when the airless and lifeless Earth was a chaotic place filled with great earthquakes and the fire of volcanoes. Her motion is erratic on her axis and she seems on the verge of destruction. A great sphere approaches the Earth then fills the sky. You fly far above and look down on the colossal explosion as the sphere impacts the Earth. The explosion ejects billions of tons of rock into space, much of it held in orbit by the Earth. Now, as you move forward in time, you see the rock fragments coalescing, forming a sphere. The Moon is born. The impact has tilted the axis of the Earth to its orbit and so the seasons begin and the ice caps begin to form. As you fly back toward the present you note how the Moon has helped stabilize the motion of the Earth, which is now cycling through regular days and nights. The great rains begin and continue for thousands of years. You come closer to the Earth and fly over the world ocean and see beneath the waves how life is forming under the influence of the Moon. First tiny algae, then plant forms waving in the currents, then tiny animal forms, then fish. And now the continents arise from the world ocean and the play of life continues on the land. Closer to the present you see humans planting fields according to the Moon rhythms. And they are erecting great stone circles to study and to honor the power of the Moon so intimately connected with water and thus with all of life. You come back to the World Tree after sundown as the full moon is rising illuminating the meadow with a soft glow. You look up at the Moon and ask it a question. . . . You wait and receive the answer, then walk back across the meadow and enter your physical body here in this place in the present time.*

The participants begin toning to integrate the experience. Maintaining the toning the participants rise and walk around the chacana, leaving offerings at the Moon circles. Then, one by one, they enter the portal that had been constructed earlier. They seat themselves within the chacana around the Sun circle, in which a fire has been built, for a period of meditation. The offerings of the participants can be placed in the fire, after which the ceremony ends.

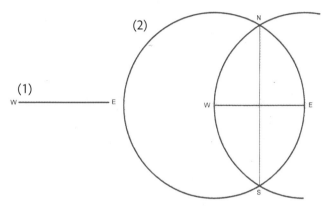

Birth of Moon drawings 1 and 2. *(1) Draw an east-west line. This will be the diameter of the circle representing the Earth. (2) Draw two intersecting circles each with a center at an end of the east-west line and a radius extending to the other end of the line. Join the intersection points of the resulting vesica with a line that locates the center of the original line and also gives the north-south line.*

Birth of Moon drawings 3 and 4. *(3) We now have a center for our Earth circle with its diameter the length of the original line. Draw the circle. (4) With the four axis ends as centers draw four circles with the same diameter as our Earth circle. Then connect the intersections of these circles to generate a square which encloses the Earth circle.*

Birth of Moon drawings 5 and 6. *(5) Locate 1/5 of the side of the square to be used in the drawing (6) by constructing the diagonal crossing as shown. (6) Using the 1/5 measure step off the 1/5 and 3/5 distances. Draw the diagonals as shown. Drop their crossing point to the horizontal diameter to locate the 7/11 section point. Mirror on the other side of the vertical axis of the circle.*

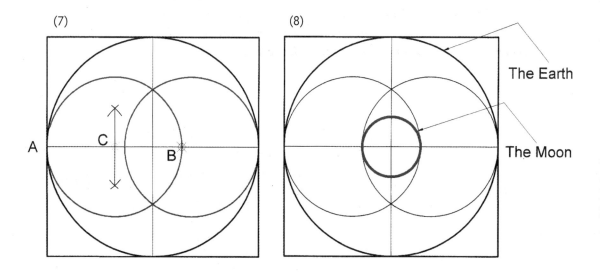

Birth of Moon drawings 7 and 8. *(7) After finding the circle centers between the section points and diameter ends draw the two intersecting circles to form the vesica. (8) Draw a circle inside the vesica. This is exactly the size of the Moon in relation to the Earth represented by the enclosing circle.*

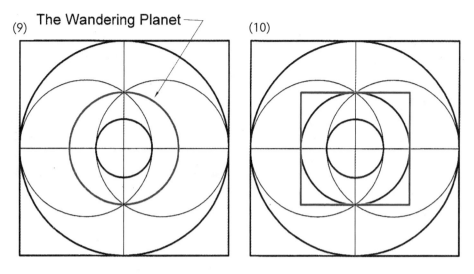

Birth of Moon drawings 9 and 10. *(9) Draw a circle around the vesica. This is the relative estimated size of the Wandering Planet, which impacted the Earth and resulted in the formation of the Moon. (10) Draw a square around the Wandering Planet.*

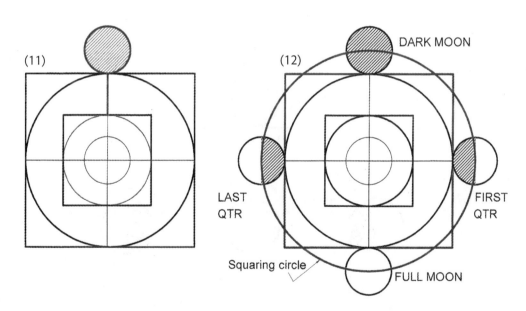

Birth of Moon drawings 11 and 12. *(11) Draw the Moon above the Earth to represent the result of the violent impact of the Wandering Planet on the Earth. (12) Draw a squaring circle through the Moon. The squaring circle's circumference equals the perimeter of the square around the Earth and gives us centers to draw the four phases of the Moon. (The squaring circle is an ancient tool of invocation that symbolically expresses union between Spirit (the circle) and matter (the square).*

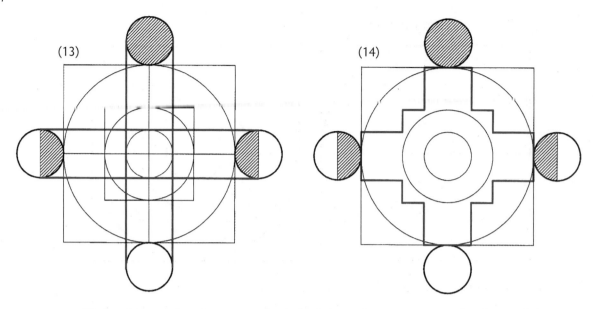

Birth of Moon drawings 13 and 14. *(13) Draw lines connecting the phases of the Moon. (14) Using the elements of the Earth, Moon and Wandering Planet shown in drawing (13), construct a chacana.*

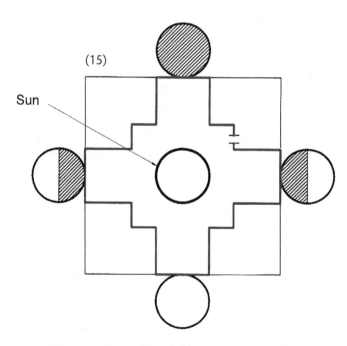

Sun

Birth of Moon drawing 15. *(15) Cut out a portal into the chacana. The central circle is left and will represent the Sun, which is the same apparent size as the Moon in the sky.*

# A Water-Honoring Ceremony

We now enter the microcosm to illuminate a sacred form: the water molecule. To construct a scale model of this molecule we will proceed according to the rules of classic geometry that, limited to the tools of compass and straightedge, is the simplest approach to the heart of geometry.

Sacred geometry, along with music, mythic stories, poetry, and sacred dance, partakes of a simple and profound way of knowing. In all of these we use *mimesis,* or representations of reality, to alter our consciousness such that we may enter into the presence of the sacred. Humans have used pictures or statues of gods for this purpose. Indigenous hunters have worn fur or feathers to *become* their prey in tribal dances before the hunt. Shamans may put on bird wings to aid in shape-shifting to access hidden knowledge. In our present example we geometrically draw an accurate representation of the water molecule to invoke the spirit of water.

In our water molecule construction we once again use the Earth/Moon size relation, and while the moon's size properties will be necessary factors in the generation of the molecule of water the presence of the moon is also a necessary ceremonial element since the moon and water are energetically connected. As usual we invoke the four directions and above and below after the east-west and north-south lines are established (drawings 1 and 2). We then construct the circle in the square and generate the moon from the half square through the agency of the golden proportion (drawings 4–7). A squaring circle is drawn through the center of the moon—both a ceremonial gesture and a practical way of locating the centers of the four Moon phases that are then constructed (drawing 8).

We now draw a vesica-tone construction (drawings 9 and 10) (see chapter 1 for a description of this figure) derived from the major-third interval that produces an inner angle of the vesica of 104.5 degrees—the bond angle of the water molecule (drawing 11). We then consider the length of the distance between the horizontal and the vertical vesica ends as the bond length of water. We now have the angle and bond length of water. The relative sizes of the atoms of oxygen and hydrogen in relation to the bond lengths are derived from the Earth/Moon drawing as shown in water drawings 12 and 13. Amazingly, the proportions turn out to quite accurately correspond to the atomic sizes.

A chacana representing the Earth containing the model of the water molecule is now drawn (drawing 14). This is the ground plan for the Temple of Water that is surrounded by the Moon phases. (This construction was demonstrated in chapter 4.) At the center of the chacana a bowl of water is placed and decorated with flowers. The participants gather around the inner walls of the chacana. They sit and make themselves comfortable, breathe deeply, and close their eyes. Following the instructions of the facilitator they begin toning the interval of the major third, which, as we have noted, is geometrically associated with the structure of the water molecule. Half the group tones a fundamental tone, and the other half tones the third above. The facilitator speaks.

*As you tone imagine that the tones are generating walls of falling water in the shape of the chacana, creating a translucent shimmering cathedral. You are co-creating this architecture with the Spirit of Water and with sacred harmony.*

(As the toning fades the journey drumming slowly begins.)

*Now, with your intention, leave the walls of water in place and come in to silence. Let your spirit-body walk around the Temple of Water. . . . Explore the secret places that call to you. . . . And now let your spirit-body move to the center of the temple where the Spirit of Water resides. Greet the Spirit of Water and thank it for its blessings. If you have a question, ask it. If not, simply ask for guidance. . . . When you receive your answer let your spirit-body come back to where you are sitting and join with your physical body.*

(The drumming ends as the toning begins.)

*Begin toning the interval of water, and with your intention slowly bring the water walls of the temple back into the earth. Now come into silence and integrate what you have learned in the Temple of Water.*

The participants can now blow their thanks to water into a flower and place it in the bowl of water. The bowl can then be emptied into a nearby river or ocean. If no body of water is available the flowers can be put into the fire and the water poured onto the earth.

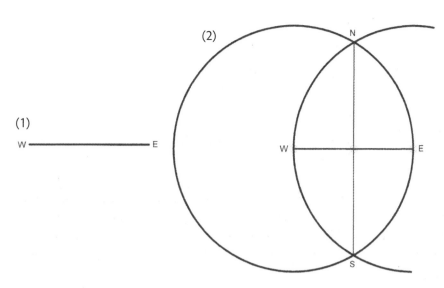

Water Ceremony drawings 1 and 2. *(1) Draw an east-west line This will be the diameter of the circle representing the Earth. (2) Draw two intersecting circles each with a center at an end of the east-west line and a radius extending to the other end of the line. Join the intersection points of the resulting vesica with a line that locates the center of the original line and also gives the north-south line.*

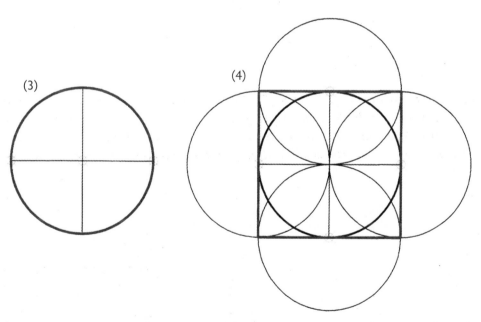

Water Ceremony drawings 3 and 4. *(3) We now have a center for our Earth circle with its diameter the length of the original line. Draw the circle. (4) With the four axis ends as centers draw four circles with the same diameter as our Earth circle. Then connect the intersections of these circles to generate a square that encloses the Earth circle.*

Water Ceremony drawings 5 and 6. *(5) Using a half-square diagonal as radius drop an arc to an extension of the side of the square. Mirror on the opposite side to generate a φ rectangle. (6) With radii the length of the φ rectangle construct a circle arc to intersect the rectangle. Mirror on the opposite side and draw a smaller rectangle inside the larger from the points of intersection.*

Water Ceremony drawings 7 and 8. *(7) A circle is inscribed within the smaller rectangle. This circle represents the Moon in proper proportion to the circle that represents the Earth. (8) A larger circle centered on the center of the Earth circle is drawn through the center of the Moon. Draw the four phases of the Moon from the points generated from this larger circle.*

Water Ceremony drawings 9 and 10. *(9) Draw two half-square diagonals as shown. Drop a line from their intersection to the horizontal diameter at x. Bisect the line xy at z. This will be the center of the first vesica-forming circle. (10) With point z as center draw a circle that intersects point x and the diameter end. Mirror the construction on the other side of the vertical axis to generate a vesica.*

**Water Ceremony drawings 11 and 12.** *(11) The internal angle of the vesica is 104.5°, which is the bond angle of water. (12) In this drawing, to find the sizes of the oxygen and hydrogen atoms that comprise the water molecule we have repeated the construction shown in water ceremony drawings 5–8, but now we consider the Moon, which we have already generated in the previous drawings, as the Earth (a). (b) Now draw a circle around both these figures—that is, around the new, smaller, Earth/Moon figure. This circumscribing circle will be our oxygen atom. (c) Divide the oxygen circle in two and draw a circle. This will be our hydrogen atom.*

(13)  (14)

**Water Ceremony drawings 13 and 14.** *(13) Center the hydrogen atoms on the ends of the lines that represent the bond lines of the water molecule. Center the oxygen atom at the vertex of the bond lines. (This model quite accurately reflects the proportions of the actual water molecule.) Place another oxygen circle in the left side of the composition. This will serve as a guide for the construction of the chacana and will later be deleted. (14) Draw the chacana: draw a line from the Earth square to the intersection of the hydrogen and vesica circles, then to the Earth circle, then to the oxygen perimeter and finally back to the Earth square. Mirror horizontally and vertically.*

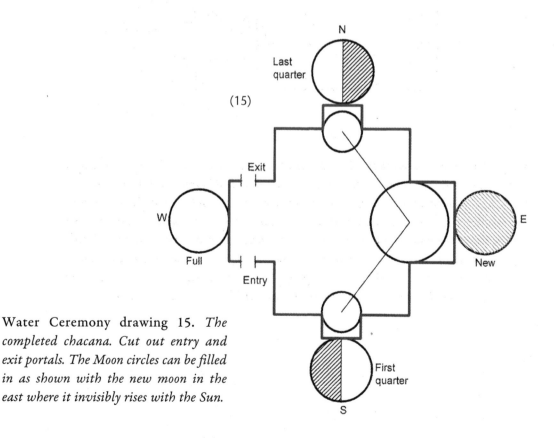

(15)

**Water Ceremony drawing 15.** *The completed chacana. Cut out entry and exit portals. The Moon circles can be filled in as shown with the new moon in the east where it invisibly rises with the Sun.*

# A Birth of
# the Cosmos Ceremony

For this ceremony we will create a ceremonial vessel based on the structure of cosmic time as revealed by the Mayan calendar. This is our Tree of Time described in chapter 10. The purpose of this ceremony is the ritual cleansing of the accumulated dark energy of the past from the energy fields of the participants by journeying back to the "First Time" before material creation and then coming forward through evolutionary time back to the present.

The beginning of the ceremony will take place in the region, described in chapter 10, that we have called the Dreamtime, after the Aboriginal term for the time when the ancestor gods were dreaming the world into being. We have hypothesized through harmonic analysis of the Mayan calendar that such a time before the Creation may have existed (see chapter 10 in the text). This is not at odds with modern scientific theory that admits the possibility of a time before the big bang, although its character remains a mystery, a mystery that we will attempt to enter with the tools of imagination and sacred ceremony.

*

The structure of our ceremonial vessel will be a Tree of Time whose roots extend into the dark soil of the Dreamtime. After the geometry is laid out, the area of the Dreamtime can be enclosed by a sweat-lodge-type of circular tent with a portal opening to the beginning of the Path of Formation (the trunk of the Tree of Time), which leads to the Era of Biological Life (the branches of the Tree). The Era of Biological Life has a fire circle enclosed by stones in its center in the middle of a branching pattern that can be decorated with leaves, flowers, shells, and so forth.

The participants will sit or lie down in the darkness and silence of the Dream Lodge. A slow drumbeat begins. The facilitator speaks.

*Breathe a long breath in. Breathe a long breath out. (Repeat ten times.) You are in the darkness of the void in an era before time, before the creation of matter. This is a time of dreaming when only Spirit exists, that Spirit which is you. You are dreaming of a seed lying within the dark void. It is filled with infinite energy yet is dormant, waiting, at peace. You examine the seed, admiring its beautiful form, feeling its potency. . . .*

*Now a drop of crystal-clear water falls onto the seed, and the seed cracks open and light radiates out from its depths. The light streaming out from the seed is filled with stars and galaxies of stars that fill the dark void with shining brilliance. Within this brilliant light you see our Sun with a cloud circling around it. You look more closely and see planets forming within the cloud. You see the early Earth, a molten sphere of lava with asteroids raining onto it. A gigantic planet-size object crashes into the Earth causing a huge explosion and sending up molten rocks that surround the Earth. Now the Moon forms from the circling rocks, and the Earth becomes calmer as it circles the Sun with its companion Moon. You come near to the Earth. An ocean has formed. You walk to the edge of the ocean and look closely at the foamy edge of a wave. You see a tiny wriggling cell and then other cells around it. Time passes. A fish leaps in the air. A lizard suns itself on a rock. You turn and walk back across the beach and into the forest. Mice play on the forest floor. Monkeys swing through the trees. Now you walk out onto a plain. Humans are gathered around a fire. They wave to you and gesture that you join them. You sit down at the fire as you wake from your dream.*

The participants rise, and the door to the Dream Lodge is opened, and they walk the Path of Formation and enter the Era of Biological Life where they gather around the fire in which they place their offerings to the Universe. The ceremony ends.

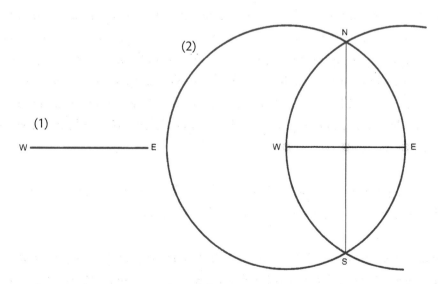

Tree of Time drawings 1 and 2. *(1) Draw an east-west line. This will be the diameter of the circle representing the Earth. (2) Draw two intersecting circles each with a center at an end of the east-west line and a radius extending to the other end of the line. Join the intersection points of the resulting vesica with a line that locates the center of the original line and also gives the north-south line.*

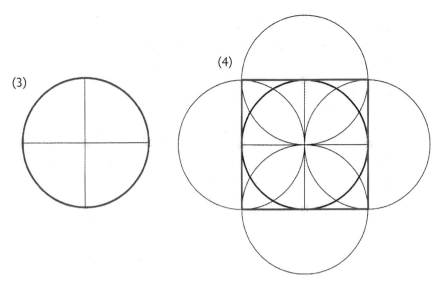

Tree of Time drawings 3 and 4. *(3) We now have a center for our Earth circle with its diameter the length of the original line. Draw the circle. (4) With the four axis ends as centers draw four circles with the same diameter as our Earth circle. Then connect the intersections of these circles to generate a square that encloses the Earth circle.*

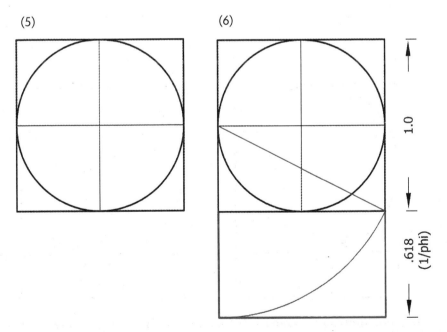

Tree of Time drawings 5 and 6. *(5) Our foundational form, the circle-in-the-square begins this part of our construction. (6) With half-square diagonal radius swing an arc to the extension of the square. Mirror on the other side and complete the golden rectangle.*

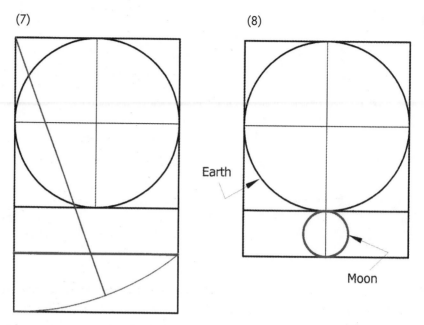

Tree of Time drawings 7 and 8. *(7) With the long side of the golden rectangle as radius swing an arc to the opposite side. Mirror, as in (6), to form a smaller rectangle. (8) Draw a circle within the new rectangle. This smaller circle is in size relation to the larger circle as the Moon is to the Earth.*

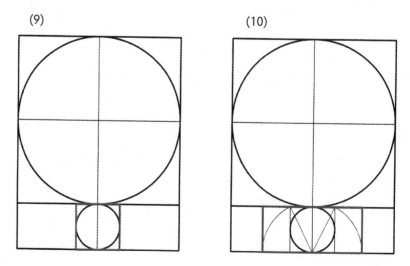

Tree of Time drawings 9 and 10. *(9) Enclose the Moon in a square. (10) With half-square radii draw 2 arcs to the baseline as shown. Complete the new rectangle whose ratio equals √5.*

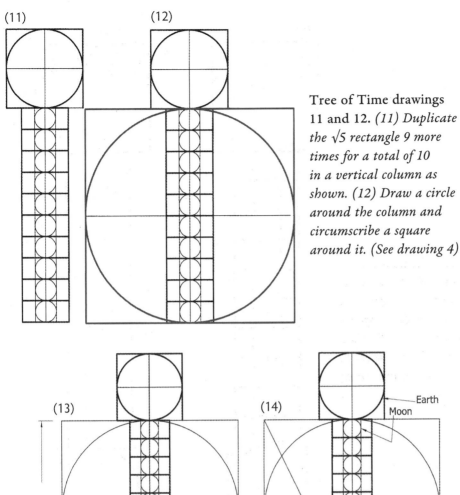

Tree of Time drawings 11 and 12. *(11) Duplicate the √5 rectangle 9 more times for a total of 10 in a vertical column as shown. (12) Draw a circle around the column and circumscribe a square around it. (See drawing 4)*

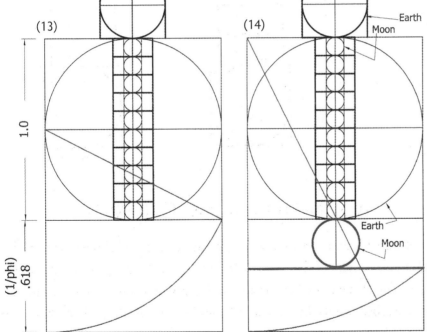

Tree of Time drawings 13 and 14. *(13) With radius of the half-square diagonal of the large circle swing an arc to the extension of the square as shown. Mirror on the opposite side and complete the golden rectangle. (14) With radius of the long side of the rectangle swing an arc to the opposite side to give a point from which to construct a smaller rectangle, as in (7). Within this smaller rectangle inscribe a circle representing the Moon in relation to the larger Earth circle.*

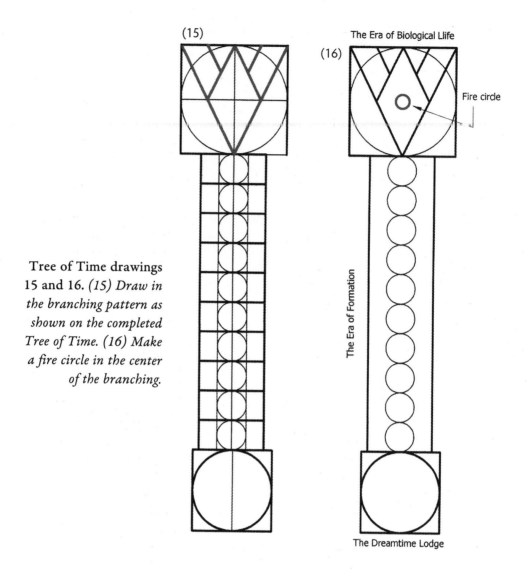

Tree of Time drawings 15 and 16. *(15) Draw in the branching pattern as shown on the completed Tree of Time. (16) Make a fire circle in the center of the branching.*

# A SUN-HONORING CEREMONY

It is not difficult to understand why so many cultures have honored the Sun. For the Quechua peoples of the Andes it is Inti. For the Shinto Japanese it is the feminine goddess Ameratasu. For the ancient Egyptians it was Ra. It's not difficult to understand, because the Sun's energy brings forth from the earth all that we need to survive. For us it is the ever-giving source of all that we have. To honor the Sun in ceremony—that is, to consciously give our thanks—seems the most natural of actions, and it has been so for most of humanity since the earliest times.

As we have for other ceremonies we will again, using sacred geometry, create an image of the object of our ceremony. Beginning with an accurate geometric

image we are already honoring the way things are: the harmony inherent in size relations that arise from sacred number. In carefully making the construction we are already establishing the heightened state of awareness that we will maintain throughout the ceremony.

We begin as usual by laying out the four directions and making our invocation. A large circle is drawn—it could be almost any size—let's say it is 20 feet in diameter. This is our Sun circle. Next we want to draw a circle to represent Earth, a circle that will be in proper proportion to the Sun circle. We know that it would take 109 Earths laid end to end to stretch across the Sun—that is, the Sun/Earth diameter ratio is 109. Because we want to find the size of the Earth *geometrically* rather than through measure we can use a method of octave reduction. Thus we will continually halve the diameter of a circle constructed within the Sun circle until we arrive at a circle with the relative size of the Earth diameter. This is demonstrated in our drawings.

When we find the size of the Earth (for example, if the Sun disc were 20 feet in diameter the Earth disc would be around 2 inches in diameter) a representation of the Earth can be made—perhaps cut out from a piece of card that can then be painted with the seas and continents. It could also be a sphere of painted clay. The Sun circle itself can be outlined in stones and decorated with found objects and flowers. Candles can be placed around the periphery. A fire circle, representing the solar core where the fusion reactions take place, is constructed in the center. The diameter of the core is generally thought to be about 1/5 of the Sun diameter. The fire is lit and the participants can be seated around the outer periphery of the main Sun circle.

The Earth disc is now passed around the Sun circle from person to person. This can give a sense of the orbit of the Earth; the periphery of the Sun, during this time, becomes the orbit of the Earth and the core circle becomes the Sun itself. As participants take the Earth disc they can express to the group or silently to themselves why they are thankful for the Sun.

An altar can be made on the periphery of the Sun circle where the Earth symbol can be placed. Burnable objects brought from home or found in nature can be placed on the altar as offerings to the Sun. Next to the altar is a small break in the periphery of the Sun circle, a portal into the interior of the Sun.

From this a narrow path leads to the central fire. The path is decorated with, in order, red, blue, and white candles representing the higher and higher temperatures as one approaches the white-hot interior of the Sun. The participants sit around the outer sun circle and the facilitator begins the journey.

*Breathe in deeply and relax with your attention on your breath. Imagine a golden ball of light within your body at your solar plexus. Breathe again expanding first your belly then your chest. Hold and release. And again breathe in deeply, hold and release.*

(The toning of the *aaahh* sound begins and continues for several minutes. As the toning fades the journey drum begins.)

*Feel your spirit body lift out of your physical body. You are in a grassy meadow. You are walking along in the bright sunshine feeling the beautiful radiance of the Sun on your face as you look up into the clear blue sky. Feel the Sun warm your skin and your bones. You stop and close your eyes. You open your arms and, with your right hand you draw the sunlight into your heart and whisper "love." With your left hand you draw the sunlight into your belly and whisper "courage." Now you feel yourself rising toward the Sun, leaving the Earth behind. You move through the ether feeling the solar wind on your face as you approach the Sun. You see gigantic flares rise from the Sun as you come closer and closer. Now you come down on the surface of the Sun and a luminous angel approaches you. You bow to the angel and ask to be taken to the Spirit of the Sun. The angel turns and beckons you to follow. There is a gap where the flames part and you follow the angel down a dazzling crystal tunnel leading in to the heart of the Sun. The flames of the tunnel change from red to blue, and you stop for a moment and you feel energy moving through you, cleansing your body and soul of any impurities that you have brought from the Earth. The angel moves on down the tunnel, and you follow. The blue color turns to white as you come to a circular space at the center of the Sun. The angel leaves and you make your prayer to the Spirit of the Sun. If you like you can ask the Spirit if there is any message or perhaps a gift that it has for you. . . . You wait for an answer. When you receive your answer you thank the Spirit of the Sun, and the angel reappears and beckons you to follow back up the tunnel. As you reach the surface you thank the angel and fly into space and see the ball of the Earth grow before you. You land in the grassy meadow and look back up at the Sun, feeling it warm your face. You now come back into this time and place at the Sun-Honoring Ceremony.*

(The journey drum stops.)

*Breathe deeply and wiggle your fingers and toes and open your eyes. Again we will tone the* aaahh *sound.*

As the toning fades participants can sit in meditation for a few moments and, one by one, rise and take their offering from the altar and enter the Sun circle and place it in the fire at the Sun's core. After this is done the participants can leave, or those who would like to stay and share their experience can do so.

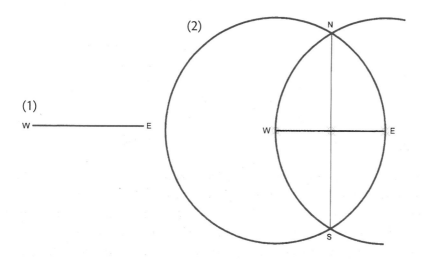

Sun Ceremony drawings 1 and 2. *(1) Draw an east-west line. This will be the diameter of the circle representing the Sun. (2) Draw two intersecting circles each with a center at an end of the east-west line and a radius extending to the other end of the line. Join the intersection points of the resulting vesica with a line that locates the center of the original line and also gives the north-south line.*

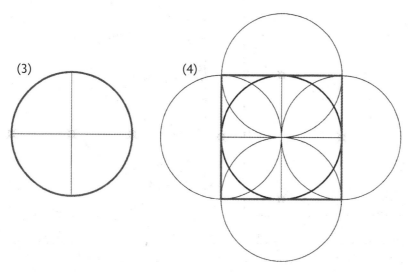

Sun Ceremony drawings 3 and 4. *(3) We now have a center for our Sun circle with its diameter the length of the original line. Draw the circle. (4) With the four axis ends as centers draw four circles with the same diameter as our Sun circle. Then connect the intersections of these circles to generate a square that encloses the Sun circle.*

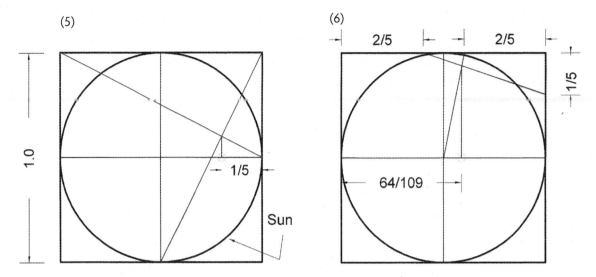

Sun Ceremony drawings 5 and 6. *(5) Draw crossed diagonals of the half-squares as shown to establish a 1/5 segment of the diameter. This segment will be used to step off 2/5 and 1/5 segments of the square in (6). Draw a new set of diagonals as shown. Now project this intersection point of these diagonals to the main horizontal diameter to give us a 64/109 (.5872) section point of the main diameter to which a circle will be drawn in (7).*

Sun Ceremony drawings 7 and 8. *(7) Draw the circle between A and the diameter end. This is the 64/109 diameter circle that must be reduced in size by 6 times to equal the 1/109 size of the Earth in relation to the Sun. Bisect the new circle at B. (8) Draw the next circle between the center of the 64/109 circle at B and the diameter end to give a circle with diameter of 32/109.*

(9)

(10)

Sun Ceremony drawings 9 and 10. *(9) Continue the process through 16/109, 8/109, 4/109, 2/109, and finally 1/109, which is the Earth circle whose size is in proper relation to the main Sun circle. (10) An enlargement of a detail of the Sun and the Earth in their correct size relationship of 109 to 1. (This can be better appreciated in a large-scale Earth drawing in which the full-size Sun drawing can be made.) When the Earth circle is drawn a representation of it may be made as noted in the text.*

(11)

(12)

Sun Ceremony drawings 11 and 12. *(11) Bisect the half-sides of the square as shown and draw a diagonal. Draw a half-square diagonal as shown that intersects the previous diagonal. Their crossing point is projected to the main diameter at a point to which a circle is drawn. This circle represents the inner core of the Sun. (12) Construct portals into the outer surface of the Sun and its inner core.*

197

# APPENDIX 2

<center>⤨</center>

# A MISCELLANY OF
# NUMBERS AND FORMS

THIS SECTION PRESENTS MORE EXAMPLES OF MATERIAL from the text including sculptural and architectural analyses, lunar notes, vesica constructions, and the golden proportion, all subjects that have been explored throughout the book. There is also additional information on the technique of diagonal geometry and ideas on the creation of harmonious forms from the vesica including pottery figures, book page layouts, and irregular shapes similar to seeds and eggs. This appendix also gives several examples of the sculptural and architectural use of the crossed-vesica constructions in several ancient cultures that we briefly mentioned in the text. The history of the gothic arch, a half-vesica shape, is considered along with some geometric arch constructions. In general, this appendix is meant to add a few practical examples to the text of the book for the use of the designer of spaces and for the philosophers and students of art and nature who are drawn to symbolic expression and to the many possibilities for creation offered by sacred geometry.

Drawing A2.1. *A drawing showing the circles of the vesica construction with a table containing the property values of the vesica circles for twelve standard tones of a just-intonation scale as well as some other tones that are relevant to the geometry of vesica construction. This is a summation of the numerical aspect of the vesica construction.*

PROPERTIES OF THE VESICA CONSTRUCTIONS OF THE TWELVE TONES

| Tone | Fund. (C) | Min. 2nd (C#) | 2nd (D) | Min. 3rd (D#) | 3rd (E) | 4th (F) | Tritone (F#) | 5th (G) | Min. 6th (G#) | 6th (A) | Min. 7th (A#) | 7th (B) |
|---|---|---|---|---|---|---|---|---|---|---|---|---|
| **C₁** Diameter | 1.0 | 1.0 | 1.0 | 1.0 | 1.0 | 1.0 | 1.0 | 1.0 | 1.0 | 1.0 | 1.0 | 1.0 |
| Area | .7854 | .7854 | .7854 | .7854 | .7854 | .7854 | .7854 | .7854 | .7854 | .7854 | .7854 | .7854 |
| Circum. | 3.1416 | 3.1416 | 3.1416 | 3.1416 | 3.1416 | 3.1416 | 3.1416 | 3.1416 | 3.1416 | 3.1416 | 3.1416 | 3.1416 |
| **C₂** Diameter | 1.0 | .9375 (15/16) | .8888 (8/9) | .8333 (5/6) | .80 (4/5) | .750 (3/4) | .7071... | .6666 (2/3) | .6250 (5/8) | .6000 (3/5) | .5555 (5/9) | .5333 (8/15) |
| Area | .7854 | .6903 | .6204 | .5454 | .5026 | .4418 | .3927 | .3490 | .3068 | .2827 | .2424 | .2234 |
| Circum. | 3.1416 | 2.9452 | 2.7922 | 2.6178 | 2.5132 | 2.3562 | 2.2214 | 2.0942 | 1.9635 | 1.8849 | 1.7452 | 1.6754 |
| **C₃** Diameter | 1.0 | .9354 | .8818 | .8165 | .7745 | .7071 | .6435 | .5774 | .5000 | .4472 | .3333 | .2582 |
| Area | .7854 | .6872 | .6107 | .5236 | .4711 | .3926 | .3252 | .2618 | .1963 | .1570 | .0872 | .0524 |
| Circum. | 3.1416 | 2.9386 | 2.7702 | 2.5651 | 2.4332 | 2.2214 | 2.0216 | 1.8140 | 1.5708 | 1.4049 | 1.0471 | .8112 |
| **C₄** Diameter | 1.0 | .8750 | .7777 | .6666 | .60 | .50 | .4142 | .3333 | .2500 | .2000 | .1111 | .0666 |
| Area | .7854 | .6013 | .4750 | .3484 | .2827 | .1963 | .1347 | .0872 | .0491 | .0314 | .0097 | .0035 |
| Circum. | 3.1416 | 2.7488 | 2.4432 | 2.0942 | 1.8850 | 1.5708 | 1.3012 | 1.0471 | .7854 | .6283 | .3490 | .2092 |
| **C₅** Diameter | 0 | .0625 | .1112 | .1667 | .20 | .250 | .2929 | .3333 | .3750 | .40 | .4445 | .4667 |
| Area | 0 | .0031 | .0097 | .0218 | .0314 | .0490 | .0674 | .0872 | .1104 | .1256 | .1552 | .1711 |
| Circum. | 0 | .1963 | .3493 | .5236 | .6283 | .7854 | .9202 | 1.0471 | 1.1781 | 1.2566 | 1.3964 | 1.4662 |
| Vesica Ratio | 1 | root-1.1427 1.0690 | root-1.2860 1.1340 | root-1.5 1.2247 | root-1.666 1.2912 | root-2 1.4142 | root-theta 1.5540 | root-3 1.7320 | root-4 2.000 | root-5 2.2361 | root-9 3.000 | root-15 3.8729 |
| Vesica Area | 1 | .6317 | .5220 | .4074 | .3443 | .2578 | .1934 | .1365 | .0874 | .0619 | .0252 | .0116 |

PROPERTIES OF OTHER VESICA CONSTRUCTIONS

| Tone | phi-tritone | 1/phi | phi/2 | 1/1.707 | septimal tritone | septimal min. 7th |
|---|---|---|---|---|---|---|
| **C₁** Diameter | 1.0 | 1.0 | 1.0 | 1.0 | 1.0 | 1.0 |
| Area | .7854 | .7854 | .7854 | .7854 | .7854 | .7854 |
| Circum. | 3.1416 | 3.1416 | 3.1416 | 3.1416 | 3.1416 | 3.1416 |
| **C₂** Diameter | .6909... | .6180... | .8091... | .5868... | .7143(5/7) | .5714(4/7) |
| Area | .3749 | .2999 | .5142 | .2695 | .4007 | .2564 |
| Circum. | 2.1705 | 1.9415 | 2.5419 | 1.8403 | 2.2440 | 1.795 |
| **C₃** Diameter | .6180 | .4858 | .7862 | .4142 | .6546 | .3780 |
| Area | .3000 | .1854 | .4855 | .1347 | .3365 | .1122 |
| Circum. | 1.9415 | 1.5262 | 2.4670 | 1.3012 | 2.0565 | 1.1875 |
| **C₄** Diameter | .3820 | .2360 | .6180 | .1716 | .4286 | .1428 |
| Area | .1146 | .0437 | .3000 | .0231 | .1443 | .0160 |
| Circum. | 1.2000 | .7414 | 1.9415 | .5390 | 1.3465 | .4486 |
| **C₅** Diameter | .3091 | .3820 | .1909 | .4142 | .2857 | .4286 |
| Area | .0750 | .1146 | .0286 | .1347 | .0641 | .1443 |
| Circum. | .9711 | 1.2000 | .5997 | 1.3012 | .8976 | 1.3465 |
| Vesica Ratio | phi 1.6180 | phi x root-phi 2.0582 | root-phi 1.2720 | theta 2.4140 | root-2.3333 1.5275 | root-7 2.6455 |
| Vesica Area | .1688 | .0799 | .3610 | .0490 | .2022 | .0370 |

Diameter formulas

$C_1/C_3 = C_3/C_4$ = Vesica Ratio

$(C_4 + 1)/2 = C_2$

$C_3$ = root-$C_4$

$C_4 = 2\,C_2 - 1$

$1/C_3$ = ves ratio

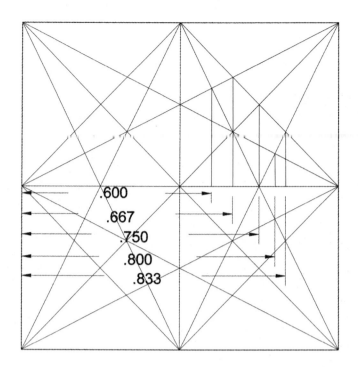

Drawing A2.2. *The square possesses an unlimited wealth of rational ratios generated from the crossing of its mostly irrational diagonals. The most well-known diagonals are those of the full square, half-square, and quarter-square. The half-square diagonal is frequently used in sacred geometry as a generator of the golden rectangle and the $\sqrt{5}$ rectangle. Crossings of these principal diagonals can generate, at their crossing points, tonal ratios when the points are projected to the main string/ diameter—that is, to the horizontal diameter of the circle-in-the-square or, here, to the horizontal axis of the square. Examples of this phenomenon are demonstrated in the present drawing—a division-by-2 "diagonal weaving" where the main consonances of the scale are generated from the crossings of these basic diagonals. Furthermore, the 1/3, 1/4, 1/5, and 1/6 segments, left over from the 2/3, 3/4, 4/5 and 5/6 tonal ratios on the string/diameter, provide the lengths that we may step off on the side of a square to produce division-by-three, four, five, and six diagonal weavings from which a great many more tones may be generated. Several of these are demonstrated in the drawings A2.3, A2.4, and A2.5. Similarly, the geometrically produced 1/φ length when applied to the sides of a square, as in drawing A2.6, provides a generating matrix for phi-family numbers.*

*In this drawing the square has been divided in half both horizontally and vertically by the axes of the circle-in-the-square, and the following tones are produced from the generated diagonals 3/5 (.60), the sixth; 2/3 (.667), the fifth; 3/4 (.75), the fourth; 4/5 (.80), the third; and 5/6 (.833), the minor third.*

*While the diagonals are constructed without measurement we must measure the resulting string-length to determine their ratios and hence their intervals. I do this with a computer drawing program, which facilitates the exact measurement of the generated string-lengths.*

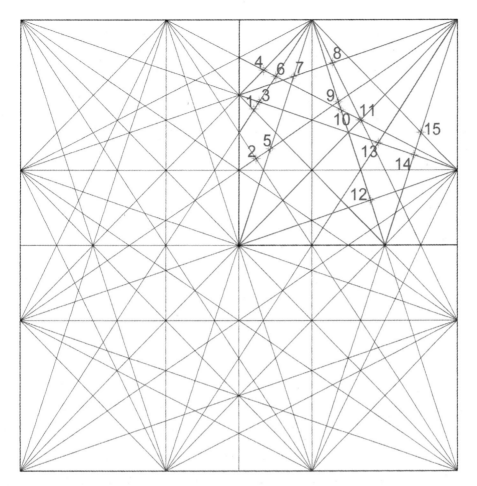

Drawing A2.3. *A division-by-three diagonal weaving. The numbered points are located by the crossings and when projected (by dropping perpendiculars) onto the horizontal diameter (considered to be a musical string) produce the following tones. (1) 8/15 (.5333), just major seventh; (2) 7/13 (.5385), septimal seventh; (3) 6/11 (.5455), neutral seventh; (4) 5/9 (.5556), acute minor seventh; (5) 4/7 (.5714), just minor seventh; (6) 7/12 (.5833), septimal sixth; (7) 5/8 (.6250), just minor sixth; (8) 5/7 (.7143), septimal tritone; (9) 8/11 (.7273), undecimal flattened tritone; (10) 11/15 (.7333), undecimal augmented fourth; (11) 7/9 (.7778), septimal third; (12) 4/5 (.8000), just third; (13) 9/11 (.8182), undecimal neutral third; (14) 9/10 (.9000), minor whole tone; (15) 11/12 (.9167), undecimal neutral second.*

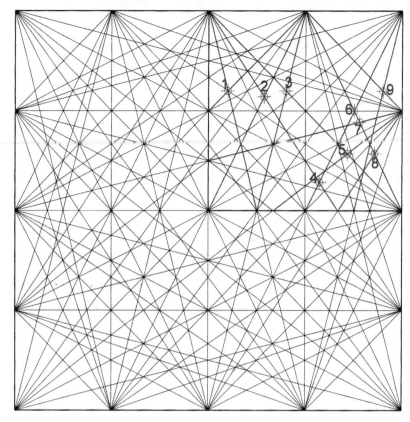

Drawing A2.4. *A division-by-four diagonal weaving. (1) 11/20 (.5500), acute minor seventh; (2) 9/14 (.6429), septimal minor sixth; (3) 7/10 (.7000), Euler's tritone; (4) 11/14 (.7857), undecimal diminished fourth; (5) 6/7 (.8571), septimal minor third; (6) 7/8 (.8750), septimal whole tone; (7) 8/9 (.8889), just whole tone; (8) 13/14 (.9286), septimal semitone; (9) 19/20 (.9500), an ancient semitone.*

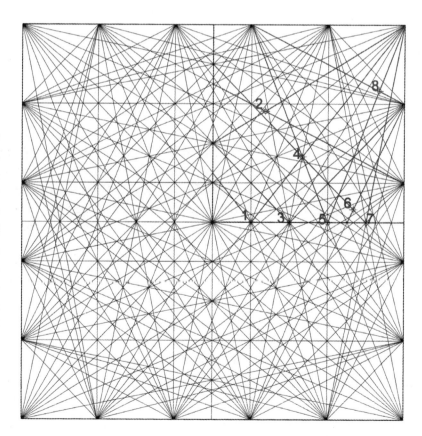

Drawing A2.5. *A division-by-five diagonal weaving. (1) 3/5 (.6000), just major sixth; (2) 7/11 (.6364), undecimal augmented fifth; (3) 7/10 (.7000), Euler's tritone; (4) 11/15 (.7333), undecimal augmented fourth; (5) 4/5 (.8000), just major third; (6) 13/15 (.8667), tridecimal 5/4 tone; (7) 9/10 (.9000), minor whole tone; (8) 14/15 (.9333), semitone.*

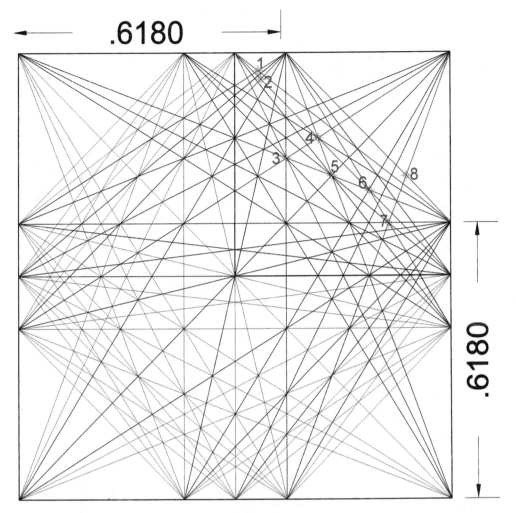

.6180

.6180

Drawing A2.6. A $\phi$ weaving containing several $\phi$-family numbers. These
reciprocals and their ratios expressed as $\phi$ numbers are as follows:

| Reciprocal | Ratio |
|---|---|
| *(1) .5528* | $2/\sqrt{5} \times \phi$ |
| *(2) .559* | $4/\sqrt{5}$ |
| *(3) .618* | $\phi$ |
| *(4) .691* | $1 + 1/\sqrt{5}$ |
| *(5) .7236* | $1 + 1/\phi^2$ |
| *(6) .809* | $2/\phi$ |
| *(7) .8542* | $\phi^2/\sqrt{5}$ |
| *(8) .8944* | $2/\sqrt{5}$ |

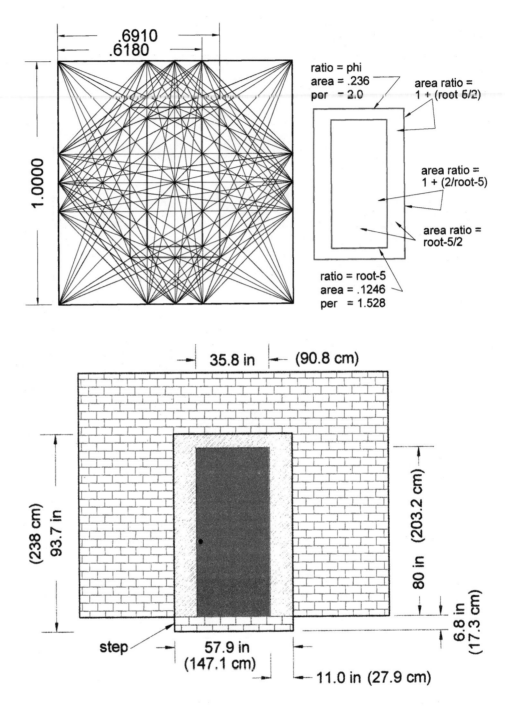

ratio = phi
area = .236
per = 2.0

area ratio =
1 + (root 5/2)

area ratio =
1 + (2/root-5)

area ratio =
root-5/2

ratio = root-5
area = .1246
per = 1.528

Drawing A2.7. *This drawing demonstrates another use of the diagonal weavings. Here we have used the full phi weaving as our design template in order to layout a doorway. Using crossing points we have generated a golden rectangle surrounding a √5 rectangle. These closely related figures—(√5 + 1) / 2 = φ )—form a harmonious doorway with the √5 rectangle as the door surrounded by trim and step composed of the φ rectangle. Further harmonies are noted in the drawing on the right.*

$$a/d = d/b = a/c = c/b = b/e = f/e = phi$$

a = h
b = f
c = d = g

phi ratio rectangles

Drawing A2.8. *On the upper left the φ tritone construction is made with two nested triangles. On the upper right the relations among the parts demonstrate the φ harmonies that pervade the structure. On the lower left we consider how the nested triangles also create φ harmonies in their matrix, the upper half-square. On the lower right is the completed wall opening, perhaps an entrance to a harmonic workshop.*

Drawing A2.9. *A √φ vesica construction of the cross section of the Great Pyramid. Pictured in (1) is the construction of the φ vesica from the half-square diagonals; (2) shows the construction of the √φ vesica within the φ vesica: the bisection point of AB and its mirror point are the centers of the vesica-forming circles that generate the √φ vesica. In (3) the pyramid cross section is placed within the √φ vesica, which is surrounded by the φ vesica.*

205

**A2.A**   **A2.B**   **A2.C**

Figure A2.A–C. *(A2.A) a page from the psalter of King Athelstan of England (924–940), reputed to have established the first guild of stonemasons in England; (A2.B) a carving from the tomb of Dona Sancha (ca. 1110, Jaca Monasterio de las Benedictinas) showing angels lifting the vesica-shaped soul of the deceased; (A2.C) Virgin in the vesica from the Porta della Mandorla at the cathedral of Florence.*

Figure A2.D

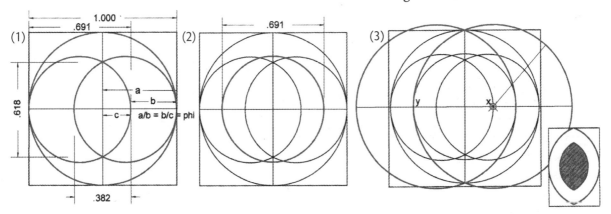

Drawing A2.10. *An analysis of the construction of the Athelstan psalter (figure A2.D, above) in which, an initial φ section of the half square (1) is made (drawing 2.8 gives a simple geometric method of finding the .691 point) and transformed into a vesica construction with a vesica with φ ratio. (2) One of the vesica-forming circles is copied and centered on the construction. (3) With a radius centered on x and extending to y another circle is drawn and mirrored, giving an enclosing vesica with a ratio of 1.4472 = 1/.691.*

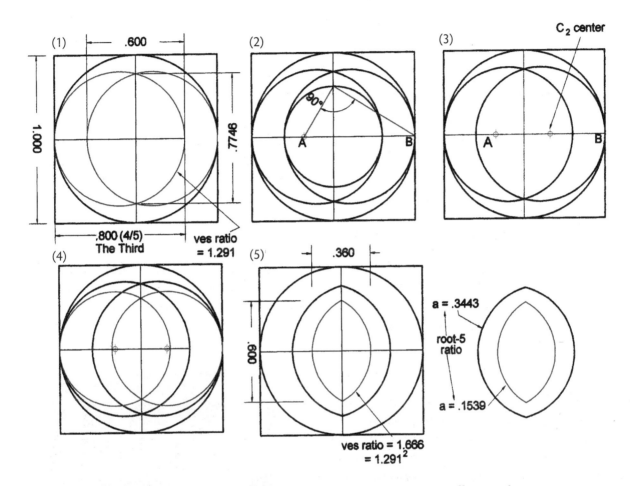

Drawing A2.11. *A variation on the vesica-within-a-vesica ring concept as illustrated in the Athelstan psalter in drawing A2.10. In this example we generate a vesica within another vesica whose axis ratio is the square of the original. (1) A vesica construction is made. (2) A $C_4$ circle is inscribed within the vesica. A line is drawn from the horizontal axis end B to the intersection of the $C_4$ circle and the vertical axis. Another line is drawn perpendicular to this line to intersect the horizontal axis. (3) Line AB is bisected giving a $C_2$ center. (4) This center is mirrored on the other side of the axis, and the $C_2$ circles are drawn generating the new vesica. (5) The two vesicas have axis ratios in square relation. In this case the vesica areas happen to be in $\sqrt{5}$ relation.*

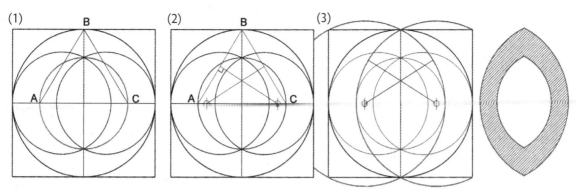

Drawing A2.12. *Continuing our vesica-within-a-vesica theme leads us to a structure in which both the inner and outer vesicas have the same ratio. The enclosing ring would then be the gnomon of the original vesica, a shape that Hero of Alexandria defined as "that form which when added to another form results in a new form similar to the original."*

(1) *A vesica construction is drawn. A $C_3$ circle is drawn, and lines AB and CB are drawn connecting the $C_3$ diameter ends with the end of the vertical axis.*
(2) *Perpendicular bisectors of AB and CB intersect the horizontal diameter.*
(3) *These intersection points are the centers of the new $C_2$ circles that generate a new vesica with the same shape as the original vesica. The gnomon is the colored area between the concentric vesicas.*

"*Pointed arches as such were not new. Even in prehistoric ornament they appear automatically as the product of intersecting circles. The Treasury of Atreus has a dome whose section is a pointed arch. Greek mathematicians and Roman architects must have known the form. The important factor, however, was not knowledge of the form but the decision to use it in architecture. The Egyptians made use of it in sections of canals, but they, and after them the Romans and the Byzantines, would not have thought of using in in an exposed position. Islamic architects were the first to recognize its aesthetic and stylistic value.*"

PAUL FRANKL,
GOTHIC ARCHITECTURE.[1]

Figure A2.E. *The Cairo Mosque of al-Hakim ca. 690 CE*

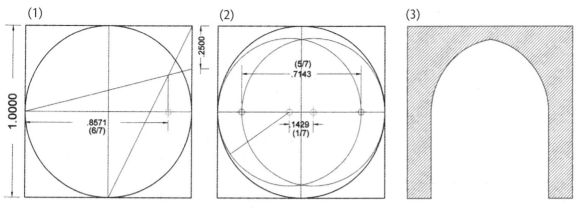

Drawing A2.13. *A design for an arch whose distance between centers is 1/5th the width of the arch. (1) The 6/7 point is located, and (2) the center point of the 6/7 length is found and mirrored, and the two C₂ circles are constructed. The width of the resulting vesica = 5/7 (.7143) and the centers are at a distance of 1/7 from each other. We note that 6/7 (a septimal minor third) is an ancient tonal ratio cited by Ptolemy that has been used in Arabic scales.*

"*A new element was brought—the pointed arch, a geometrical revolution originating in Islamic sacred architecture. The origin of the pointed arch in Europe has been determined as being at the Italian Benedictine monastery of Monte Cassini, built 1066–71. . . . It was only a matter of time until all the geometric secrets of the Arab masons were incorporated into Western sacred architecture to form a new transcendent style—now known universally by its eighteenth-century derogatory name, Gothic.*"

NIGEL PENNICK, *SACRED GEOMETRY: SYMBOLISM AND PURPOSE IN RELIGIOUS STRUCTURES.*[2]

Figure A2.F. *Portal of Amiens Cathedral, thirteenth century*

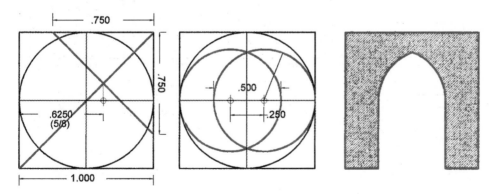

Drawing A2.14. *The construction of a "drop arch" a type of Gothic arch in which the distance between arch centers is 1/2 the width of the arch. This arch is generated from the vesica construction at the minor-sixth tone resulting in a vesica with ratio = 2.*

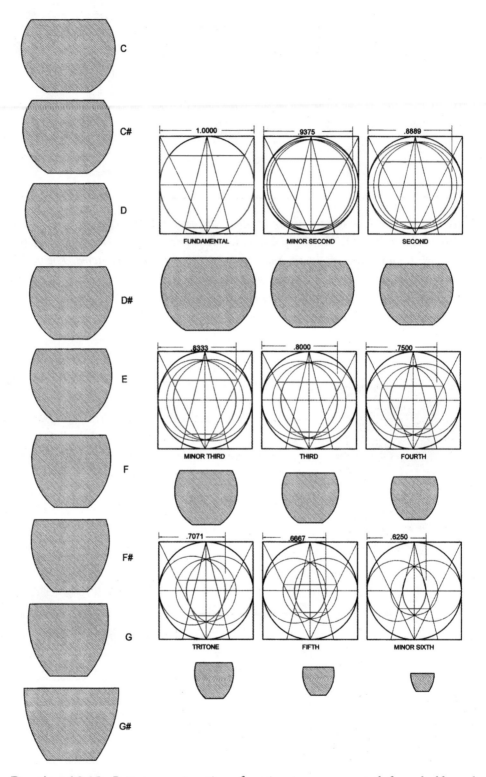

**Drawing A2.15.** *Pottery constructions for nine tones generated from half- and quarter-square diagonals within vesica constructions. On the left, the pots are scaled so that their heights are equal.*

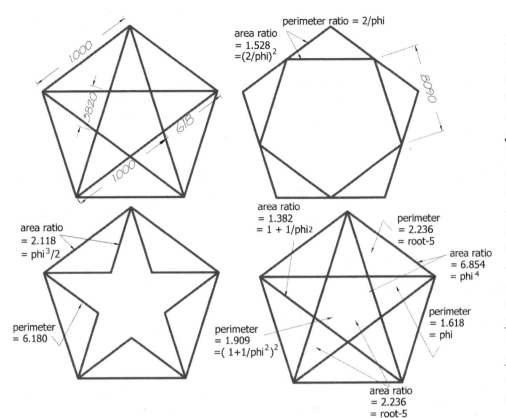

area ratio
= 1.528
= $(2/phi)^2$

perimeter ratio = 2/phi

.8090

area ratio
= 2.118
= $phi^3/2$

perimeter
= 6.180

1.000
.3820
.618
1.000

area ratio
= 1.382
= $1 + 1/phi2$

perimeter
= 1.909
= $(1+1/phi^2)^2$

perimeter
= 2.236
= root-5

area ratio
= 6.854
= $phi^4$

perimeter
= 1.618
= phi

area ratio
= 2.236
= root-5

Drawing A2.16. *An illustration of some of the many φ-family properties that are contained within the pentagon, the vessel of the golden ratio. On the upper left: the diagonals cross other diagonals at φ points. The base of the small triangles are .382 = 1/φ² . Upper right: the internal pentagon within the main pentagon has sides of .809 = φ/2. Perimeters and area ratios all have φ-family values. Lower left: the perimeter of the star = 6.180 = 10/φ. Lower right: the perimeters of all the elements are related to φ as are the area ratios.*

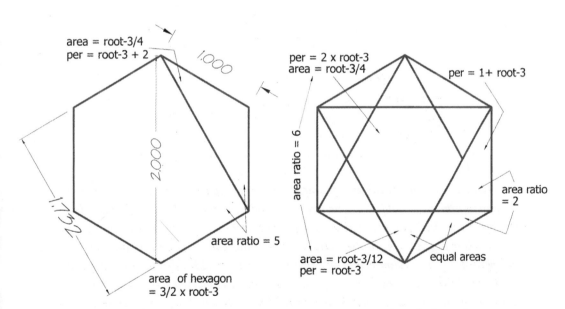

area = root-3/4
per = root-3 + 2

1.000

2.000

1.732

area ratio = 5

area of hexagon
= 3/2 x root-3

per = 2 x root-3
area = root-3/4

area ratio = 6

per = 1+ root-3

area ratio
= 2

area = root-3/12
per = root-3

equal areas

Drawing A2.17. *An analysis of the hexagon in which some of its √3 (1.732) properties are shown. On the left we see how √3, or 1.732, is derived from the hexagon. The hexagon, while containing many √3 harmonies, also, as shown in both drawings, includes the ratios of 2, 5, and 6, which gives it a more universal quality than the pentagon whose inner dimensions seem to be completely dominated by φ. This universal quality becomes evident in the unfoldment of the vesica piscis (see chapter 11) from which all the polygons, including the pentagon, take form.*

211

Drawing A2.18. *A practical use to which rectangular space division using the vesica construction may be applied is the layout of the book page. Here is an example in which we use the 7/11 interval as the generating tone. The two-page sheet is the basic module of the book. In the context of the vesica construction the sheet becomes the rectangle that circumscribes the two $C_2$ circles. In (2) half and full diagonals are drawn within the sheet rectangle, and a point a is located where the half-page diagonal intersects a $C_2$ circle. (3) A vertical line is drawn from a to intersect a full diagonal at b. A horizontal is extended from b to a half-diagonal to give point c. A vertical from c intersects a horizontal from a at d, completing the text block that is then mirrored on the other page (4). In this example the ratio of the text block and the page are equal with ratios of 14/11. Margin ratios are shown in (5). While this construction uses the American standard paper sizes, the same construction could, of course, be made on metric-system paper.*

Drawing A2.19. *More book-page layouts based on musical tones and using the method shown in drawing A2.18.*

Drawing A2.20. *The typeface designer or calligrapher may employ the vesica construction in its many forms for designing letter-width modules. After constructing (or measuring out) a ratio—in this case the 8/11 ratio—a vesica construction is generated (1a and b) and the various vesica circles are drawn. Through experiment, letter widths are found between various nodes formed by the elements of the construction.*

214

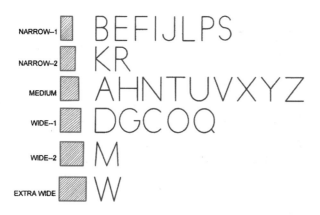

NARROW–1 BEFIJLPS

NARROW–2 KR

MEDIUM AHNTUVXYZ

WIDE–1 DGCOQ

WIDE–2 M

EXTRA WIDE W

WHENEVER I CONSIDER IN MY THOUGHTS

THE BEAUTIFUL ORDER

HOW ONE THING ISSUES OUT OF

AND IS DERIVED FROM ANOTHER

THEN IT IS THOUGH I HAD READ A DIVINE TEXT

WRITTEN INTO THE WORLD ITSELF

NOT WITH LETTERS BUT WITH ESSENTIAL OBJECTS

SAYING: MAN STRETCH THY REASON HIGHER

SO THOU MAYEST COMPREHEND THESE THINGS.

JOHANNES KEPLER

Drawing A2.21. *Letters and text generated from the module widths of the 8/11 tone demonstrated in drawing A2.20.*

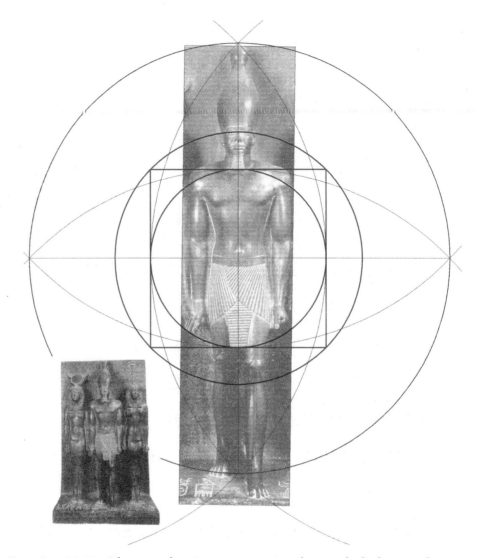

Drawing A2.22. *The crossed-vesicas construction that we looked at in chapter 8 may have had a wide use in ancient art and architecture. Formed from arcs of the geometric tritone (drawing 8.6, p. 109) a circle squaring is established generating a quadrature geometry that sculptors used to structure the proportions of the human body so that the vital centers were subtly emphasized. This harmonic approach when employed by consummate artists assisted them in their goal of manifesting ideal types of humanity. Our first example is an analysis of a sculpture of Pharaoh Menkaure of Fourth Dynasty Egypt using a crossed-vesica construction and quadrature that locates the second chakra, throat chakra, and brow chakra. The top of the crown may correspond to the seat of the soul, the "sky point" of the Egyptians. The intersection of fabric arcs on his kilt locates the root chakra. The whole is centered on the second chakra at the top of his kilt, the center of power in some traditions. The two geometric means, one from each end of the body-as-monochord, are placed at the ends of his ritual beard and the tongue of his kilt.*

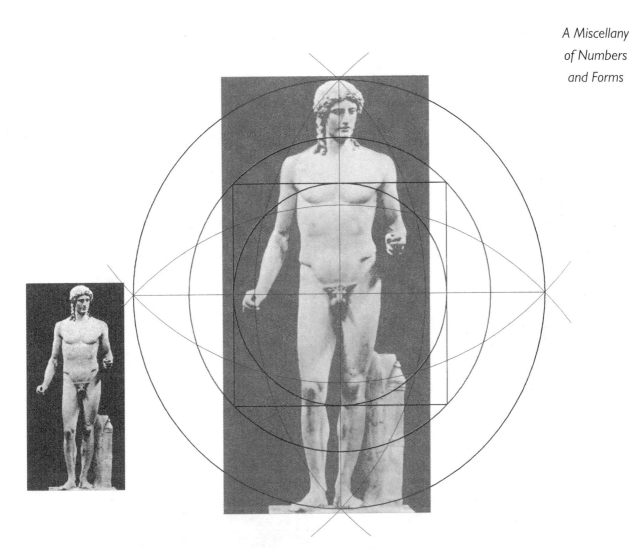

Drawing A2.23. *The* Cassel Apollo, *a Roman marble copy of the Greek bronze original of ca. 470–460 BCE. In this and the other analyses in which we have overlaid the crossed-vesicas construction we notice the importance of the placement of the knees, which mirror the placement of the vital center of the heart-lungs at the fourth chakra. The human knees are essential to our upright stance and bipedality and have much to do with what it means to be human as evidenced by the sense of celebration that happens when a child begins walking. The hands are also freed up at this time. Mircea Eliade writes: "It is sufficient to recall that the vertical posture already marks a transcending of the condition typical of the primates. Uprightness cannot be maintained except in a state of wakefulness. It is because of man's vertical posture that space is organized in a structure inaccessible to the prehominians: in four horizontal directions radiating from an 'up'- 'down' central axis. In other words, space can be organized around the human body as extending forward, backward, to right, to left, upward, and downward. It is from this original and originating experience—feeling oneself 'thrown' into the middle of an apparently limitless, unknown, and threatening extension—that the different methods of orientatio are developed; for it is impossible to survive for any length of time in the vertigo brought on by disorientation. The experience of space oriented around a 'center' explains the importance of the paradigmatic divisions and distributions of territories, agglomerations, and habitations and their cosmological symbolism."[3]*

217

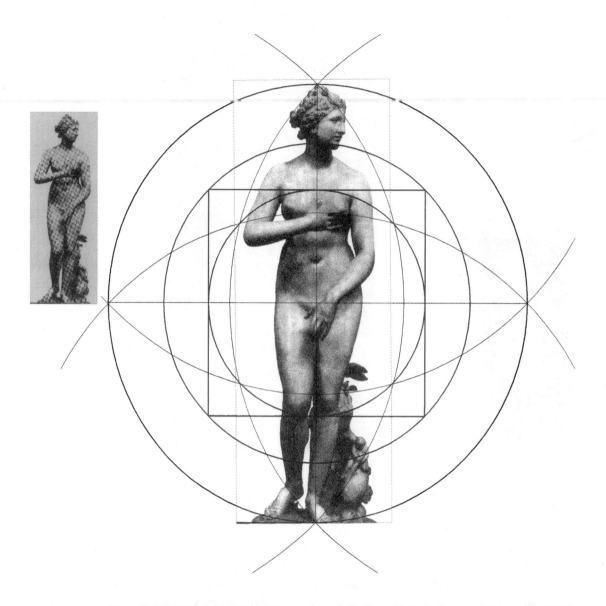

Drawing A2.24. *The Medici Venus by a follower of Praxiteles, marble, ca. 300 BCE. The same crossed-vesicas geometry as we have previously seen is applied to the female body. Here, again, the essential bodily elements are clearly set out—the head with its regulating functions: the root chakra at the center; and, at the geometric means, the heart-lung node (centers of breath and feeling) and the knees, whose function produces the unique upright stance of the human.*

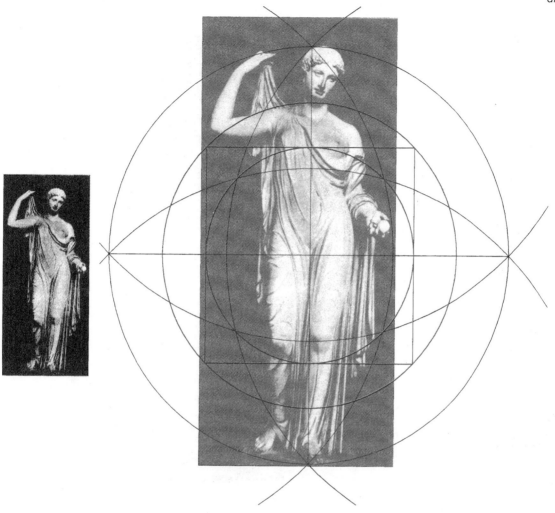

Drawing A2.25. Aphrodite from Frejus. *Roman marble copy after Greek original of*
*ca. 430–400 BCE. Is it coincidence or angular illusion that the proposed guidelines*
*are tangent to the upraised hand and the ball in the other hand? In any event such*
*cues would make the accurate copying of sculpture a bit easier.*

219

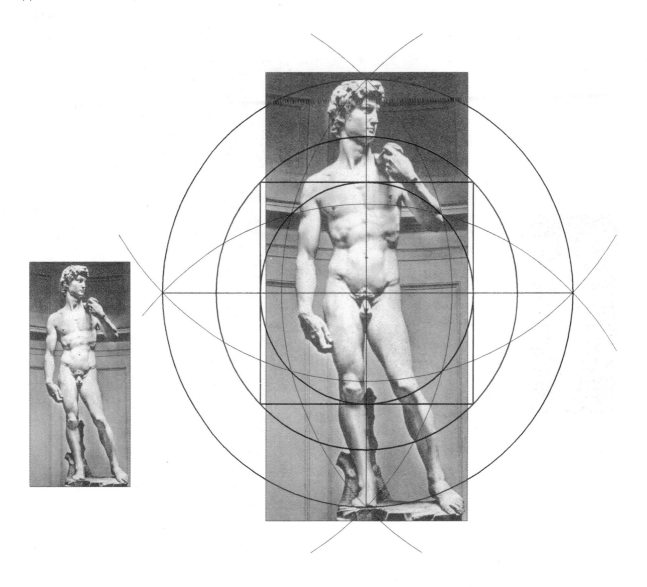

**Drawing A2.26.** *Michaelangelo's* David, *sculpted about 2,000 years after the classical Greek sculptures and of quite different composition yet with a similar arrangement of groin, chest, knees, and head as ordained by the crossed-vesicas construction. This is an example of the rediscovery of classical proportional standards by Renaissance artists.*

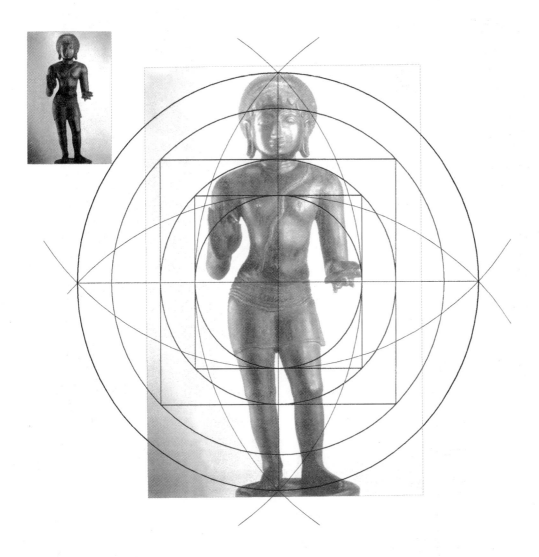

Drawing A2.27. Mannikkavachakar, *a seventeenth-century Indian sculpture in which we see a variation of the classical crossed-vesicas construction. While in most of the previous analyses the center was at the root chakra, in this case the center is at the second chakra slightly below the navel (as in the Pharaoh Menkaure sculpture). The heart-lung area, the fourth chakra, is at the geometric mean position. The next circle locates the throat chakra, which is at the same distance from the center as the knees. The next circle intersects the brow chakra.*

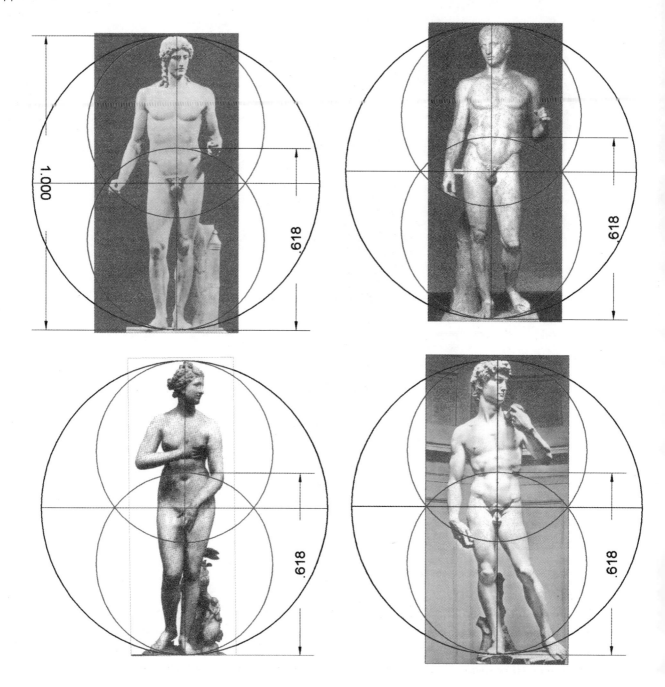

Drawing A2.28. *Four of the previous sculptural analyses with their golden section points in the area of the solar plexus, the third chakra.*

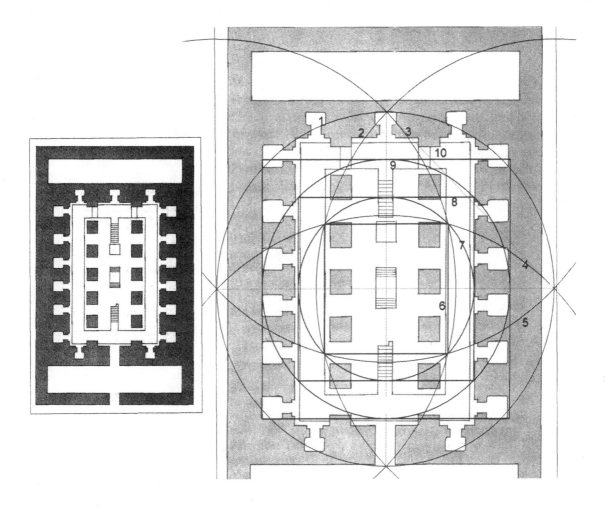

Drawing A2.29. *An example of doubling quadrature generated from crossed vesicas used to generate a temple plan. This is the ground plan of the ancient Osirion temple at Abydos, Egypt.*

> *(1) A containing circle is drawn to the vertical ends of the structure.*
> *(2, 3, 4, 5) The crossed vesicas are drawn.*
> *(6) A square is drawn to the intersecting points of the crossed vesicas.*
> *(7) A circle, also drawn to these points, circumscribes the square.*
> *(8) A square circumscribes the circle of (7).*
> *(9) A circle circumscribes the square of (8).*
> *(10) A final square circumscribes the circle of (9).*

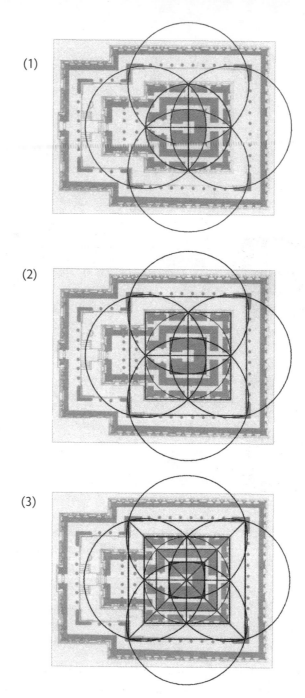

(1)

(2)

(3)

Drawing A2.30. *A setting-out of some elements of the Vaikunthaperumal Hindu temple at Kanchipuram, India, eighth century CE, using a crossed vesica and quadrature construction. (1) The building is composed of nested squares. Beginning with a central circle the crossed geometric tritone vesicas are drawn. Their components immediately give all the essential layout directions. (2) The outer crossings of the vesica-generating circles provide points to draw the containing square. The inner square and middle square are also drawn to the points provided by the original geometry. (3) Another square between the inner and middle squares is drawn with the help of diagonals that cross the containing square.*

**Drawing A2.31.** *The shape of the wind when, as it streams out of the high-pressure areas, is sucked into the low-pressure areas. The wind direction in the drawing occurs in the Southern Hemisphere, flowing counterclockwise out of the high and clockwise into the low.*

**Figure A2.G.** *A similar pattern to the shape of the wind (drawing A2.31) is demonstrated when two hurricanes approach each other exhibiting the "Fujiwhara effect." Shown here are Iona at lower left and Kirsten off the Pacific coast of Mexico in the month of August 1974.*

**Figure A2.H.** *The taiji symbol and liquids mixing in a cup have a similar interlocking spiral pattern as that of the winds.*

**Drawing A2.32.** *The taiji symbol*

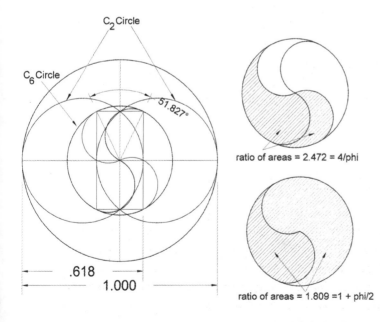

ratio of areas = 2.472 = 4/phi

ratio of areas = 1.809 =1 + phi/2

**Drawing A2.33.** *The taiji, when revolved, becomes a circle-dividing tool. We need only have an angle of rotation to construct a second pair of vanes. A vesica construction can be used to set this out. Given an angle, in this case the Great Pyramid base-to-apothem angle of about 51.827°, we first divide the angle in two and then take the 1/tan of the result, which gives our vesica ratio with which we may make a construction. Half of this angle is 25.913°, and the reciprocal of its tangent equals 2.058 ($\phi \times \sqrt{\phi}$). After drawing the vesica construction, with its $C_2$ circle = .618 (1/phi), the next step is to circumscribe the vesica with a rectangle and then to circumscribe the rectangle with a circle ($C_6$). This is the taiji circle. The revolved taiji vanes are constructed to intersect the rectangle corners and divide the $C_6$ circle as shown. On the right are the resulting $\phi$-based area ratios.*

225

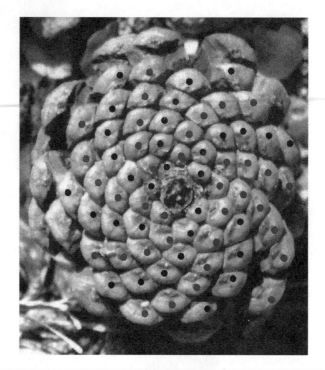

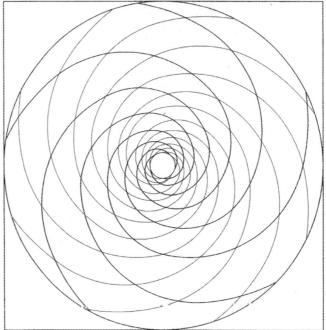

Drawing A2.34. *Fibonacci numbers in nature. On the top is a pinecone with an 8/13 system of opposing spirals. Thirteen rows spiral clockwise, each row having either all red or all black dots. Eight rows spiral counterclockwise, each having alternating red and black dots. On the bottom is another similar pattern—a 5/8 array of opposing spirals. Both of these are Fibonacci patterns that can be found throughout nature in the seedheads of flowers such as the sunflower.*

*The Fibonacci series is a summation series in which each number of the series is the sum of the two previous numbers:*

*0, 1, 1, 2, 3, 5, 8, 13, 21, 34, 55, 89, 144, 233, 377, 610, 987, 1,597, and so on.*

*For example, on a large seedhead there may be 89 spirals going one way and 55 the other way, or 55 one way and 34 the other way. The quotients of any two adjacent ratios gradually approach yet never quite reach the irrational ratio of $\phi = 1.6180339. \ldots$ Thus:*

$$1/0 = \infty; \ 1/1 = 1; \ 2/1 = 2; \ 3/2 = 1.5;$$
$$5/3 = 1.666; \ 8/5 = 1.6; \ 13/8 = 1.625;$$
$$21/13 = 1.61538; \ 34/21 = 1.61904;$$
$$55/34 = 1.61764; \ 89/55 = 1.61818;$$
$$144/89 = 1.61797; \ 233/144 = 1.6180555;$$
$$377/233 = 1.6180257; 610/377 = 1.618037135;$$
$$987/610 = 1.6180345; \ 1{,}597/987 = 1.6180345;$$
*and $1.6180345/1.6180339 \ldots (\phi) = 1.000000371$, the degree of accuracy in relation to $\phi$ at this stage of the Fibonacci series.*

*We recognize the ratios of the Fibonacci series to be musical intervals. In terms of string length: 1/1, the unison; 1/2, the octave; 2/3, the fifth; 3/5, the sixth; 5/8, the minor sixth; followed by more unusual intervals. The first interval, 1/0 whose quotient equals $\infty$, might suggest that the series has its origin in the infinite. The next interval, 1/1, the unison, is the relation of two identical tones. Levy and Levarie say of this interval,*

> *There is only one perfect consonance between two tones: the unison. . . . All other intervals . . . are more or less dissonant. . . . The underlying assumption is some musical unity, a oneness of sound, in which the partaking tones lose their identity. Acoustics offers us two prominent manifestations of such a unity: the oneness of the string which vibrates simultaneously as a whole and in parts, and the oneness of the harmonic series which forms one tone. . . .[4]*

*An example of unison in nature is the apparent equality of sizes between Sun and Moon, which is most obvious during a solar eclipse. In geometry we have seen a striving toward unison in the circle-squaring practices discussed earlier in the book.*

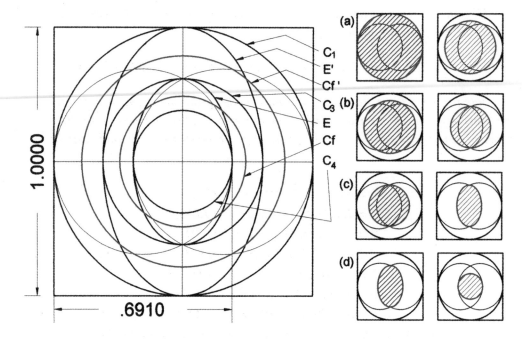

Drawing A2.35. *The vesica and the ellipse. The ellipse can be seen as the "fulfillment" of the vesica, rounding off its sharp poles and transforming it from a geometric symbol into a more natural object with innumerable manifestations from the shape of certain galaxies to the orbits of planets to the forms of microbes. Geometrically the area of the vesica itself seems discordant within the vesica construction, that is, there is no simple proportion that joins it to its inner ($C_4$) and circumscribing ($C_3$) circles. However, when we transform it into an ellipse a geometric proportion emerges: $C_3$/ellipse = ellipse/$C_4$. The above drawing of our familiar φ-tritone vesica construction includes two ellipses forming an ellipse ring, that is, an ellipse around the vesica and an ellipse connecting the $C_1$ containing circle and the $C_3$ circle. We have also added two other circles to the construction, the ellipse focus circles, Cf, which join the foci of each ellipse. The following are the areas and area ratios of the elements of the construction.*

| | |
|---|---|
| $C_4 = .1146$ | (a) $C_1/Cf' = φ$ (1.618) |
| $Cf = .1854$ (focus circle) | (b) $Cf'/C_3 = φ$ |
| $E = .1854$ | (c) $C_3/E = φ$ |
| $C_3 = .3$ | (d) $E/C_4 = φ$ |
| $Cf' = .4854$ (focus circle) | |
| $E' = .4854$ | |
| $C_1 = .7854$ | |

*Also, E' is the arithmetic mean between E and $C_1$; E is the geometric mean between $C_3$ and $C_4$. The progression of numbers .1146, .1854, .3, .4854, .7854 is an additive progression in which each number is equal to the sum of the two previous numbers. The series can also be transposed into the series 1, φ, φ², φ³, φ⁴. The eccentricity of the ellipses is .7861 = 1/√φ.*

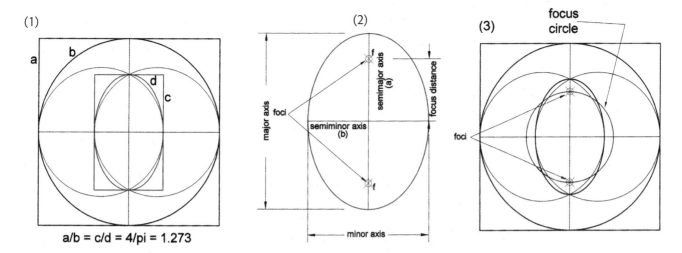

**(1)**

a
b
d
c

a/b = c/d = 4/pi = 1.273

**(2)**

major axis

foci

semiminor axis (b)

semimajor axis (a)

f

f

focus distance

minor axis

**(3)**

focus circle

foci

Drawing A2.36. *Three drawings of the ellipse that help to describe this shape. In (1) we demonstrate how the square is to the circle as the rectangle is to the ellipse—they form a proportion that equals $4/\pi$, or 1.273. (2) The principal properties of the ellipse are shown. Given the lengths of the axes, the foci can be calculated with the formula: $f^2 = a^2 - b^2$ where a is the semimajor axis and b is the semiminor axis and f is the distance from the center to the focus. The equation for the area of the ellipse is area $= ab\pi$. The eccentricity of the ellipse ranges from 0 to 1 and is given by the equation $e = f/a$. (3) The focus circle is constructed.*

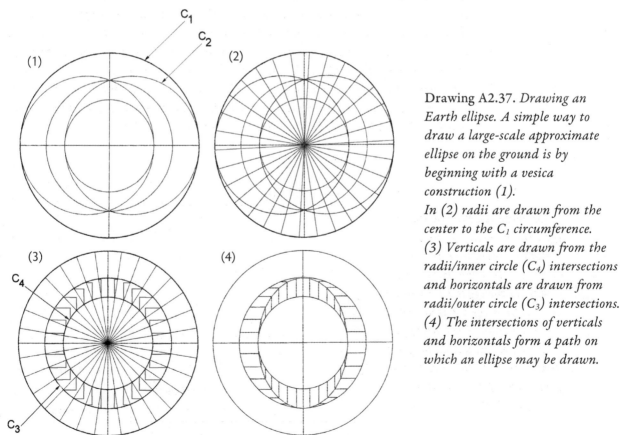

$C_1$

$C_2$

**(1)**

**(2)**

**(3)**

$C_4$

$C_3$

**(4)**

Drawing A2.37. *Drawing an Earth ellipse. A simple way to draw a large-scale approximate ellipse on the ground is by beginning with a vesica construction (1). In (2) radii are drawn from the center to the $C_1$ circumference. (3) Verticals are drawn from the radii/inner circle ($C_4$) intersections and horizontals are drawn from radii/outer circle ($C_3$) intersections. (4) The intersections of verticals and horizontals form a path on which an ellipse may be drawn.*

229

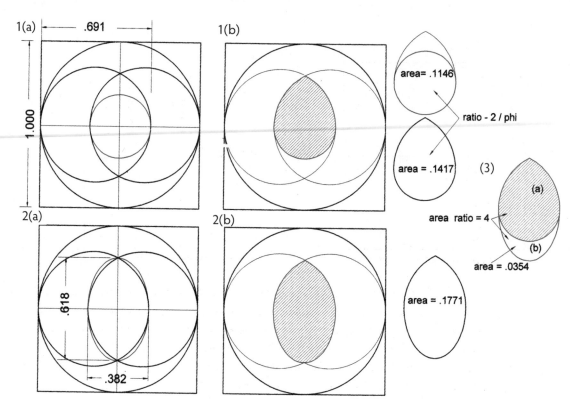

1(a)

.691

1.000

1(b)

area= .1146

ratio - 2 / phi

area = .1417

(3)

(a)

area ratio = 4

(b)

area = .0354

2(a)

.618

.382

2(b)

area = .1771

Drawing A2.38. *Among the innumerable forms that seeds take, a common shape can be drawn from a vesica combined with a circle or an ellipse. The vesica construction enables us to create seed forms from the numbers of musical intervals or, in the present case, from φ-based numbers. In (1) the seed is a composite of the vesica and the $C_4$ circle. Its area is about 1/7th of the enclosing square. Its height-to-width ratio equals $φ^2/2$. The areas of seed and $C_4$ circle are in $1.236 = 2/φ$ ratio. (2) A composite of a vesica and a vesica ellipse. Its height-to-width ratio equals φ. (3) The two seeds are conjoined with area ratio $a/b = 4.0$.*

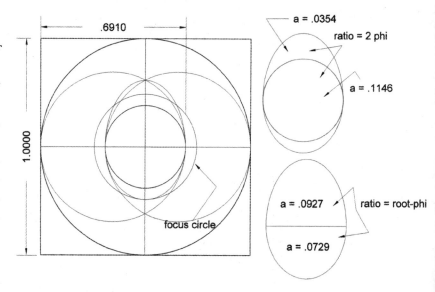

Drawing A2.39. *The shape of eggs. Harmonious egg shapes can also be drawn from the vesica/ ellipse construction. Here the top part of the egg is a half ellipse derived from the φ-tritone vesica construction. The bottom part is a half ellipse with a long axis that extends to the vesica ellipse focus circle. The axis ratio of the egg = $1/.691 = 1/(1 + 1/\sqrt{5})$.*

.6910

1.0000

focus circle

a = .0354

ratio = 2 phi

a = .1146

a = .0927

ratio = root-phi

a = .0729

230

a    b    c

Figures A2.I. *Many (or most) shapes in nature are more or less asymmetrical, a quality that gives them a one-of-a-kind beauty: (a) pumpkin seed, (b) Mitra cardinal is shell, and (c) acorn squash. This fact of nature inspires us to create offset shapes with harmonious proportions.*

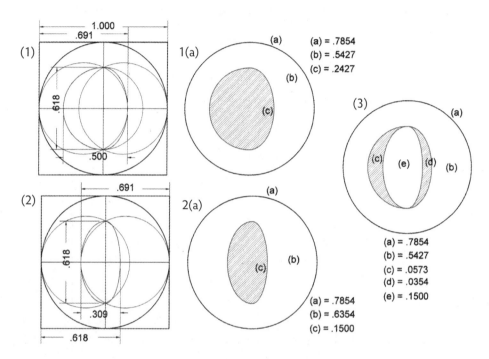

Drawing A2.40. *Asymmetrical harmonies. Two asymmetrical figures that separately and conjoined produce a variety of φ family ratios. The area values are shown next to the figures. (1) Half of the vesica ellipse is combined with the $C_3$ semicircle producing an offset shape with area of .2427 = 1/(2φ × √φ).*

$$\text{Area ratios:} \quad a/b = 1.4471 = 1/\sqrt{5}$$
$$a/c = 3.236 = 2\phi$$
$$b/c = 2.236 = \sqrt{5}$$

*(2) A composite of the ellipse at the .691 tonal position and the ellipse at the .618 tonal position. The area of the offset shape (c) = .15 = $1/2\phi^2 \times \sqrt{\phi}$.*

$$\text{Area ratios:} \quad a/b = 1.236 = 2/\phi$$
$$a/c = 5.236 = 2\phi^2$$
$$b/c = 4.236 = \phi^3$$

*(3) Combining the figures in (1) and (2) generates a figure with the following ratios.*

| | |
|---|---|
| $a/b = 1.4472$ | $b/d = 15.330 = \phi^4 \times \sqrt{5}$ |
| $a/c = 13.706 = 2\phi^4$ | $b/e = 3.618 = \phi \times \sqrt{5}$ |
| $a/d = 22.186 = 2\phi^5$ | $c/d = 1.618 = \phi$ |
| $a/e = 5.236 = 2\phi^2$ | $e/c = 2.618 = \phi^2$ |

Drawing A2.41. *Moon octaves. The Moon in its phases has a musical quality manifested in the steady advance of the dark/light line, the terminator, across its diameter imagined as a musical string. In this diagram we see the diatonic tonal positions of the Moon as its string/diameter is stopped at specific points and plucked. (Of course, all possible tones are silently sounded during the lunation, tones that correspond to each second of the monthly cycle.)*

*Four octaves are sounded during the course of a month. With this phenomenon we have a manifestation of both time and space measures expressed as a unity. For example, at the fifth (G) position between new and first quarter, the terminator touches the Moon diameter of 2,160 miles at the 1,440 mile point (2/3 × 2,160 = 1,440). The number 1,440 is a key number in time measurement being the number of minutes in a day. It is also four times the number of degrees in a circle; and 144 is 1/6 of 864, the Sun number (i.e., Sun diameter = 864,000 miles).*

*The 2,160-mile standard chosen for the Moon has, as previously discussed, a temporal significance since 2,160 is the number of years in a Great Month, or Age, of the precessional cycle, the Great Year of 25,920 years. Thus our intervals seem to be stepping off cosmic time during the lunation cycle.*

*Besides these indications of the time-space quality of the lunation we note the well-known physical and emotional influences that the Moon has on life-forms, including its effects on the human psyche. The creative process may also be enhanced when the creator becomes aware of the lunar cycles. From the author's experience the time from new to first quarter is a time of seeding of ideas and of inspiration; from first quarter to full, a time of action and creation; from full to last quarter, a time of finishing up; from last quarter to new, a time of rest, contemplation, and integration.*

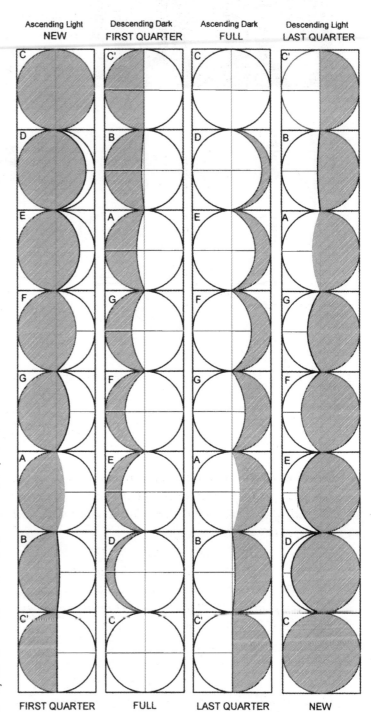

232

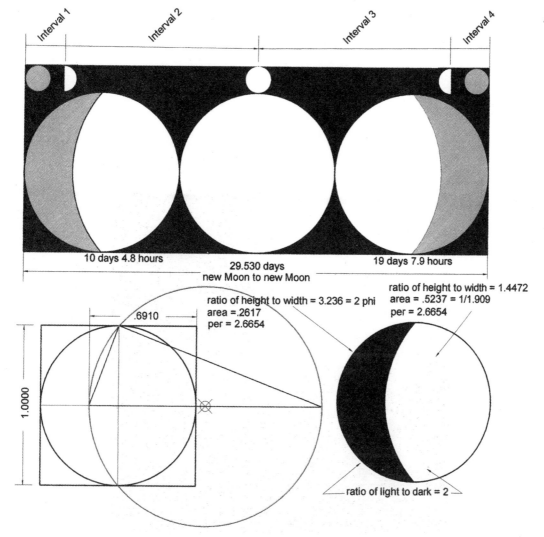

**Drawing A2.42.** *The Moon at the φ tritone. Four tonal regions make up the lunation as described in drawing A2.41. Here we have concentrated on the shape of the Moon at the φ-tritone position (between F and G) in regions 2 and 3 during the waxing and waning gibbous periods of the lunation in which the light and dark lunar areas are in a 2:1 ratio. This configuration results in several φ-family numbers as shown.*

*We have discussed the harmonious geometric properties of this φ-tritone tonal position throughout the book. Here we see it applied to the relation of the light to dark areas of the Moon during the lunation. The φ tritone is a transition stage between, on the one hand, the complete darkness of the new moon and the brilliance of the full moon; and, on the other hand, between the full moon and the return to the darkness of the new. In both stages the light predominates over the darkness in a ratio of 2 to 1.*

*For the creator working within lunar time the first of these two stages occurs during a time of concentrated work that is illuminated by the growing light. The second stage occurs during the time of perfecting the work before the growing dark prevails and the creator returns to rest within the profound peace of stillness, of darkness.*

233

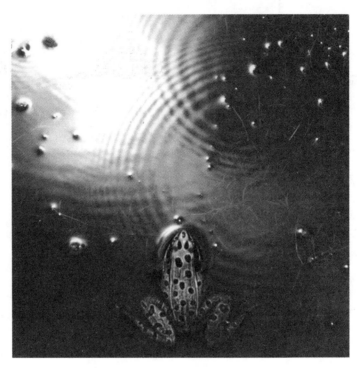

Figure A2.J.

*The unseen dark plays on his flute*
*and the rhythm of light*
*eddies into stars and suns*
*into thoughts and dreams.*
                RABINDRANATH TAGORE[5]

# NOTES

## INTRODUCTION.
## A HARMONY THAT STRUCTURES THE UNIVERSE

1. Von Franz, *Number and Time,* 286.

## CHAPTER 1. THE FIELD OF HARMONY

1. Vitruvius, *De architectura,* quoted in Needham, *Science and Civilisation in China,* 4:202.

## CHAPTER 2. THE GEOMETRY OF TIME

1. Daniélou, *Music and the Power of Sound,* 156.
2. Leet, *Universal Kabbalah,* 5.
3. Hambidge, *The Elements of Dynamic Symmetry,* 84.

## CHAPTER 3. MOON AND EARTH

1. Eliade, *The Sacred and the Profane,* 156.
2. McClain, "The Shih-Chi," 142.
3. Needham, *Science and Civilisation in China,* 4:200.
4. Levarie and Levy, *Tone,* 56.

## CHAPTER 4. THE TEMPLE OF WATER

1. Thom, *Megalithic Sites in Britain,* 2.
2. Ibid., 2–3.
3. Bentov, *Stalking the Wild Pendulum,* 110.
4. Laszlo, *The Akashic Field,* 70.
5. Villoldo, *The Dance of the Four Winds,* 116.

## CHAPTER 6. THE SPIRALING OCTAVE

1. John Michell, *The Dimensions of Paradise,* 196.
2. Eddington, *Stellar Movements and the Structure,* 244.

## CHAPTER 7. HARMONIC STRUCTURES

1. Alberti, *The Ten Books of Architecture.*
2. The list of proportions of concert halls is taken from a chart in *Tone,* by Levarie and Levy, 186, figure 65.

3. Hale, *Sacred Space, Sacred Sound*, 6.
4. Kayser, *Akroasis*, 77.

## CHAPTER 8. THE CIRCLE OF RESONANCE

1. Kayser, *Textbook of Harmonics*, 1:29.
2. Heath, Richard, *Matrix of Creation*, 42.
3. West, *Serpent in the Sky*, 40, 42.

## CHAPTER 9. THE MUSICAL UNIVERSE

1. Feynmann, *The Character of Physical Law*, 57.
2. John Michell, *The Dimensions of Paradise*, 197, 199.
3. Kepler, *Mysterium Cosmographicum*.

## CHAPTER 10. THE TREE OF TIME

1. Eliade, *The Sacred and the Profane*, 81.
2. Munn, *The Transformation of Subjects and Objects*, 59.
3. Campbell, *The Hero with a Thousand Faces*, 234.
4. Kayser, *Textbook of Harmonics*, 1:21.
5. Proskouriakoff, *A Study of Classic Mayan Sculpture*, 111.

## CHAPTER 11. THE COSMIC FLOWER

1. Bachofen, *Grabersymbolik der Alten*, quoted in Kayser, *Textbook of Harmonics*, lxxvii.
2. Lawlor, *Voices of the First Day*, 37.
3. George Michell, *The Hindu Temple*, 73.
4. Bentov, *Stalking the Wild Pendulum*, 151.

## APPENDIX 1. THE VESSEL OF CEREMONY

1. John Michell, *The Dimensions of Paradise*, 13–14.
2. Villoldo, *The Journey*, 41.

## APPENDIX 2. A MISCELLANY OF NUMBERS AND FORMS

1. Pennick, *Sacred Geometry: Symbolism and Purpose in Religious Structures*, 84.
2. Frankl, *Gothic Architecture*, 20.
3. Eliade, *A History of Religious Ideas*, 1:3.
4. Levarie and Levy, *Tone*, 199.
5. Tagore, *The English Writings of Rabindranath Tagore*, 1:475.

# BIBLIOGRAPHY

Alberti, Leon Battista. *The Ten Books of Architecture.* N.p., 1452.

Bachofen, Johann Jakob. *Versuch über die Gräbersymbolik der Alten.* Basel: Bahnmaier, 1859.

Bamford, Christopher, ed. *Homage to Pythagoras: Rediscovering Sacred Science.* Hudson, NY: Lindisfarne Press, 1982.

Bangs, Herbert. *The Return of Sacred Architecture: The Golden Ratio and the End of Modernism.* Rochester, Vt.: Inner Traditions, 2006.

Bentov, Itzhak. *Stalking the Wild Pendulum: On the Mechanics of Consciousness.* Rochester, Vt.: Inner Traditions, 1988.

Campbell, Joseph. *The Hero with a Thousand Faces.* Novato, Cal.: New World Library, 2008.

Calleman, Carl Johan. *The Purposeful Universe: How Quantum Theory and Mayan Cosmology Explain the Origin and Evolution of Life.* Rochester, Vt.: Bear and Company, 2009.

Daniélou, Alain. *Music and the Power of Sound: The Influence of Tuning and Intervals on Consciousness.* Rochester, Vt.: Inner Traditions, 1995.

Eliade, Mircea. *A History of Religious Ideas.* Vol. 1, *From the Stone Age to the Eleusinian Mysteries.* Chicago: University of Chicago Press, 1978.

———. *The Sacred and the Profane: The Nature of Religion.* San Diego, Calif.: Harcourt Brace Jovanovich, 1987.

Eddington, Arthur Stanley. *Stellar Movements and the Structure of the Universe.* London: MacMillan and Company, 1914.

Feynmann, Richard. *The Character of Physical Law.* Cambridge, Mass.: The MIT Press, 1965.

Frankl, Paul. *Gothic Architecture.* Baltimore: Penguin Books, 1962.

Godwin, Joscelyn. *The Harmony of the Spheres: The Pythagorean Tradition in Music.* Rochester, Vt.: Inner Traditions, 1992.

Hale, Susan Elizabeth. *Sacred Space, Sacred Sound: The Acoustic Mysteries of Holy Places.* Wheaton, Ill.: Quest Books, 2011.

Hambidge, Jay. *The Elements of Dynamic Symmetry.* Mineola, N.Y.: Dover Publications, 1967.

Heath, Richard. *Matrix of Creation: Sacred Geometry in the Realm of the Planets.* Rochester, Vt.: Inner Traditions, 2004.

———. *Sacred Number and the Origins of Civilization.* Rochester, Vt.: Inner Traditions, 2006.

Heath, Robin. *Sun, Moon and Earth.* London: Walker Books, 2001.

Jenkins, John Major. *Galactic Alignment: The Transformation of Consciousness According to Mayan, Egyptian, and Vedic Traditions.* Rochester, Vt.: Bear and Company, 2002.

Kayser, Hans. *Akroasis.* Boston, Mass.: Plowshare Press, 1970.

———. *Textbook of Harmonics.* Vols. 1 & 2. Translated by Ariel Godwin. Edited by Joscelyn Godwin. Santa Barbara, Calif.: Sacred Science Library, 2006.

Kepler, Johannes. *Mysterium Cosmographicum.* N.p., 1596.

Laszlo, Ervin. *The Akashic Field: An Integral Theory of Everything.* Rochester, Vt.: Inner Traditions, 2007.

Lawlor, Robert. *Sacred Geometry: Philosophy and Practice.* New York: Thames and Hudson, 1982.

———. *Voices of the First Day: Awakening in the Aboriginal Dreamtime.* Rochester, Vt.: Inner Traditions, 1991.

Leet, Leonora. *The Secret Doctrine of the Kabbalah.* Rochester, Vt.: Inner Traditions, 1999.

———. *The Universal Kabbalah.* Rochester, VT: Inner Traditions, 2004.

Levarie, Siegmund, and Ernst Levy. *Tone: A Study in Musical Acoustics.* Kent, Ohio: Kent State University Press, 1968.

McClain, Ernest G. "The Shih-Chi." In *Plato, Time and Education: Essays in Honor of Robert S. Brumbaugh.* Edited by Brian Patrick Hendley. Buffalo: State University of New York Press, 1988.

Michell, George. *The Hindu Temple: An Introduction to Its Meanings and Forms.* Chicago: University of Chicago Press, 1988.

Michell, John. *The Dimensions of Paradise: Sacred Geometry, Ancient Science, and the Heavenly Order on Earth.* Rochester, Vt.: Inner Traditions, 2008.

Munn, Nancy D. *The Transformation of Subjects and Objects in Walbiri and Pitjantjatjara Myths.* Nedlands, W.A.: University of Western Australia Press, 1970.

Needham, Joseph. *Science and Civilisation in China.* Vol 4. Cambridge: Cambridge University Press, 2004.

Pennick, Nigel. *Sacred Geometry: Symbolism and Purpose in Religious Structures.* San Francisco, Calif.: Harper & Row Publishers, 1980.

Proskouriakoff, Tatiana. *A Study of Classic Mayan Sculpture.* Washington, D.C.: Carnegie Institute of Washington. Pub. 593. 1950.

Thom, Alexander. *Megalithic Sites in Britain.* Oxford: Oxford University Press, 1976.

Tresidder, Jack. *The Complete Dictionary of Symbols.* San Francisco, Calif.: Chronicle Books, 2004.

Tagore, Rabindranath. *The English Writings of Rabindranath Tagore.* Vol. 1, *Poems.* Edited by Sisir Kumar Das. New Delhi: Atlantic Publishers and Distributors, Ltd., 1994.

Villoldo, Alberto. *The Dance of the Four Winds.* Rochester, Vt.: Destiny Books, 1995.

———. *The Journey.* Coconut Grove, Fla.: The Four Winds Society, 2004.

Von Franz, Marie-Louise. *Number and Time: Reflections Leading toward a Unification of Depth Psychology and Physics.* Evanston, Ill.: Northwestern University Press, 1986.

Vicentino, Nicola. *Ancient Music Adapted to Modern Practice.* New Haven, Conn.: Yale University Press, 2011.

West, John Anthony. *Serpent in the Sky: The High Wisdom of Ancient Egypt.* Wheaton, Ill.: Quest Books, 1993.

# ILLUSTRATION CREDITS

Frontispiece. *The First Tone of Plainsong* from William Fleming, *Art and Ideas* (New York: Houghton Mifflin Harcourt School, 1986).

## CHAPTER 1

Fig. 1B (a). Calendar Stone, from Nicholas Fry, *Treasures of World Art* (London: Tiger Books International, 1986), 218.

Fig. 1B (b). West rose window, Notre Dame de Paris, from Marcel Aubert, *Art of the High Gothic* (New York: Crown Publishers, Inc., 1965), 30.

Fig. 1B (c). Pi disc, from Wen Fong and James C. Y. Watt, *Possessing the Past: Treasures from the National Palace Museum Taipei* (New York: Metropolitan Museum of Art; Taipei: National West rose window, Notre Dame de Paris, from Marcel Aubert, *Art of the High Gothic* (New York, Crown Publishers, Inc., 1965), 30.

Fig. 1C. Dividing cell, from Boyce Rensberger, *Instant Biology* (New York: Ballantine Books, 1996), 97.

## CHAPTER 2

Fig. 2A. Photo of Apollo temple, photos: Henri Stierlin; text: Roland Martin, *Living Architecture: Greek* (London: Oldbourne Book Co. Ltd., 1967), 101.

Drawing 2.4. Apollo temple plan, from Isabel Hoopes Grinnell, *Greek Temples* (New York: Metropolitan Museum of Art, 1943), 30.

## CHAPTER 4

Fig. 4A, Fig. 4B. Waterdrop, photos by Oscar Kreisel, text by Jacob Bronowski, *The Ascent of Man* (Boston/Toronto: Little Brown 1973), 185.

Drawing 4.4 (1). Long Meg and Her Daughters, from Alexander Thom, *Megalithic Sites in Britain* (Oxford: Oxford University Press, 1976), 151.

Drawing 4.4 (3). Flattened circles, from Alexander Thom, *Megalithic Sites in Britain* (Oxford: Oxford University Press, 1976), 28.

## CHAPTER 5

Drawing 5.5 (1). Jar from Susa, from Trudi Kawami, *Ancient Iranian Ceramics* (New York: The Arthur M. Sackler Collection, 1992), 18.

Drawing 5.5 (2). The Sanctuary Rhyton, from Nikolaos Platon, *Zakros* (New York: Charles Scribner and Sons, 1971), 165.

## CHAPTER 6

Fig. 6A (b). *Begonia* 'Duartei,' from Kjell B. Sandred, photos, and Ghillean Tolme Prance, text, *Leaves* (New York: Crown Publishers, 1985), 17.

## CHAPTER 8

Drawing 8.7 (1). Doryphoros, from H. A. Groenewegen-Frankfort and Bernard Ashmole, *Art of the Ancient World* (Englewood Cliffs, N.J.: Prentice Hall, 1972 ), 318.

Drawing 8.7 (2). Amiens plan, from Paul Frankl,

# INDEX